eyewitness

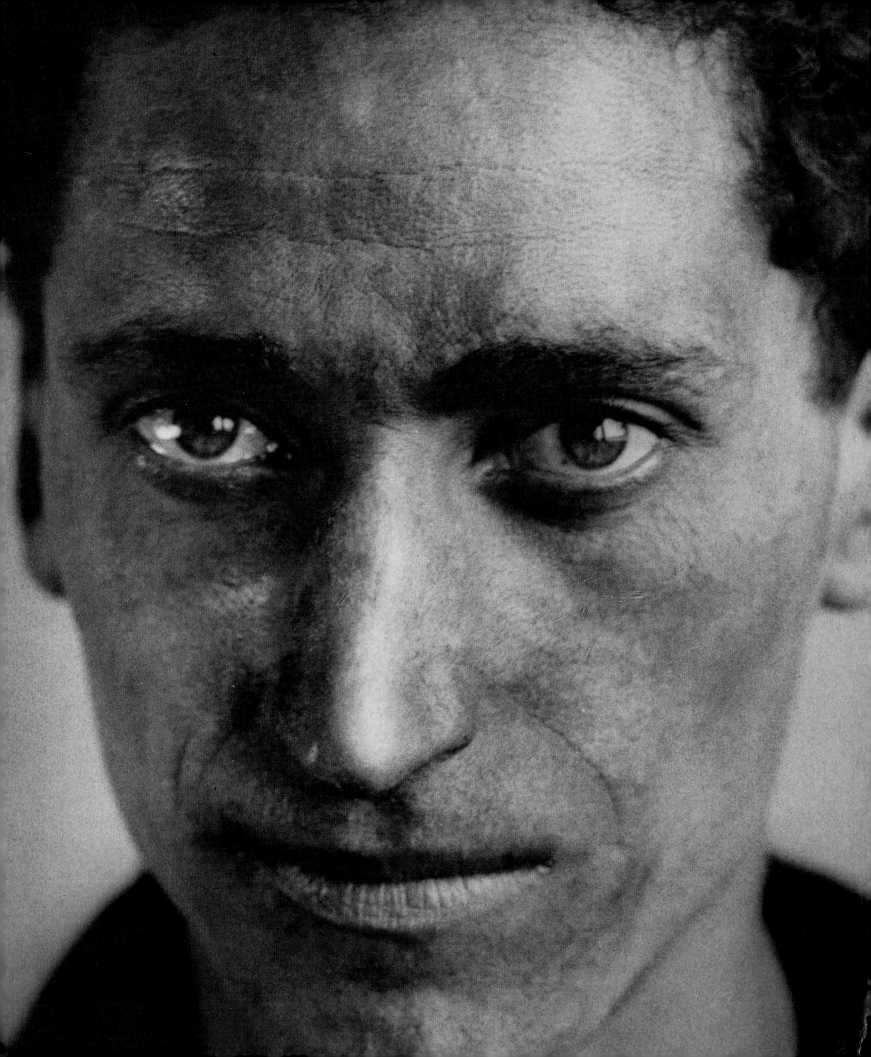

Hungarian
Photography
in the
Twentieth Century
Brassaï
Capa
Kertész
Moholy-Nagy
Munkácsi

eyewitness

Péter Baki | Colin Ford | George Szirtes

Royal Academy of Arts

First published on the occasion
of the exhibition
'Eyewitness: Hungarian Photography
in the Twentieth Century.
Brassaï, Capa, Kertész,
Moholy-Nagy, Munkácsi'

Royal Academy of Arts, London
30 June – 2 October 2011

The Royal Academy of Arts is grateful to
Her Majesty's Government for agreeing
to indemnify this exhibition under the
National Heritage Act 1980, and to
Resource, The Council for Museums,
Archives and Libraries, for its help in
arranging the indemnity.

EXHIBITION CURATORS
Colin Ford
with Péter Baki

assisted by Sarah Lea,
Royal Academy of Arts

EXHIBITION ORGANISATION
Sunnifa Hope

PHOTOGRAPHIC AND COPYRIGHT
CO-ORDINATION
Trine Lyngby Hougaard
Christos Ioannidis
Katharine Oakes

CATALOGUE
Royal Academy Publications
Beatrice Gullström
Carola Krueger
Sophie Oliver
Peter Sawbridge
Nick Tite

Translation of texts by Péter Baki
from the Hungarian: Andrew Gane
Design: Adam Brown_01.02
Colour origination: DawkinsColour
Printed in Italy by Graphicom

British Library Cataloguing-in-Publication Data
A catalogue record for this book is available
from the British Library

ISBN 978-1-905711-77-2 (paperback)
ISBN 978-1-905711-76-5 (hardback)

Distributed outside the United States and
Canada by Thames & Hudson Ltd, London

Distributed in the United States and Canada
by Harry N. Abrams, Inc., New York

EDITORIAL NOTE
In the plate captions and the list of works
on pages 235–37 the term 'vintage' is used to
designate a photographic print that was printed
either by the photographer or under his or her
direct supervision, at or around the time the
photograph was taken. When a print of this
kind was made significantly later than the date
on which the photograph was taken, the date of
the print is also given. In the case of prints made
posthumously it is indicated when the print was
made from the original negative.

ILLUSTRATIONS
Page 2: detail of cat. 42
Page 6: detail of cat. 26
Page 43: detail of cat. 12
Page 91: detail of cat. 58
Page 103: detail of cat. 119
Page 169: detail of cat. 137
Page 193: detail of cat. 182

2009–2013 Season supported by

Exhibition organised by the Royal Academy
of Arts on the occasion of the Hungarian
Presidency of the EU 2011

Supported by

GOVERNMENT OF
THE REPUBLIC OF HUNGARY

BALASSI
INSTITUTE

hungaro**fest**

HCC
Hungarian Cultural Centre
LONDON

www.eu2011.hu/culture

otpbank

Contents

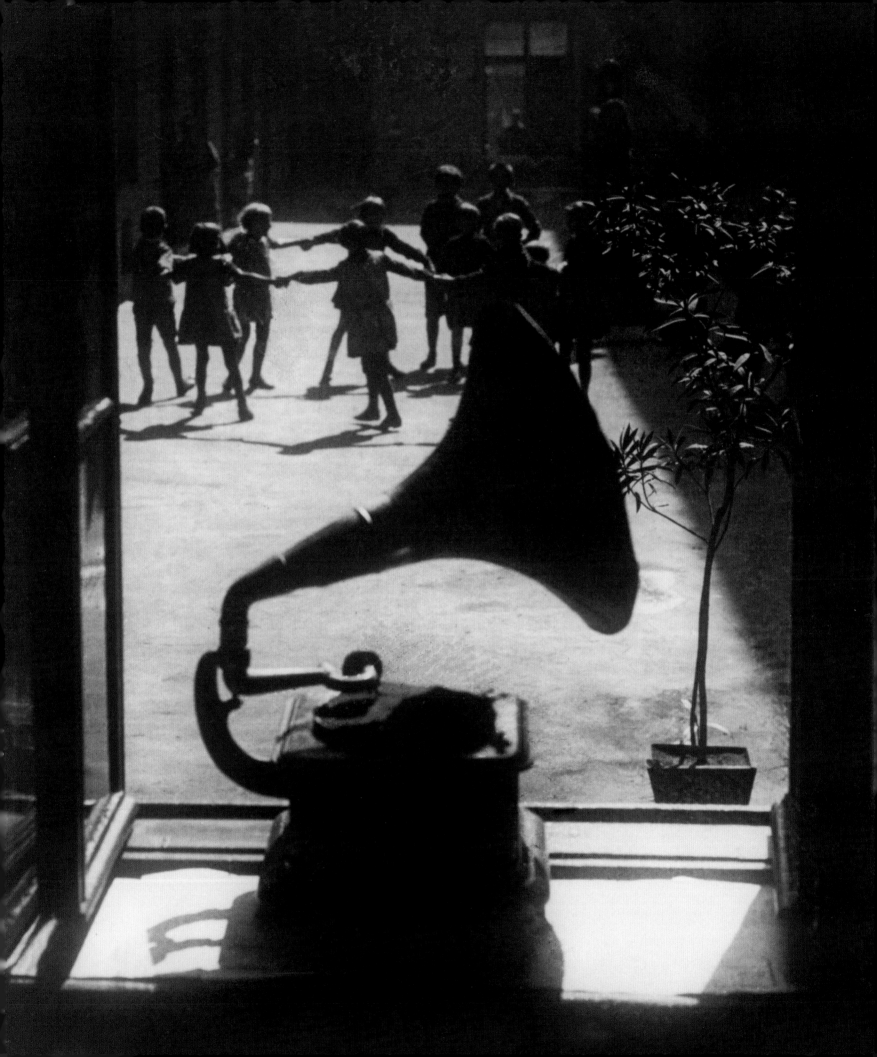

President's Foreword

The last major photographic exhibition to take place at the Royal Academy was 'The Art of Photography, 1839–1989', a survey in which Brassaï, Capa, Kertész, Moholy-Nagy and Munkácsi all featured as prominent figures in the history of the medium. A truly remarkable number of talented photographers began their journeys in Hungary, that cultural and geographical intersection between east and west whose vigorous illustrated press made it a wellspring of photojournalism in the early twentieth century. Burgeoning photographic genres were shaped by the vision and originality of these individuals. Photography thrived as a result, both in Hungary, where diverse influences were interpreted through the Hungarians' refined national sensibility, and abroad, in the cosmopolitan vibrancy of the European and American cities through which other Hungarian photographers moved on their different paths. One such city was London, and we are delighted to present here a unique exhibition that brings together these influential and internationally recognised photographers to explore their careers within the richly textured photographic milieu of their country of origin.

The exhibition has been curated by Colin Ford, photographic historian and founding director of the National Media Museum, Bradford, with Péter Baki, photographic historian and director of the Hungarian Museum of Photography, Kecskemét. They are responsible for the careful selection of over two hundred photographs, which offer insights into the extraordinary legacy of Hungarians to the world of modern photography.

Opening as the Hungarian presidency of the European Union draws to a close, this exhibition is appropriately resonant with the spirit of cultural exchange so emphatically put into practice by these pioneers of modern photography. We are indebted to the government and institutions of Hungary for supporting this project in myriad ways. We are grateful to László Baan and Ferenc Csák for their invaluable support during the genesis of the project. A special thank you is due to Ildikó Takács and her colleagues at the Hungarian Cultural Centre in London for their constant co-operation, which has been vital to this project, as indeed has the organisational support of the Balassi Institute, Budapest, and Hungarofest, to whose staff we are most grateful.

We cannot overstate our gratitude to the Hungarian Museum of Photography for lending the majority of the photographs in the exhibition. It has been a privilege to work with its exceptional collection of over one million Hungarian and international photographs, which spans the entire history of photography and continues to grow, reflecting developments in contemporary photographic practice today. We are also very grateful to the Hungarian National Museum, which has lent items from the important and extensive photographic archive it holds as part of its wider collection. The exhibition has benefited greatly from the knowledge and experience of the curators of both museums, and we thank them all for their collaboration. We would also like to extend our thanks to other public and private collections that have lent works to the exhibition.

Our exhibition programme would not be possible without the help of loyal benefactors. We owe much gratitude to JTI, 2009–2013 Season Supporter of our programme in the Sackler Wing of Galleries, and to Hungarofest and OTP Bank, who have generously supported this exhibition.

Sir Nicholas Grimshaw CBE PRA

Supporters' Statements

Brassaï, Robert Capa, André Kertész, László Moholy-Nagy and Martin Munkácsi are all known for the important changes they brought about in photojournalism and art photography. As the long-term Season Supporter of exhibitions in the Sackler Wing of Galleries, JTI is honoured to be associated with this celebration of Hungary's rich photographic tradition.

Martin Southgate
Managing Director UK, JTI

The exhibition in London of these world-class photographers is a worthy closing of the Hungarian EU Presidency 2011. Hungary is extremely proud of these great Hungarian masters of photography, whose profound influence on photojournalists and filmmakers continues to this day.

Mónika Balatoni
Creative Director, Hungarofest

Acknowledgements

The Royal Academy would like to acknowledge its gratitude to the following individuals for their assistance during the making of this exhibition and its catalogue:

Béla Albertini, László Baán, Mónika Balatoni, Martin Barnes, Erin Barnett, Mariann Bjerre, Stephen Bulger, Ferenc Csák, Szilvia Csányi, Csilla Csorba, László Csorba, Borbála Czakó, Tibor Dóka, Kálmán Fehér, Polly Fleury, Sue Grayson Ford, Inga Fraser, Henrietta Galambos, Bernadett Gárdos, Robert Gurbo, László Haris, Willis E. Hartshorn, Michael Hoppen, Magda Keaney, Dávid Kerényi, Hanna Kiss, Péter Korniss, Orsolya Kőrösi, Zsófia Kovács, Janka Krasznai, Beatrix Lengyel, János Lengyel, Jenő Lévai, Brian Liddy, Adrian Locke, Sebastian Lux, Sarah McDonald, Zsuzsanna Mehrli, Gustavo Grandal Montero, John G. Morris, Natália Nagy, Martin Parr, Terence Pepper, Mila Phillips, Attila Pőcze, Barbara Pötzner, Stefan van Raay, Rita Rubovszky, Kathleen Soriano, Orsolya Szabó, Ildikó Takács, Andrea Tarsia, Christopher Tinker, Emőke Tomsics, László Török, Balázs Zoltán Tóth, Tamás Urbán, Gyöngyi Végh, Brian Wallis, Marc Ward, Michael Wilson, Cynthia Young.

Flower of my country, your stem has been crushed,
And my sorrow finds no relief.
A storm has swept over my village home;
Land that I love, farewell![1]

'It's not enough to have talent, you also have to be Hungarian.'[2] These words of Robert Capa, perhaps the most widely known of the photographers shown here, may have been said partly as a joke, but they have more than a germ of truth in them. For what we now think of as a small nation, Hungary has produced a surprisingly high number of internationally known photographers. As long ago as 1931, the British journal *Modern Photography*'s list of 'The World's Hundred Best Photographs' included eight names from Hungary, more than from any other nation – among them Kertész, Moholy-Nagy and Munkácsi. In our own time, the distinguished American journalist and picture editor John G. Morris has written that photography is 'a vocation that seems to come naturally to Hungarians'.[3] This essay explores this intriguing thought, with particular reference to Brassaï, Robert Capa, André Kertész, László Moholy-Nagy and Martin Munkácsi, but also to other photographers who left Hungary and made their careers abroad.

In the half-century before the First World War, Hungary (more properly, Austria-Hungary) was by area the second-largest country in Europe, with the continent's third-highest population, after Russia and the German Empire. The so-called Dual Monarchy, with two separate parliaments but only one monarch, came into existence in 1867, as a result of the Austro-Hungarian Compromise. In the decades that followed, Budapest – joint capital of the Austro-Hungarian Empire – was Europe's fastest-growing city, tripling its population to more than one million. It even opened mainland Europe's first underground railway in 1896.

Of the five photographers mentioned above, two (Capa and Kertész) were born in Pest, the financial and cultural half of Budapest, one (Moholy-Nagy) in southern Hungary, and two (Brassaï and Munkácsi) in Transylvania, part of Hungary ceded to Romania after the First World War (Capa's father also came from Transylvania). All came from Jewish families (although none seems to have been strongly religious) and all changed their birth names at some point in their lives. Five percent of Hungarians before the First World War were Jewish,[4] although an indication of their position in educated society is that between a quarter and a half of all university students were Jewish, and that more than three hundred Jewish bankers' and financiers' families had been ennobled for their contributions to the nation and to ensure their continued assistance to the government.

The First World War changed all this. The assassination in Sarajevo of the heir to the Austro-Hungarian throne triggered a series of events that led to virtually every European country being involved in war. Hungary was on the losing side, and the subsequent Treaty of Trianon forced it to give up 72% of its territory (and all access to the sea), and 64% of its population, which was reduced from 21 million to 7.5 million.

When war was declared, Gyula Halász (Brassaï), Andor Kohn (André Kertész) and László Weisz (Moholy-Nagy) were called up. Kertész was the only one who took a camera with him (cat. 62). He and Moholy-Nagy were both seriously wounded. Moholy-Nagy, who had for a time been a law student, made drawings on postcards during his time in hospital, where he suffered so much that his hair partly turned prematurely white. Kertész's left hand was paralysed for a while as a result of a bullet narrowly missing his heart, but he continued to take photographs throughout his convalescence. After the war, Brassaï was captured by the Romanian army when it entered Hungary; he caught typhoid while a prisoner, and was seriously ill when he was rescued. All three were profoundly affected by their experiences.

Although Márton Mermelstein (Munkácsi) was eighteen years old in 1914, and had moved with his family to Budapest three years earlier, he was for some reason not called up.[5] Endre Ernő Friedmann (Robert Capa) was less than a year old at the outbreak of war, and thus did not have to endure its life-changing experiences. Had he been born a few years earlier, he too would probably have experienced war as a young man, and been shocked. He might then not have grown up to photograph five wars in eighteen years, and to be described by the Hungarian-born founding editor of Britain's *Picture Post*, Stefan Lorant, as 'the world's greatest war photographer' (fig. 1).[6]

Lorant (István Reich) knew about photography as a boy, as his father was manager of the highly successful Budapest studio of Mór Erdélyi and a friend of Ede Kabos, editor of *Az Érdekes Ujság* (*Interesting Newspaper*), the only Hungarian paper to have 'secured the patent to reproduce pictures by rotogravure'.[7] Lorant had photographs published in this on 9 August and 27 September 1914, when he was only thirteen; three years later, one of his photographs appeared on the cover. Two years after that, he was making photo reportage (combining pictures and text) for several other Budapest publications, linking text and a series of photographs into a coherent story. Lorant emigrated to Germany, editing a number of picture magazines there between 1925 and 1928, before becoming editor of the *Münchner Illustrierte Presse*. His ideas about the picture story developed, and saw him cropping photographs into different shapes, overlapping them, and using captions of varying lengths to create a strong layout design, usually within a double-page spread. These principles spread to other German papers, and further afield. After being imprisoned by the Nazis for 'political offences', Lorant returned to Budapest, where he edited the pictorial *Pesti Napló* (*Pest Diary*) for four months. He then fled to England, where he was the founding editor of *Picture Post* (fig. 2). Picture stories were the staple of many European

Photography: Hungary's Greatest Export? | *Colin Ford*

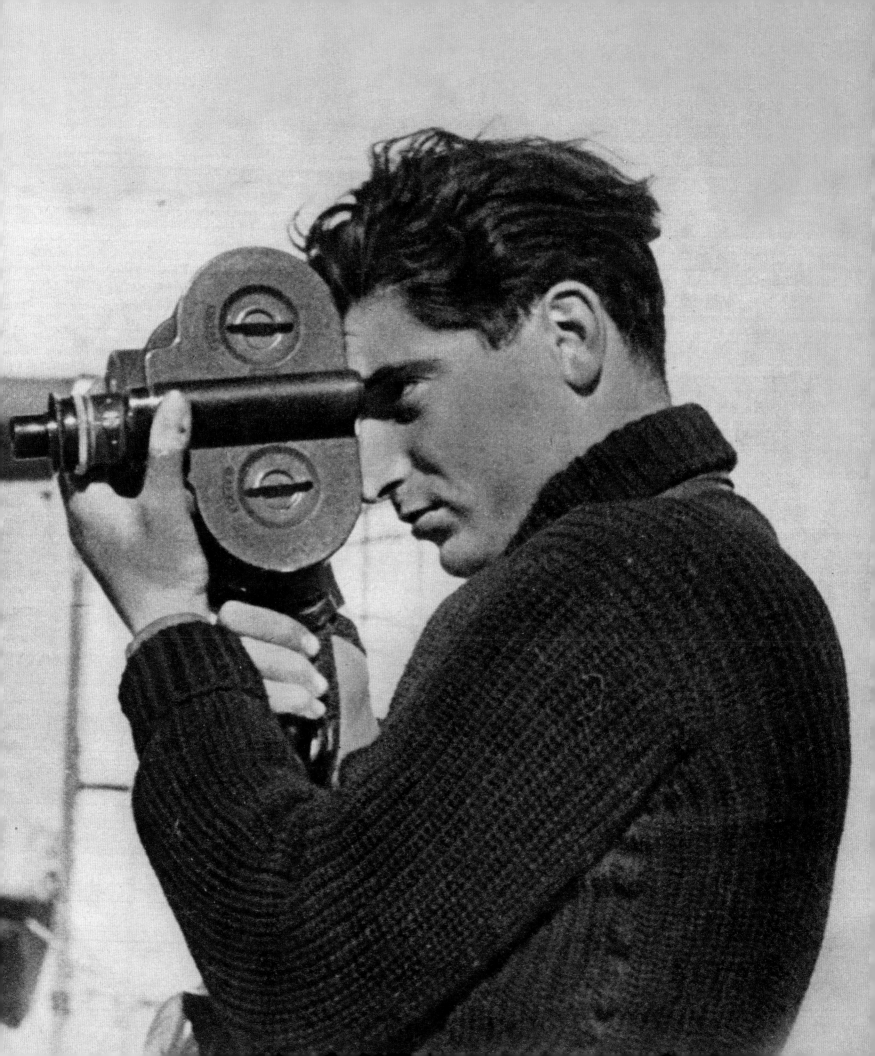

and American illustrated magazines. Capa's younger brother Cornell (Kornél) later described the photographer's aims in such stories: 'Isolated images are not the most representative of my work. What I do best are probably groups of interrelated pictures which tell a story. My pictures are the "words", which make "sentences", which in turn make up the story.'[8]

The fact that Brassaï, Capa, Kertész, Moholy-Nagy and Munkácsi changed their names to disguise their origins and help them to find employment points to another fundamental factor in the story. After its defeat in the First World War, the Austro-Hungarian monarchy collapsed, and in November 1918 Hungary declared itself a democratic republic. This did not last long. After five months of turmoil, during which armies from Czechoslovakia, Romania, Serbia and other Balkan countries entered Hungary under the command of General Franchet d'Esperey, the government – which had also failed on the domestic front – was defeated. The liberal Prime Minister, Mihály Károlyi, resigned and fled to Paris.[9]

After this collapse, the ensuing communist régime lasted an even shorter time. Its leader, Béla Kun, himself Jewish, came from Kolosvár (Cluj in present-day Romania) in Transylvania. When Admiral Miklós Horthy took over as dictator (cat. 65), his conservative and oppressive régime, which set itself against communists, liberals, artists and intellectuals (and therefore large numbers of Jewish people), instituted the 'White Terror' during which 5,000 people were killed and 70,000 imprisoned. Capa's mother witnessed the brutal beating-up of Jewish students in the same building as her family's apartment, in the heart of the secular Jewish neighbourhood and opposite a bank used by many of them.[10] In 1920 the Numerus Clausus, one of the first anti-Jewish acts of the twentieth century in Europe, was introduced in Hungary, limiting the percentage of Jewish people allowed to attend university to 5%. This meant that Hungarian Jewish people often had to leave their homeland merely to get a university education.

Anti-Semitism was not confined to Hungary at this time, nor even to Europe: in the 1920s, the President of Harvard University proposed a limit on the number of Jewish students.[11] But the growth of these restrictions certainly affected the lives and careers of Hungarian photographers. Many years later, when Munkácsi had almost stopped taking photographs, he spent five years writing a partly autobiographical novel, *Fool's Apprentice*, which describes the childhood of Imre Rich, son of a drunkard house-painter (as was Munkácsi's own father).[12] The title comes from the fact that an apprentice from a nearby madhouse had indeed lodged with the Munkácsi family. A central theme of the novel is the growing tide of antagonism towards Jewish people among the Hungarian communities of Transylvania: 'Transylvanians in those days, if they thought about it at all, would have defined an anti-Semite as a man who hated Jews more than necessary.'[13]

Fig. 1 (previous page)
Robert Capa, photographed by Gerda Taro at the Segovia Front. From *Picture Post*, 1, 10, 3 December 1938 (cat. 202)

Fig. 2
'How Picture Post Is Produced', showing the magazine's editor Stefan Lorant, *Picture Post*, 24 December 1938

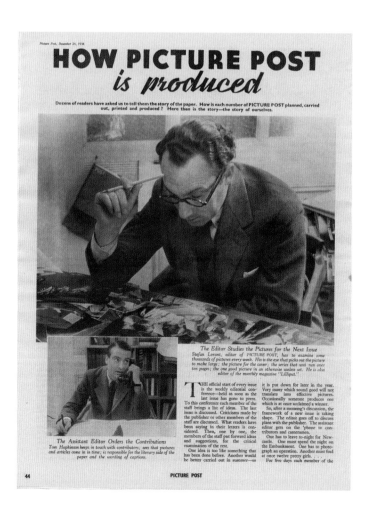

Even in the twenty-first century, there is a strong tradition among Jewish Hungarians to tell their children stories, especially at Passover, and to encourage them to make illustrations of them. Another eminent Hungarian Jewish émigré who settled in England, Andor Kraszna-Krausz[14] (founder of the immensely successful Focal Press), once told me that it was traditional in pre-war Hungary for young boys to be given a camera as a birthday present in their early teens. This happened to him at the age of eleven or twelve, as it did to Lucien Aigner (aged nine), Károly Escher (twelve), Rudolf Balogh and Zoltán Berekméri (both fourteen), among others. Many of the photographers in this exhibition seem to have benefited from this custom. Kertész, on the other hand, did not own a camera until 1912, when he was eighteen and his mother gave him an ICA box camera, which took tiny (4.5 × 6 cm) glass negatives. His earliest surviving photograph, *Boy Sleeping* (cat. 1), taken that year, is an extraordinarily accomplished achievement for a novice. The cropping of the print has been so precisely calculated that the sleeping young man just fills the width of the frame. The newspapers above his head and beneath his elbow show that he is in the kind of relaxed coffee house that allows its customers just to sit and read. This apparently casual snapshot has a rigorous 'X' composition, although Kertész did not crop the original 1912 horizontal negative to its even stronger vertical shape until more than half a century later.

Kertész's achievement is even more striking when one considers that he had little formal training in art or photography, although he did take what turned out to be an unsatisfactory month's instruction from Angelo in 1924, shortly before going to Paris. Indeed, many of the great Hungarian photographers, among them Escher and Munkácsi, were proud of being self-taught. Kertész said that, although he did not actually start taking photographs before he was eighteen, a dozen or so years earlier he had begun to imagine 'photographs without camera … visualising exactly what I wanted to do', studying the engravings and woodcuts in the magazines read by his family. 'My only problem was the technique.'[15]

The Hungarian language has very little in common with any other language except, perhaps, Finnish. Cornell Capa said he was partly 'driven towards photography' by the fact that he was 'born in Hungary, a small country where a language is spoken that no one else in the world understands'.[16] The author Arthur Koestler, who spent much of his life in Britain, wrote: 'Hungarians are the only people in Europe without racial or linguistic relatives in Europe, therefore they are the loneliest on this continent. This … perhaps explains the peculiar intensity of their existence … Hopeless solitude feeds their creativity, their desire for achieving … To be Hungarian is a collective neurosis.'[17] This might well have motivated some Hungarians who left their homeland to express themselves in photography (as well as in music and painting) rather than words.

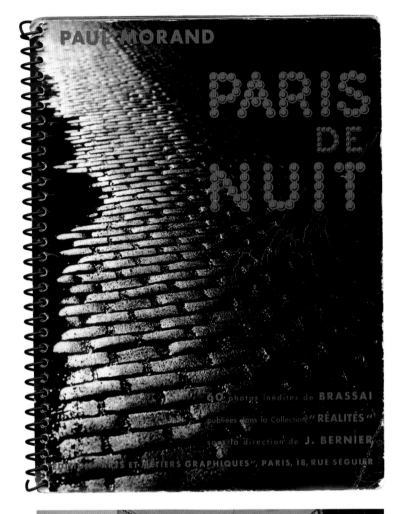

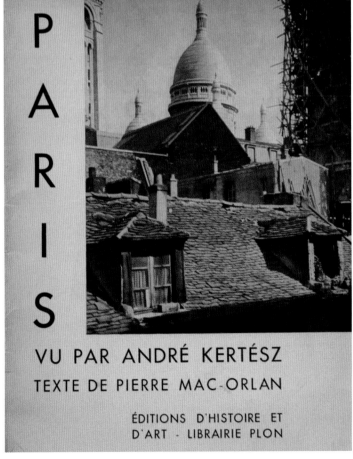

Fig. 3
Paul Morand and Brassaï, *Paris de Nuit: 60 photos inédites de Brassaï*, Editions Arts et Métiers graphiques, Paris, 1932 (cat. 184)

Fig. 4
Pierre Mac-Orlan and André Kertész, *Paris vu par André Kértesz*, Librairie Plon, Paris, 1934 (cat. 185)

When Munkácsi took his famous first fashion photograph for *Harper's Bazaar* (cat. 119), he could not speak English at all, and had to instruct his model by means of hand gestures. In 1935 Moholy-Nagy was taken to a London party by John Betjeman, who had commissioned him to take photographs for his book *An Oxford University Chest* (fig. 15). On his arrival he said to his hostess: 'Thank you for your hostilities.' Kertész never really mastered French or English, the languages of the two countries in which he lived after leaving Hungary; nor did Robert Capa, who spoke a mixture known among his colleagues as 'Capanese'. He once told the FBI, which investigated him in 1953 during the McCarthy era, that he became a photographer because it was 'the nearest thing to journalism for anyone who found himself without a language'.[18] All this inevitably meant that Hungarian photographic émigrés were, to a greater or lesser degree, always seen as outsiders, and probably thought of themselves that way too.

Another result of this difficulty of communicating in foreign lands was that émigré Hungarians – like other groups of exiles – stuck together. Hungarians in New York, Munkácsi among them, met regularly at the Balaton Restaurant on 79th Street.[19] There and elsewhere, Hungarians did everything possible to help each other. In Paris, Kertész introduced Brassaï, who had failed to earn a living there as a painter and sculptor, to the more profitable line of photography. 'I was not yet a photographer,' said Brassaï, 'and gave no thought at all to photography about which I knew nothing and even despised when, about 1926, I met André Kertész' who 'had two qualities which were essential to a great photographer: an insatiable curiosity of the world of life and of people and a precise sense of form … But rarely are the two qualities found in the same person.'[20] For a time, Brassaï submitted articles with photographs by Kertész to the German illustrated papers. But Kertész's example led Brassaï to spend the next few months taking photographs for his 1932 book *Paris de Nuit* (fig. 3), a brilliant mix of his highly skilled vision of the city under its new electric street lighting and the words of the novelist, playwright and poet Paul Morand (whose name appears bigger on the jacket than Brassaï's). Kertész was envious (perhaps because, it has been suggested,[21] he had been offered the project first but turned it down). Within a year, he brought out his own *Paris vu par André Kertész* (fig. 4).[22] Here too the publishers thought it necessary to have words by a well-known author, in this case the novelist and journalist Pierre Mac-Orlan. The 48 photographs in *Paris vu par André Kertész* paint a much gentler picture of the city than Brassaï's, with more concentration on familiar buildings, the river, and what he called 'little happenings'. Somehow, as in all his work, one senses the presence of the photographer in every one of the book's striking layouts.

When Éva Besnyő, who had lived in an apartment in Budapest next to the Capas, moved to Berlin – where Robert Capa had fled after he was

briefly arrested following a political rally – she encouraged him to take up photography. A keen photographer in Budapest, she had studied with József Pécsi and taken Capa on photographic outings. In Berlin, she introduced him to the founder of the Dephot (Deutsches Photodienst) photographic agency, Simon Guttman, who was, it seems almost superfluous to say, Hungarian.[23] Although Capa started as a darkroom assistant, he borrowed one of the agency's 35 mm Leicas and taught himself how to use it. In 1932 Guttman sent him on his first important commission, to photograph Trotsky speaking in Copenhagen (fig. 7). Of all the photojournalists present, only Capa was using a modern 35 mm camera; the others had old-fashioned and unwieldy press cameras and could not react so quickly. A Berlin newspaper devoted a whole page to his dramatic photographs, and his reputation began to build.

After Capa moved to Paris, Kertész passed on some jobs and contacts to him, and may perhaps have lent him money. Capa finally dropped his birth name, and became Robert Capa: 'Cápa', the Hungarian word for shark, had been a childhood nickname,[24] based on his wide mouth and aggressive manner. Éva Besnyő now encouraged him to adopt it as a professional name because it sounded convincingly American, and made it easier for him to sell himself as an American photographer, and thus to command high fees. The strategy worked, and he was soon selling photographs to French newspapers for something approaching three times the European going rate. His studio manager was another Hungarian, the photographer Imre Weisz, who had been a close friend of Capa and Kati Deutsch (later Horna) in Budapest.[25] After the outbreak of the Spanish Civil War in 1936, Lucien Vogel, editor of *Vu*, a magazine that gave prominence to strong graphic design of photo stories and regularly used photographs by Kertész (fig. 9) and others, sent Capa to cover it. His extraordinary photographs shot Capa to international fame. Three-quarters of a century later, his *Death of a Loyalist Militiaman* (cat. 108; fig. 6), apparently showing the moment of death of a Republican fighter, is still instantly recognisable to many who have never heard of the photographer.

Kertész himself was already becoming well-known in Paris. He had arrived in October 1925, without the woman with whom he was in love, Elizabeth Salomon: 'Go away and establish yourself and then come for me,' she told him.[26] She surely regretted this when the lonely Kertész suddenly married Roszi Klein, a Hungarian violinist and photographer in Paris who adopted her husband's new first name and called herself Rogi André (fig. 5). When Kertész had arrived in the city, the only person he knew was the Dadaist Tristan Tzara, who had moved there in 1919 from a Romanian Jewish community just outside Transylvania. Through Tzara, Kertész soon got to know other Hungarian immigrant artists, such as József Csáky, Gyula Zilzer and the deaf-mute Lajos Tihanyi, to whom he grew particularly close

Fig. 5
Lilliput, 18, 3, 105, March 1946, with a photo of Picasso by Rogi André (Roszi Klein) (cat. 200)

Fig. 6
The death of Robert Capa on 25 May
1954 is reported in *Life*, 36, 23, 7 June
1954 (cat. 186); the article reproduces
his famous *Death of a Loyalist Militiaman*
(cat. 108) and *American Soldier Landing
on Omaha Beach, D-Day* (cat. 137)

Fig. 7
Robert Capa, *Trotsky Speaking
in Copenhagen*, 27 November
1932. Silver gelatin print, 22.6 ×
34.1 cm. International Center of
Photography, New York

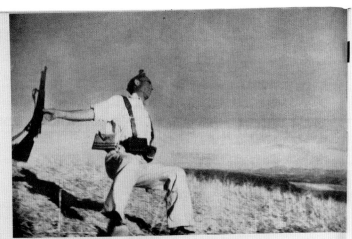

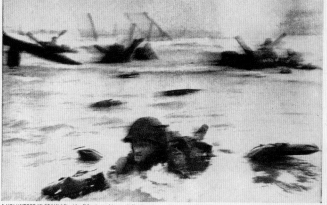

◄ **A VOLUNTEER IN SPAIN** falls with a Falangist machine-gun bullet through his head, near Cordoba in the summer of 1936. Capa had joined up with a hastily organized, amateur Loyalist force, watched from a trench while wave after wave of them were destroyed trying to attack a professionally placed Franco position.

THE LANDING ON D-DAY brought Capa in with the first wave, turning around to photograph a rifleman in the surf off "Easy Red" beach in Normandy. "I just stayed behind my tank," wrote Capa, "repeating a sentence from my Spanish Civil War days, *Es una cosa muy seria*. This is a very serious business...."

A PHOTOGRAPHER'S JOURNAL
...UP TO HIS FINAL WAR

Not long ago Robert Capa announced he was "happy to be an unemployed war photographer" and hoped to stay so for the rest of his life. Specializing in peaceful subjects, he remained one of the world's top photographers. Circumstances surrounding the beginning and end of his career, however, make it inevitable that his professional biography is written mostly in his great war pictures. It began with Spain in 1936 where 22-year-old Capa took a picture (*above, left*) that made him famous

almost overnight. He left Spain for China to cover the fight against Japan, eventually came to the U.S. In London he reported the 1941 blitz, later went with U.S. troops to North Africa and Italy where he photographed the mourning Neapolitan mothers (*below, left*). He got back to England in time to land on a Normandy beach (*above*) on D-day, 10 years ago this week. He went on to the siege of Bastogne and the Rhine (*below*). In Israel in 1948 he saw his fourth war—his next to last.

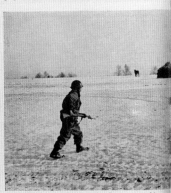

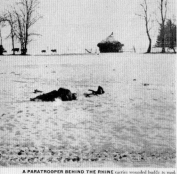

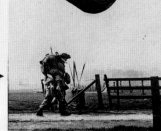

MOTHERS OF NAPLES lament their children, killed in the abortive uprising of September 1943 before Allies took over from retreating Germans. Of this story Capa said in an expression of his hatred for war: "... Those were my truest pictures of victory, the ones I took at that simple schoolhouse funeral."

INFANTRYMAN AT BASTOGNE approaches a German paratrooper lying in the snow, near the end of the fateful Battle of the Bulge in December 1944. It was on this occasion that Capa was taken for an enemy soldier by trigger-happy GIs, saved himself by yelling, with as little accent as possible, "Take it easy!"

A PARATROOPER BEHIND THE RHINE carries wounded buddy to medical aid station after the drop in March 1945, as spent chute flaps from telephone wires overhead. U.S. officers had asked combat veteran Capa to jump with a raw outfit rather than a seasoned one in order to improve the men's morale.

CONTINUED ON NEXT PAGE

28

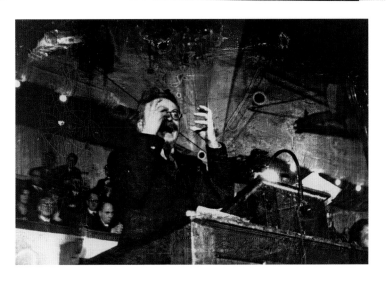

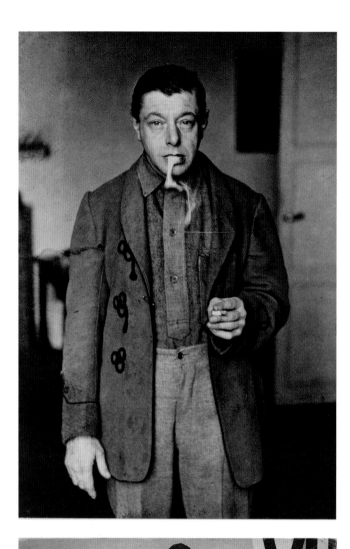

(fig. 8). Another Hungarian friend, Pál Winkler, founded the press agency Opera Mundi.

Non-Hungarians in the artistic community also welcomed Kertész: Mondrian, Chagall, Léger, Brancusi, Vlaminck, Ernst, Man Ray, Calder… the list goes on and on. He visited their studios and took their pictures (cats 96, 98). They sat and chatted in the cafés of Montparnasse, particularly the Café du Dôme (fig. 10), where Kertész's photographs were often passed round. In March 1927 he was invited by one of the café's regulars, Jan Sliwinsky, owner of the gallery Au Sacre du Printemps a few minutes' walk away, to exhibit them.[27] Alongside abstract paintings by Ida Thal, Kertész showed 36 small prints, nearly half of them portraits of other artists (fig. 11). For the opening, the Belgian Surrealist Paul Dermée wrote a prose poem, whose final line translates thus: 'In this asylum for the blind, Kertész sees for us.' This is a tribute to the photographer's vision, but also a direct reference to the Dadaists' notion of a world in which all but they are blind. If Kertész never wholly embraced Surrealism, modernism or any other art movement, he knew about them all: 'I am not a Surrealist. I am absolutely a Realist,' he said.[28] His *Underwater Swimmer* (cat. 17) is a realistic record of what he saw, but it achieves elements of abstraction through the ripples of light on the water and the elongation of the apparently headless body. This also makes it feel rather Surrealist, and it was the precursor of his 1933 series of 'Distortions' (cat. 100), which share some of the same characteristics.[29]

We generally consider photography to be a realistic medium, but that may well have been why it was embraced by so many Surrealists, who found in it a convincing way to juxtapose objects one would not expect to be seen together. But for Kertész a poetic response to the real world and real people was always the most important element in his pictures. Cecil Beaton summed this up brilliantly, writing that Kertész 'was always awaiting the unfamiliar and, using different angles, presented odd compositions … which combine tenderness with amusement'.[30]

The fact that Kertész was in Paris when Surrealism was born is another clue to why Hungarians made such a mark on photography. Seeming somehow always to be in the right place at the right time, they were in at the beginning of this and other movements, among them Neue Sachlichkeit (New Objectivity), humanism, modernism, Constructivism, Surrealism and Dadaism. The Hungarians were always *there*. In Berlin, a much more edgy city than Paris at the time, the art world was more subversive, with such artists as Max Beckmann, George Grosz and László Moholy-Nagy. Moholy-Nagy's colleague and friend in Budapest, the Hungarian avant-garde poet and painter Lajos Kassák, was also there, having been one of the first to leave Budapest. Moholy-Nagy probably took up photography in 1920, and his experimental work (at first in collaboration with his then wife Lucia) included photograms (photographs taken without a camera

Fig. 8
André Kertész, *Lajos Tihanyi, Paris*, 1926.
Silver gelatin print, 24.6 × 17.1 cm.
Museum of Fine Arts, Houston.
Museum purchase with funds provided
by the National Endowment for the Arts
matched by funds from Mrs Joan H. Fleming

Fig. 9
The back cover of *Vu*, 125, 6 August 1930,
showing Carlo Rim, the magazine's new
editor-in-chief, photographed by André
Kertész at the Luna Park Funhouse in the
Bois de Boulogne (cat. 187)

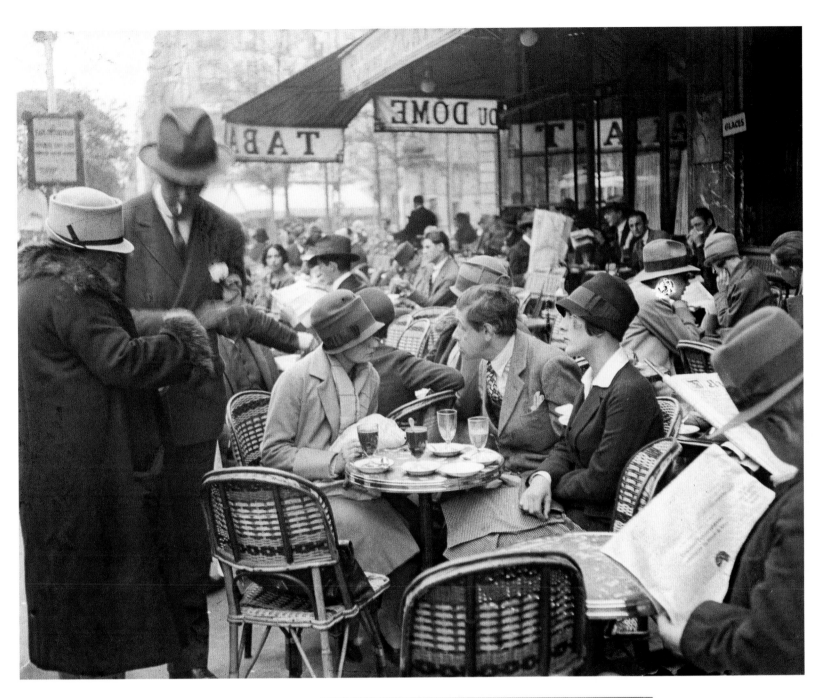

Fig. 10
André Kertész, *Café du Dôme*, 1925. Glass
negative, 6 × 9 cm. Médiathèque de
l'Architecture et du Patrimoine, Paris

Fig. 11
André Kertész, *Jan Sliwinsky, Herwarth
Walden and Friends at Au Sacre du Printemps*,
1927. Silver gelatin print, 7.9 × 11 cm.
The J. Paul Getty Museum, Los Angeles

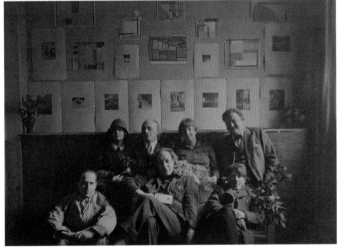

BAUHAUS BÜCHER

8

L. MOHOLY-NAGY

MALEREI
PHOTOGRAPHIE
FILM

[cat. 72]), photomontages, multiple exposures, solarisation, and other ways of stretching the medium (cats 70–71). He was excited by Constructivism (as is exemplified in his photograms) and Surrealism, to which he had been introduced by Kassák, and the two men collaborated on the publication of an activist magazine, *Ma* (*Today*), which gave many Hungarians their first taste of the latest developments in the European art world. Moholy-Nagy's 1925 book of essays and images, *Malerei, Photographie, Film* (fig. 12), was a manifesto of his theories about photography. Its typography and design integrated words and photographs in striking layouts, with large areas of white space, and compositions of arrows, dots, photographs and heavy lines. The ideas it contained about the making and interpretation of pictures, and about the ability of photography to extend our perception, made it virtually the bible of photographic modernism.

Moholy-Nagy taught design at the Bauhaus from 1923 to 1928 (fig. 13), and managed to get photography accepted as a formal discipline there (cat. 199). The antidote to pictorialism, Neue Sachlichkeit (New Objectivity) began in Germany at about this time. For the seminal modernist exhibition 'Film und Foto', mounted in Stuttgart in 1929 (fig. 14), Moholy-Nagy designed the first room and selected the photographers in it, including himself and Kertész. Soviet and American photographers featured in other rooms, and the influence of the exhibition spread beyond Germany when it was shown in Switzerland, Austria and Japan.

Berlin was what might today be called a 'media centre', with no less than 120 newspapers and a thriving film industry. Among the 19,000 Hungarians living in the city were a number who worked in the film studios, among them Stefan Lorant and Alexander Korda. Korda became a hugely successful film producer, and frequently gave work to Hungarians. He asked Brassaï – who arrived in Berlin in 1920 as a correspondent for three newspapers – to design the trademark for his French film company. Later, when he set up his last and biggest film operation in London, Korda commissioned Moholy-Nagy (who had come to London after the Nazis had closed down the Bauhaus) to design special effects for a film of H. G. Wells's *Things to Come* (in the end, however, Moholy-Nagy's kinetic sculptures and abstract light effects were rejected by the director). During his few years in England, Moholy-Nagy took some rather more conventional photographs to illustrate three books about the English way of life: John Betjeman's *An Oxford University Chest* (fig. 15), Bernard Fergusson's *Eton Portrait* (fig. 16) and Mary Benedetta's *The Street Markets of London* (fig. 17). In 1937, having being turned down for a teaching job at the Royal College of Art, he decided England was not for him, and moved to America.

Art photography in the 1930s did not pay the bills. Most photographers – whether in Paris or Berlin – earned their living through publication in the illustrated press. Here too, it helped to be Hungarian. In addition to

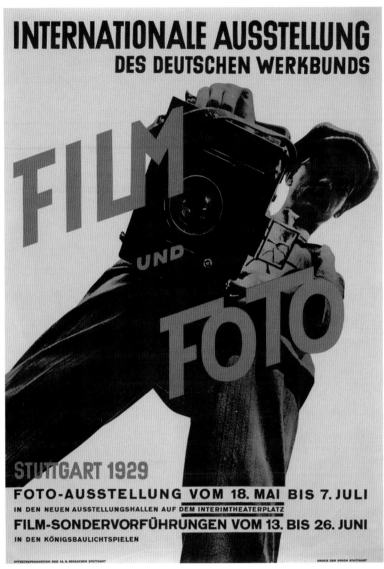

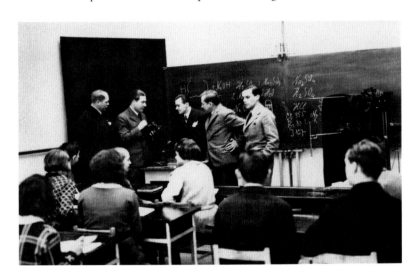

Fig. 12 (opposite)
László Moholy-Nagy, *Malerei, Photographie, Film*, Bauhaus Bücher 8, Munich, 1925 (cat. 188)

Fig. 13 (left)
Unknown photographer, *László Moholy-Nagy, György Kepes and Others Teaching at Skola nmeleckych remesiel (School of Arts and Crafts), Bratislava*, 1931. Copyprint after a lost original. Private collection, Bratislava

Fig. 14 (above)
Poster for 'Film und Foto' (International Exhibition of the German Industrial Confederation), Stuttgart, 1929. Offset lithograph, 84 × 58.5 cm. Museum of Modern Art, New York, 415.1988. Gift of the Lauder Foundation, Leonard and Evelyn Lauder Fund

the Berlin photo agency Dephot, the major agency in Paris was Rapho, founded in 1933 by the Hungarian immigrant Charles Rado, for which Brassaï worked for a dozen years.[31] The Paris office of the Keystone Agency, founded in London by the Hungarian Bert Garai, was run by Garai's brother Alex, who in 1936 arranged for Kertész to go to work for the agency in New York (where the office was run by another Hungarian, Erney Prince). Keystone was at the time the largest press agency in the world.

Munkácsi arrived in Budapest from Transylvania at the age of fourteen, and left the family home in the city two years later. Two years later still, he had become a journalist illustrating his articles with his own photographs. He defined photojournalism as seeing 'within a thousandth of a second the things that indifferent people blindly pass by – this is the theory of the photo reportage. And the things we see within this thousandth of a second, we should then photograph during the next thousandth of a second – this is the practical side of the photo reportage'.[32] Munkácsi's photographic career began in the early 1920s, when he was asked to take photographs of the sports events he was writing about, probably for the newspaper *Az Est* (*Evening*). Working for several publications, he always looked for unusual angles, and the results were so successful that he was soon able to boast that he was the highest-paid photographer in Hungary. In 1927 he was badly injured in an accident at a cross-country race, but recovered sufficiently to collaborate with György Vidor in making a film about life in Transylvania, *Cigánylakodalom* (*Gypsy Wedding*), before moving to Berlin in 1928. In Berlin he immediately signed a contract to take photographs for the prestigious, fifty-year-old publishing house Ullstein Verlag. The company owned the *Berliner Illustrirte Zeitung*, the illustrated weekly with the highest circulation in Germany (approaching two million), which was pioneering the use of modern photojournalistic layouts (fig. 18). A famous series of Munkácsi photographs of the actress, filmmaker and soon-to-be Nazi heroine Leni Riefenstahl (cat. 78) appeared in *BIZ* (as it was popularly known). One of the portraits was used on the cover of *Vu* on 18 February 1931. Another of his stories, which led to a special issue of *BIZ*, was the notorious Day of Potsdam, 21 March 1933, when Hitler and the Nazi party assumed absolute power in Germany.

Two months later, *BIZ*'s Jewish editor, Kurt Korff, was removed from office and Munkácsi, in the face of growing fascism, visited America, eventually emigrating there the following year. Once there, he was soon claiming to be New York's highest-paid photojournalist. Somewhat to his surprise, he was asked to take fashion photographs for *Harper's Bazaar*. At first, he was disappointed – he wanted to be a photojournalist (indeed he had perhaps created the very idea of a twentieth-century photojournalist). But when he treated his models like the sports stars he had been used to photographing (fig. 19), he turned fashion into photojournalism,

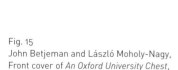

Fig. 15
John Betjeman and László Moholy-Nagy,
Front cover of *An Oxford University Chest*,
John Miles Ltd, London, 1939

Fig. 16
Bernard Fergusson and László Moholy-Nagy,
Front cover of *Eton Portrait*, John Miles Ltd,
London, 1937

Fig. 17
Mary Benedetta and László Moholy-Nagy,
Front cover of *The Street Markets of London*,
John Miles Ltd, London, 1936

Fig. 18
Berliner Illustrirte Zeitung, 33, 21 August 1932,
with a photograph by Martin Munkácsi of
Greta Garbo beneath a parasol (cat. 189)

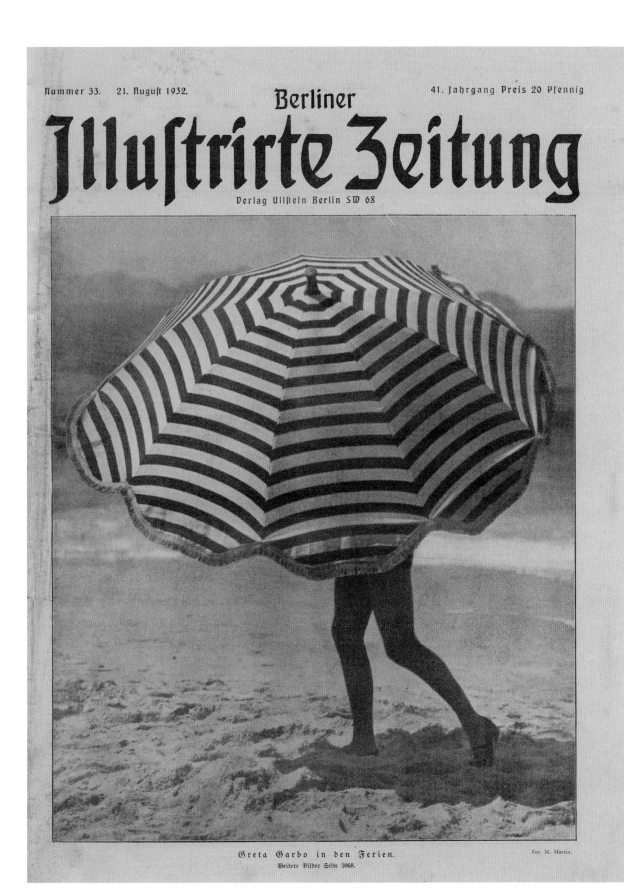

Nummer 33. 21. August 1932. **Berliner** 41. Jahrgang. Preis 20 Pfennig

Illustrirte Zeitung

Verlag Ullstein Berlin SW 68

Greta Garbo in den Ferien. Fot. M. Martin.
Weitere Bilder Seite 1068.

introducing movement and drama to create a new style. He changed the world of fashion photography for ever, taking it out of the studio and onto the streets. The great American fashion photographer Richard Avedon, acknowledging Munkácsi's influence, wrote that he 'brought a taste for happiness and honesty and love of women to what was, before him, a joyless, lying art. He was the first … and today the world of what is called fashion is peopled with Munkácsi's babies, his heirs.'[33] Two other famous American fashion photographers, Herb Ritts and Bruce Weber, were also demonstrably influenced by him. It is said that the photographer hero of the 1957 musical film *Funny Face*, played by Fred Astaire, is at least partly based on Munkácsi.

How much of the nature and quality of the work of these famous emigrants comes from their being so far away from the land of their birth? Kertész's photographs in Hungary and France are full of a love of people, family, friends, passers-by and peasants, but they become far more impersonal in New York, which was so different from pre-war European cities. The buildings, empty benches, clouds, toy boats and such like can all be read as symbols of loneliness and alienation. Kertész later said of his *Lost Cloud* (cat. 128): 'What I felt when making this photo was a feeling of solitude – the cloud didn't know which way to go.'[34] Like many Hungarians, Kertész wore his heart on his sleeve, and his photographs betray his emotional state. Even the more worldly Munkácsi, after his success as a highly paid journalist had faded, wrote his novel *Fool's Apprentice*, in which homesickness and nostalgia are only too obvious: 'the morning was so beautiful – such mornings are found only in Transylvania, and even there in the springtime after rain, when the sun breaks suddenly through the clouds to drench the world in light, and the waking earth has the pervading scent of an enormous rose'.[35] Brassaï, Capa, Kertész, Moholy-Nagy and Munkácsi all achieved fame outside Hungary, and the praise heaped on them in the decades since their death has given them reputations unrivalled in the history of twentieth-century photography. It is safe to predict that even those who have never heard of the names mentioned at the beginning of this essay will at once recognise some of their classic images, and that this will continue to be so throughout the twenty-first century. Do the explanations in this essay really prove why this is so? Or is it, after all, simply that what Robert Capa said is right? 'It's not enough to have talent, you also have to be Hungarian!'

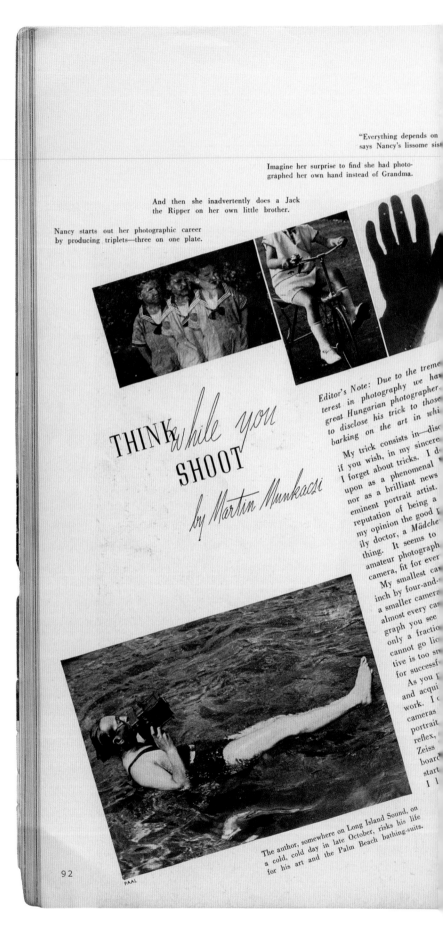

Fig. 19
Martin Munkácsi, 'Think While You Shoot',
Harper's Bazaar, 2677, November 1935
(cat. 190)

In her hurry to finish her first portrait
she let it dry in the sun and so—

point of view,"

And then at last she did get a perfect
portrait, but alas! she broke the plate.

"The fight of two negroes at midnight in
a tunnel," or "She forgot to open the lens."

Below: "The Fight between Szabo and Browning,"
a perfect example of a great modern snapshot,
with brains behind the shutter and no slip-ups.

ous current in-
persuaded our
artin Munkacsi,
ho are just em-
he has excelled.

ing all tricks. Or,
sire to photograph,
t care to be looked
dscape photographer,
mera man, nor as an
am satisfied with the
od photographer." In
ographer must be a fam-
ir *Alles*, able to do any-
excellent advice for our
o acquire, first, a universal
ind of work.
a carries a three-and-a-half-
alf-inch plate, and I never use
cause the modern picture is, in
e result of cutting. The photo-
ned with my name is sometimes
f the original photograph. One
unting with a pistol. If the nega-
, the fraction will be far too small
nlargement.
ress you will add to your equipment
ameras and lenses for every kind of
y along, when necessary, three or four
eight or ten lenses. I do not take a
h a hand camera, a sport picture with a
ws shot with a Heliar, a landscape with a
sar lens. Quite the contrary. When I
e Graf Zeppelin for South America, or
t to photograph Mustafa Kemal Pasha,
myself down (Continued on page 152)

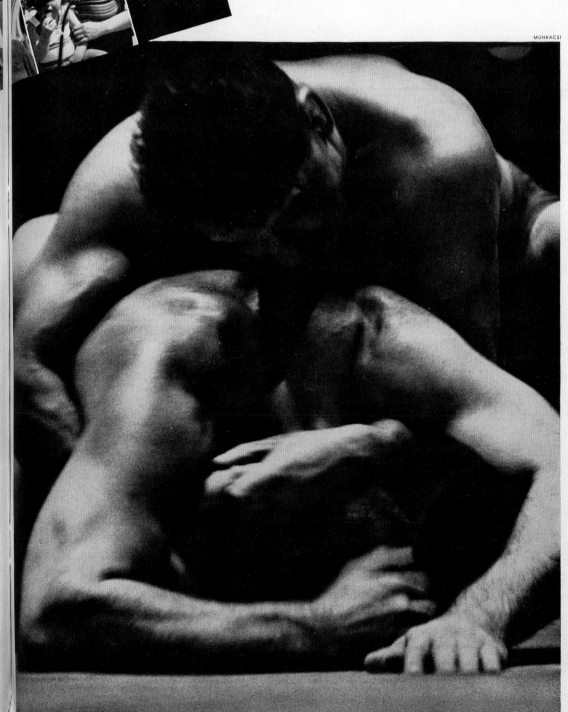

MUNKACSI

At the beginning of the twentieth century, developments in Hungarian art – including photography – mirrored artistic movements and trends throughout Western Europe. Between 1904 and 1914 the art of the Hungarian Fauves (Magyar vadak) developed in a similar manner to that of their French counterparts,[1] while the Eight (Nyolcak), a group of Hungarian avant-garde artists formally established in 1911 but active from 1909, also aspired to a renewal of art.

Several nineteenth-century photographers from Hungary had sought and achieved recognition in Western Europe: for instance, György Klösz, who won a silver medal at the 1878 Paris Exposition. Klösz's professional success was linked with Hungary's increasing prosperity after the 1867 Austro-Hungarian Compromise. Indeed, the development and expansion of Budapest coincided almost precisely with his professional career, as he documented the Hungarian capital's growing dynamism and vibrancy. Any analysis of the art photography of this early period must also give attention to Ferenc Veress, whose attempts at colour photography were contemporaneous with the experiments of the Lumière brothers.[2] At the turn of the twentieth century Veress, who was living in Kolozsvár (today Cluj-Napoca, Romania), experimented with a process he called heliochromy. By 1911 he had used this process to produce more than 6,000 photographs, achieving recognition in Hungary and abroad. Sadly, the results of his experiments, begun in the late 1890s, were never published, and only his photographs survive as a record.[3]

The effect of film was immediately felt in Hungary: the first film footage was made at the time of the celebrations surrounding the 1,000th anniversary of Hungarian settlement in 1896, and the first Hungarian movie, with Béla Zsitkovszky as its director of photography, was produced in 1901. Other Hungarian photographers, including Károly Escher and Dénes Rónai, subsequently became involved in film-making.

The new century saw the establishment of Hungary's first amateur photography clubs, an important influence in the development of the art throughout the twentieth century in Hungary. Although Hungary's cultural and photographic organisations were slow to develop and were mainly subject to German cultural influences, the Photographische Gesellschaft had been established in Vienna as early as 1861. The Photo-Club Magyar Amatőr Fényképezők Országos Egyesülete (Association of Hungarian Amateur Photographers) was founded in 1899. A further idiosyncrasy was that most members of photography clubs were drawn from the aristocracy, and the appearance of a burgeoning middle class was not reflected in their membership.

A striking advance was the foundation of six photography journals in Hungary between 1900 and 1907. Already exhibiting a certain amount of specialisation, these were to proceed along separate paths of development.[4]

To meet demand from a growing number of amateur photographers, the Viennese magazine *Der Amateur* had been established in the spring of 1904, and in October of that same year *Az Amatőr* (*The Amateur*) began publication in Hungary. This Hungarian magazine developed into one of the most influential photography publications of the period, alongside the journal *A Fény* (*The Light*), which was founded in 1906 (fig. 21).

The year 1906 also saw the foundation of the Magyar Fényképészek Országos Szövetsége (National Association of Hungarian Photographers),[5] which sought to defend its members' professional interests. The organisation remained in operation until the end of the Second World War. From the late nineteenth century until the outbreak of the First World War, many professional studios were in operation in Hungary, competing with each other. Prestigious and renowned studios and professional studio chains developed, often owned by several generations of the same family. The Divald family, for instance, established studios in several Hungarian towns, while the Klösz family owned photographic and printing companies. Successful individual studios were not uncommon: for example, Manó Mai's in the heart of Budapest or those owned by József Pécsi and Dénes Rónai. Thus, in the period before the First World War, one can clearly perceive the development of a studio structure and a system of professional representation among professional photographers, as well as the emergence of art photography and a degree of stratification among amateur photographers and their movements.

After the First World War, however, photography developed at a slower pace in Hungary than in Western Europe, although some exceptional Hungarian photographers managed to keep up with advances in the medium. Some even exceeded them, such as József Pécsi in the field of advertising photography. The path of development taken by Hungarian photography reflects Hungary's pre-1914 economic success, to the extent that the country's spectacular economic and cultural development, which exceeded that of neighbouring countries, resulted in a rather exaggerated sense of national identity even within the field of photography.

The First World War and the ensuing revolutions in Hungary naturally provided more opportunity for photojournalism, but led also to developments in the printing of photographs, especially in newspapers. The careers of several men and women who subsequently left an indelible mark on Hungarian photography began at this time. Rudolf Balogh started out in 1902 as a 'newspaper illustrator', the term used at the time. He and Gyula Jelfy subsequently became war correspondents for *Vasárnapi Ujság* (*Sunday News*).

In 1914 Balogh published the first issue of the professional magazine *Fotóművészet* (*Photo Art*). The opening lines he wrote in the first issue of the magazine pointed to his artistic approach, which was to

'Let Us Stay Here': Twentieth-century Photography within Hungary | *Péter Baki*

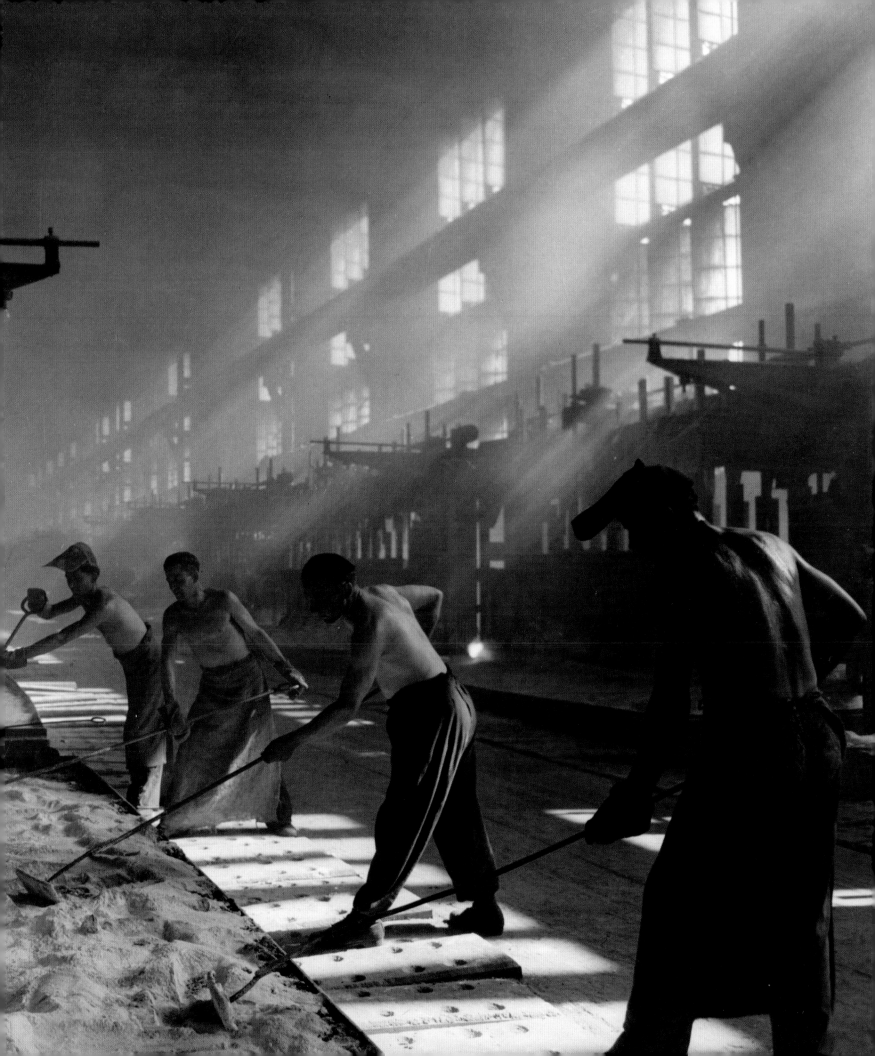

become a leading genre or style within Hungarian photography:

> There is no need to photograph the formulaic landscapes of international tastes. Let us stay here, searching for and finding subjects within our own country that will make us successful abroad; let us create a Hungarian photo art, with Hungarian air and a clear Hungarian sky![6]

Balogh began working as a photojournalist for *Vasárnapi Ujság* in 1902, and opened his first studio in 1912. He became the principal exponent of the first generation of Hungarian press photographers, joining the staff of *Pesti Napló* (*Pest Diary*) in 1920, where he worked with Stefan Lorant, the well-known Hungarian-born picture editor. Balogh's colleagues at the newspaper – Márton Munkácsi, Károly Escher (fig. 22) and Ernő Vadas – were some of the most forward-looking Hungarian photographers of the period.

The newspaper's pictorial supplement, *Pesti Napló Képes Műmelléklete*, was illustrated exclusively with photographs and published with six pages until 1928 and mostly with twelve thereafter. It became very popular: readers demanded pictures of foreign lands and these were mostly obtained from the Wide World photographic agency in America. The extensive use of foreign photographs by the supplement's editors is demonstrated by a statistic from 1927, when photographs by Hungarian photographers accounted for fewer than ten percent of the 3,092 published. While working for *Pesti Napló*, Balogh mainly photographed rural scenes in Hungary and produced genre photographs.

Balogh was a member of the Hungarian Photographers' Club, which was established in 1914. He and other members of the club – Olga Máté, Aladár Székely, József Pécsi and Dénes Rónai – helped to raise standards in Hungarian photographic art. Balogh also contributed greatly to the world of photography, serving as chairman or board member of several associations and organisations. He is most renowned, however, for establishing the 'Hungarian style' (fig. 23).[7]

In the interwar period, several photographic genres and styles that had originated in other countries, such as photojournalism, studio photography, documentary photography and art photography, gained a footing in Hungary. Each was different, although there were areas of overlap and interaction. The Hungarian style represented a unique blend of art and photography, taking elements from the many different European traditions and creating a new, national style. Its practitioners abandoned the various non-silver printing processes beloved of the pictorialists in favour of more traditional silver gelatin prints, which brought them closer to the ideals of the Neue Sachlichkeit movement. Even so, they used soft-focus lenses to produce their pictures, making use of backlight to enhance their compositions. Preferred themes included Hungarian landscapes,

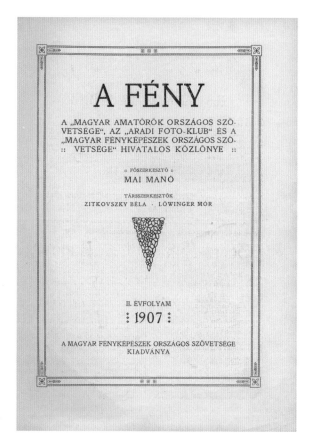

Fig. 20 (previous page)
Detail of cat. 157

Fig. 21
Title page of the magazine
A Fény (The Light), 1907

Fig. 22
Károly Escher, *Editors of Pesti Napló*, 1930.
Silver gelatin print, 23.2 × 17.3 cm.
National Gallery of Art, Washington DC,
Patrons Permanent Fund

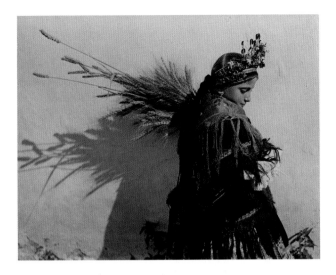

village scenes and the everyday lives of rural inhabitants (cat. 9). Their main aim was to use light and shadow effects to present the beauty of the Hungarian countryside and the uniqueness of the Hungarian people. The Hungarian style flourished between the wars in Hungary, influencing the work of several generations of photographers. Its impact could still be felt in the era of Socialist Realism that prevailed after the Second World War. Adherents of the style – among them Andor Angyalfi, Rudolf Balogh, Tibor Csörgeő, Frigyes Haller, Kálmán Klell, Miklós Korschelt, Kálmán Szöllősy, Gyula Ramhab and Ernő Vadas – were not primarily interested in portraying the true state of Hungarian society; rather they focused on a romanticised, pre-industrial vision of the country and its people. Unlike American photographers who worked for the Farm Security Administration in 1935–44, whose brief was to record the activities of a programme designed to ameliorate conditions for farmers struggling during the Depression, Hungarian photographers active in the same decade did not approach their subject-matter from a sociological perspective but continued instead to adhere to an aesthetic approach.

As a counterbalance to the Hungarian style, the prevalence of photography as social documentary increased (see cat. 10). The title of the first work on Hungarian social-documentary photography made reference to what had become a socio-political slogan: 'Hungary, country of three million beggars.'[8]

Between the wars, politically inspired documentary photography in Hungary (and in areas ceded to neighbouring countries by Hungary under the 1920 Treaty of Trianon) was largely the work of three groups. The early 1930s saw the almost simultaneous development of the Sickle Movement (Sarló mozgalom) under Edgar Balogh in Czechoslovakia (in the areas detached from Hungary); of the Work Circle (Munka-kör) under Lajos Kassák in Budapest; and of the Artistic Youth College (Szegedi Fiatalok Művészeti Kollégiuma) under the ethnographer Gyula Ortutuy in Szeged.

Although their political motivations differed, all three groups struggled against social injustice with the help of photography. The philosophy of Kassák's group was most closely reflected in Lajos Gró's words: 'May these photographs be the weapons of the class struggle.'[9] The aim was to photograph the human face in such a manner that personality would be shown – as a kind of archetype. These photographers did not employ soft filters or light techniques; instead they emphasised physiognomy through skilful editing.

This 'new vision' became a documented part of Hungarian photographic history with the publication of Iván Hevesy's *A modern fotóművészet* (*Modern Photography*) in 1934. Hevesy analysed the phenomenon of social-documentary photography, advising photographers to avoid in their work any trace of what he called 'poverty sentimentalism' (fig. 24).

Fig. 23
Rudolf Balogh, *Young Girl with Ears of Corn, Váralja*, 1935. Silver gelatin print, 23.5 × 29 cm. Hungarian Museum of Photography, Kecskemét

Fig. 24
Sándor Gönci, *Track Painter*, 1931. Silver gelatin print, 24 × 18 cm. Hungarian Museum of Photography, Kecskemét

The publication in 1937 of *Tiborc* (figs 25.1–2) by Kata Kálmán marked the zenith of Hungarian social documentary photography.[10] Kálmán had been greatly influenced by Helmar Lerski's pioneering work,[11] although *Tiborc* actually shows greater affinities with Erna Lendvai-Dircksen's photography book *Das Gesicht des Deutschen Ostens*,[12] as the photographs were shot on location rather than in a studio.

The work of other Hungarian photographers in the first half of the twentieth century, including that of Angelo, Nándor Bárány, Károly Escher, Olga Máté, József Pécsi and Dénes Rónai, was not associated with a particular style or political orientation. The world of photography in Hungary was, however, influenced by the debate between the 'populists' and 'urbanists', a debate that was particularly intense in the field of literature. The main difference between the two cultural strands lay in their objectives: populist writers strove to create a new national identity that would incorporate the entire Hungarian nation, while urbanists sought to give emphasis to the cultural values of the metropolis.

József Pécsi was the most multi-faceted and arguably the most important of these photographers (cats 13, 21, 25, 31, 33, 36). A commercial operator but also an innovator, he was certainly the most successful of them. He was also one of the interwar Hungarian talents who remained active after the Second World War. His career began in the 1910s. He acquired the basic skills in Munich, where he graduated from the Lehr- und Versuchsanstalt für Photographie, Chemographie, Lichtdruck und Gravür with a distinction, subsequently receiving the Dührkoop Medal, Germany's highest award for photography at the time. At the age of only 24, he received honorary membership of the London Salon of Photography. Pécsi's manifold success was due mainly to his photographs in the traditionally accepted pictorialist style. In 1913 he helped to establish photography courses in Hungary, but from 1920 he was subjected to a teaching ban on account of his left-wing views. The best photographers of the era visited Pécsi's studio, and many who later became key public figures in Hungarian photography, among them Éva Besnyő, László Bruck and Margit Kelen, acquired their skills while working there.

In the course of his photographic work Pécsi – like František Dtrikol in Prague – was drawn to the art-deco style, but his focus was advertising photography, which he raised to an art form. His book *Photo und Publizität* (fig. 27), published in Germany in 1930, influenced advertising photographers throughout Europe. Pécsi also produced unmatched works in the fields of self-portraiture and nude photography; indeed, he was the first photographer in Hungary to publish an album of nudes. *Deutsche Kunst* and *The Studio* published his photographs on several occasions. Pécsi's Jewish beliefs forced him into hiding in the Second World War. During the Siege of Budapest in January 1945, a bomb destroyed his studio; his negatives and the

Figs 25.1–2
Kata Kálmán, *Tiborc*, Cserépfalvi, Budapest, first edition, 1937 (cat. 191): an opening showing two portraits by Kálmán, *The Door-to-door Fruit-seller, Erzsébet Horváth, Widow of József Sándor* (1932) and *Ernő Weisz, Factory Worker* (1932; cat. 42), with the cover of the book below

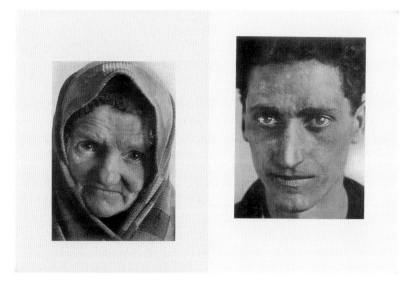

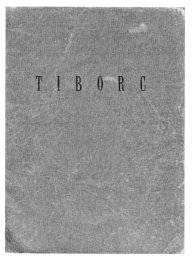

majority of his collection of eighteenth-century furniture and art were lost. After the war financial hardship and lack of a studio meant that he was no longer in a position to create works that reflected his talent. He established a small studio in his apartment, and produced passport photographs. Nevertheless, when a portrait had to be made of Mátyás Rákosi to mark the communist dictator's sixtieth birthday, Pécsi was commissioned by the authorities to undertake the task.

Angelo, Bárány, Escher, Máté and Rónai similarly missed out on international recognition throughout their careers. From the interwar period until the political changes of 1989, Hungary lacked a receptive milieu for their achievements, which were considerable even by international standards.

It is also true that the modernisation of international photography, which began in the 1920s, had little effect within Hungary. For instance, Hungarian photography magazines failed to report on the publication of *Malerei, Photographie, Film* (fig. 12) by László Moholy-Nagy in 1925, and they similarly ignored the advances in photography being made by the Bauhaus in Dessau. Although the 1929 Stuttgart exhibition 'Film und Foto', an exploration of the modernisation of photography (fig. 14), received months of advance coverage, the response within Hungary during the show was limited, despite its inclusion of seven photographs by André Kertész and more than ninety by Moholy-Nagy. Moreover, photography magazines and the Hungarian public showed no interest in the work of Marton Munkácsi, who had resigned from his post at *Pesti Napló* and moved abroad. Robert Capa's *Death of a Loyalist Militiaman* (cat. 108) received not a mention, still less any professional recognition. The practitioners of the Hungarian style were averse to modernism. Photographers within Hungary became isolated and withdrawn. They ignored international trends, and their work became unadventurous and conventional. Even the many Hungarian photographers who had received recognition elsewhere in Europe proved unable to change this mentality (fig. 26).

After the Second World War, factors undermining Hungarian society as a whole exerted a detrimental effect on photography there. Attempts to democratise artistic life were prohibited or rendered impossible. Although the Photo-Club (established in 1899) was not actually banned, its premises and studios were confiscated in 1951. A highly centralised system of institutions was established and Socialist Realism became the official aesthetic doctrine. Ideological slogans were formulated on the basis of the progressive communist ideals of the interwar period, and the words of Lajos Gró, which had given social-documentary photography its cultural foundation, now became a reality, albeit in more radical form, as Demeter Balla put it: 'The camera is the weapon of class struggle in our hands.'[13]

Fig. 26 (below left)
Nándor Bárány, *Cylindrical Bodies*, 1934. Silver gelatin print, 28.2 38.5 cm. Hungarian Museum of Photography, Kecskemét

Fig. 27 (below)
József Pécsi, 'Mentor Cameras', in *Photo und Publizität* (*Photo and Advertising*), 1930, Table XII. Hungarian Museum of Photography, Kecskemét

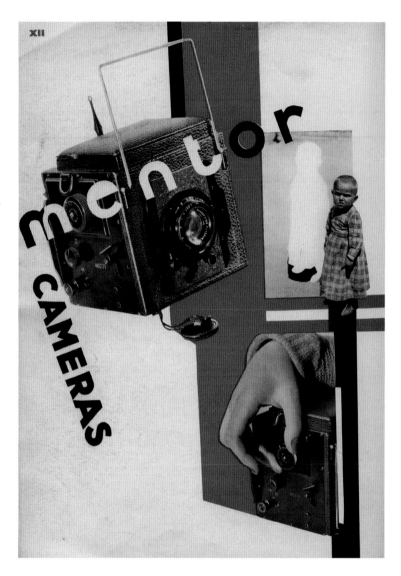

During the first period of Socialist Realism, from 1949 until 1953,[14] an ideological foundation was provided exclusively by articles published in *Új Magyar Fotó* (*New Hungarian Photo*) or by the works of Hungarian painters who conformed to Soviet orthodoxy. Many artists attempted to go along with the dictates of Socialist Realism. According to an unofficial, humorous definition made by a poet, Socialist Realism is when 'the portrayal of a man by a man ceases'.[15] Nevertheless, photography was highly suited to propaganda, which enhanced its prominence. For the time being, however, photography in Hungary, although it now encompassed Socialist Realism, continued to adhere to the formal solutions of the Hungarian style.

A radical change came about in the 1950s when Hungary's photography studios were nationalised. Although many photographers continued to work in the studios, they did so now as their managers rather than their owners. During these years, photographic work for the state was monopolised by the Hungarian Photographic State Enterprise, with many photographers joining its staff. Enforced changes took their emotional and financial toll. On the other hand, many artistic and creative groups were formed at this time, bringing together the best professionals. For instance, after 1956, Ernő Vadas, József Németh and Károly Gink worked together for MTI, the Hungarian news agency. Moreover, some photographers voluntarily withdrew from official Hungarian art of the 1950s, preferring to keep their creativity at home and accepting that their works of art would languish unseen in a drawer. It was with this in mind that the artist Tihamér Gyarmathy produced his photograms in 1953, at which time the state's position on abstract art was bound to an inflexible art theory (fig. 28).

The new political course required – in photography too – artists who were able and willing to accomplish the desired changes in art. Some of these changes were predictable, but others came as a surprise. Predictably enough, the new régime gave exalted positions to photographers who in the interwar period had helped to organise and run the underground communist party or had left-wing sympathies. Many of these had helped to 'construct socialism', having already put down their cameras. Lajos Lengyel, who as a member of Lajos Kassák's Work Circle had taken some important photographs in the interwar period, became director of a printing company after the war and remained in that position until 1969. Lajos Tabak – another former member of the Work Circle – found employment at the Ministry of Light Industry in 1948, subsequently becoming manager of a sugar factory in Kaposvár and then in Szolnok. No one was surprised when, in 1947, Miklós Rév was appointed director of the photography department at the Hungarian Film Office or when, in 1948, he began working as a photojournalist for *Szabad Nép* (*Free People*), the country's principal newspaper. Kata Kálmán tried once again to present the working class and peasant farmers in her photography, but she now portrayed them as part

Fig. 28
Tihamér Gyarmathy, *Untitled (Photogram)*,
1953. Silver gelatin print, 18 × 13 cm.
Private collection

Figs 29.1–2
Picture Post, a feature on the Hungarian
Revolution, 73, 6, 12 November 1956 (cat. 192)

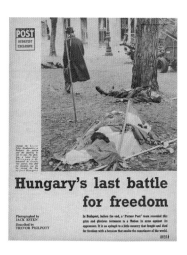

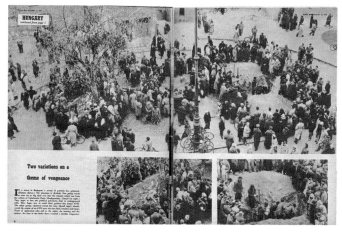

of the social élite, as happy people – in complete contrast to their mood at the time.[16] A surprising reversal occurred in the work of Ernő Vadas, who during the interwar period had been considered the most talented exponent of the third generation of Hungarian-style photographers and who had kept his distance from – and even criticised – the social-documentary photography movement. Despite this, in 1954 he became chief editor of the magazine *Foto*, for several years Hungary's sole photography magazine.

Examining the photography of the 1950s, we may draw a parallel between the photographic techniques of Socialist Realism and the Hungarian style of the interwar period; there is certainly a resemblance. One might almost say that the only real difference lies in the social class of the people in the photographs; the pictorial solutions are the same (see cat. 157).

A fundamental change at the organisational level of photographic life took place in 1956, shortly before the Hungarian Revolution. The Association of Hungarian Photographers was founded in response to efforts by the authorities to bring leading photographers under central control. Membership of the Association was of crucial importance to the fate of individual photographers, as it implied numerous privileges that were to last until the social and political changes of 1989. As Ernő Vadas wrote: 'The affairs of Hungarian photographers reached a historical turning point.'[17] Membership was not granted to Olga Máté, Jenő Dulovits or even Iván Vydareny, a major exponent of the Hungarian style. In a letter to Ernő Vadas, a former pupil of his who had become chairman of the Association, Vydareny wrote: 'I have been taking photographs for several decades. I have done my bit for Hungarian amateur photography. Perhaps I deserve a place in the Association. My biography is known. My friend Ernő Vadas could recommend me – if he wants to. Best regards, Iván Vydareny.'[18] But Vydareny was to be denied membership for political reasons, as Vadas's reply reveals: 'I do not consider myself to be responsible, because what else could I have done other than put in a word? (I have witnesses to this.) But the will of the higher authorities and the majority was binding upon me too.'[19]

The amateur movement declined in importance, as the country's intellectuals and civil servants had less opportunity and incentive to become involved. It was not until the 1960s that the professional photography movement, which was subject to political control, began to expand.

It is striking that none of Hungary's photographers took pictures of events during the 1956 Hungarian Revolution. Photographs were taken of conditions after the conflict, but we find no photo reports of the actual events, like those produced by foreign photographers (fig. 29). On 2 November 1956, in the immediate aftermath of the Hungarian Revolution, photographs were taken by a Hungarian boy who was later, in the 1970s, to achieve recognition as an avant-garde photographer. Aged thirteen, László Haris, accompanied by his elder brother, photographed the area

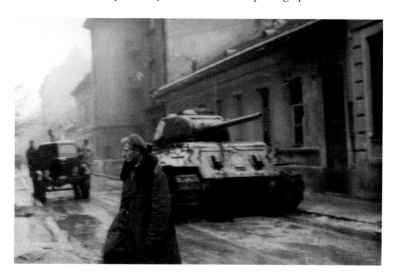

Fig. 30
László Haris, *Kisfaludy Street, Budapest*, 1956.
Silver gelatin print, 6 × 9 cm.
Private collection

surrounding the family's apartment on Szigetvári Street, close to key sites of events during the Revolution. Each day they heard the sound of weaponry and the noise of tanks, until at the beginning of November the guns had fallen silent, and László's parents allowed him to go out on to the street and take photographs between 10 am and 3 pm (fig. 30).[20]

In the 1960s the Corvina Publishing House published a series of photography books edited by Kata Kálmán. These reflected certain political aims, but several volumes covered photographers who stood outside official cultural policy. Thus, in 1968, a volume was published on Aladár Székely, who had been active at the time of the First World War and who had embodied the bourgeois lifestyle. The following year saw publication of a volume on Rudolf Balogh, who had been politically supported during the interwar period.

Hungarian photographers born in the post-war years and emerging as artists in the 1960s were effectively isolated from developments in European art; they lacked exemplars from whom to draw inspiration. Those Hungarian interwar photographers who had been exposed to European artistic influences, figures such as Angelo, Balogh, Pécsi, Rónai, were no longer active or had died. These factors may explain why it was not until 1967 that a well-received photographic exhibition presenting a new style of photography took place.[21] The principal organisers of *Műhely '67* (*Workshop '67*) – Csaba Koncz, György Lőrinczy and Zoltán Nagy – soon left the country (Nagy left even before the exhibition opened). In 1972 Lőrinczy published *New York, New York* (fig. 32), an album of photographs taken during a visit to the city in the autumn of 1968. The volume has been recognised as one of the most significant photography books of the period, for its combination of the genres of commissioned guidebook and photographic artwork. Over 6,000 copies were sold within Hungary in the course of a month to a readership inspired by the desire for freedom (fig. 31).

Although photographers working in fine-art photography were still unable to achieve a breakthrough in Hungary in the early 1970s, the same period saw the growing success of Hungarian photojournalists working abroad. Gold medals in the World Press Photo contest were won by László Török in 1972, Endre Friedmann in 1973 and Imre Benkő in 1974. A further gold medal was awarded to Imre Benkő in 1977. Prior to these successes, in 1965, László Fejes won a World Press Photo gold medal for *Wedding* (cat. 163), but this led to reprisals. Fejes had taken the picture on the fourth floor of a house on Damjanich Street in Budapest on 18 June 1965, following the wedding of his brother-in-law, László Laczkovics. After its success in the World Press Photo contest, the picture was published in the German political magazine *Stern*, where a connection was drawn with the 1956 Hungarian Revolution. The communist authorities in Hungary imposed various sanctions on Fejes and prevented him from publishing his work.[22]

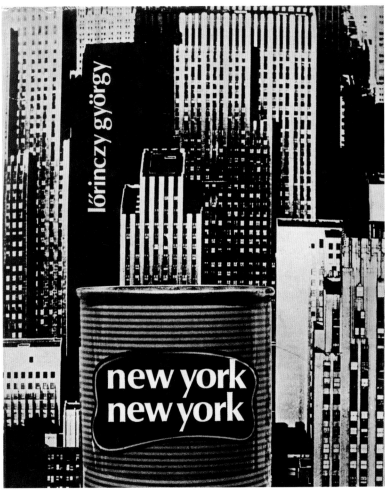

Fig. 31
György Lőrinczy, *Composition V*, 1966.
Silver gelatin print, 15.5 × 23.9 cm. Hungarian
Museum of Photography, Kecskemét

Fig. 32
György Lőrinczy, *New York, New York*,
Magyar Helikon, Budapest, 1972 (cat. 193)

The New Economic Mechanism, a programme of decentralisation with a new focus on profit generation, was introduced in Hungary in 1968. This had a significant effect on artistic matters and continued to do so even after the programme was abandoned. During these years, although the public could see the news on the television, press photography increased in importance. Several illustrated magazines – *Nők Lapja* (*Women's Magazine*), *Ország Világ* (*Country World*), *Tükör* (*Mirror*), and *Képes 7* (*Pictorial Weekly*) – enjoyed mass appeal even in the 1980s. However, these magazines were subject to the political will of the authorities rather than to market forces. At the weekly *Képes 7*, more than ten full-time staff worked on the photography column, a level of staffing that would not have been feasible in a market economy.

Despite Hungary's political thaw, the fields of art and culture – including photography – continued to be subject to surveillance by the police and secret services. Although the communist authorities operated a network of informers, exhibitions were banned only under exceptional circumstances. The last photographic exhibition to be banned opened in 1983: Péter Tímár's exhibition 'Gyász' ('Mourning') showed how the communist state treated its dead (fig. 33).

In these years, no opportunities existed in higher education for students to acquaint themselves with photography as a branch of art. Prospective photographers could obtain either a vocational qualification or acquire skills at one of the schools of journalism. In 1976, however, the Association of Hungarian Photographers established the Studio of Young Photo Artists, and this studio soon came to represent the most avant-garde branch of Hungarian photographic art, giving it new foundations.

Thanks to the efforts of Tamás Féner and Tamás Révész, social-documentary photography, which had seen its heyday in interwar Hungary, enjoyed renewed public attention. Meanwhile Péter Korniss began to explore the work of Hungarian social-documentary photographers active in neighbouring countries beyond the Trianon borders.

Until the political changes of 1989–90, a duality could be observed in Hungarian photography: although news of developments in American and European photographic art and reports on major Western exhibitions did reach those inside the country, most works produced within Hungary, such as those of Gábor Kerekes (cats 168, 171–72, 174), imitated these foreign trends or were based on unique individual perspectives barely influenced by artistic developments abroad. At the same time, a radical shift took place in the public's perception of photography. Private photographic collections began to be formed and conditions were created for the foundation of an independent museum of photography.

If Hungarian photography was less influenced by developments elsewhere in Europe in the interwar period, then it was left isolated by the post-war communist takeover. The subsequent thaw opened a window onto the world, enabling Hungarian photographers again to produce works of European significance. However, it was not until the political and social changes that moved across Europe in 1989 that the main obstacles were finally removed to the free flow of information – obstacles that had left their mark on the light-sensitive surfaces of Hungarian photography.

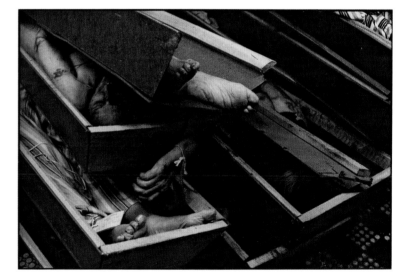

Fig. 33
Péter Tímár, *Untitled* (detail from 'Mourning' series), 1981. Silver gelatin print, 15.9 × 23.8 cm. Hungarian Museum of Photography, Kecskemét

In 1940 a young girl of sixteen travelled from her home town of Cluj in Transylvania – a town that, being Hungarian, she called Kolozsvár – all the way to Budapest. She was able to do this because the part of Transylvania that included Kolozsvár had just been returned to Hungary by the Second Vienna Award, arbitrated by Hitler's Germany and Mussolini's Italy. Having been born a Romanian citizen, she was now what her parents had been: Hungarian.

She was an attractive, strong-willed girl who had been bedridden for a year two years before, following an attack of rheumatic fever that almost killed her. Somehow or other her parents – I imagine it must have been her parents – had arranged for her to work as an assistant or apprentice to the well-known photographer Károly Escher.

It seems like a brave, almost foolhardy thing to do for someone so young who had been so ill. She must have been very determined. But then my mother was that sort of person.

What did she know of Escher, or indeed of photography? What was, or could have been, known? Was she aware of the work of André Kertész, of László Moholy-Nagy, of Martin Munkácsi? All these people were abroad and had been for years.

After the failed Hungarian Uprising of 1956 my parents – chiefly my mother, so my father said – decided to leave the country. They took the absolute minimum with them, this minimum including a small hard case that would once have held a toy typewriter, but into which she now swept a number of photographs that she had kept in a chest of drawers. It was my job to carry that small case across the border when we walked into Austria. I still have it, under my desk.

What was in it? It seems to me a hasty, miscellaneous collection of varying artistic value. The prizewinning photograph of my brother is there (fig. 35). He is aged about one, which would date it to the summer of 1953. He has long, curly locks and is supporting himself against the seat of a park bench, his bottom lip slightly stuck out. A long stick, possibly a walking stick, is propped next to him, making a nice diagonal line in the composition. The whole thing is cute but well balanced. The photograph in itself is a moment of personal and historical balance. Apparently the image was popular enough to have been turned into a small porcelain statue that you could buy in shops. I have never seen it.

Later I realised that the case was a curiously Hungarian piece of symbolism. It contained a small random sample of photographs that we had carried abroad at a time of fear and anxiety. The case was as much a refugee as we were. Time and again cases have been packed and unpacked. The preservation of moments, the recording of having been somewhere, the documentation of an identity, had long been matters of pathos and urgency.

There is a marvellous photograph by Escher, *The Horse of the Apocalypse* (fig. 34), not a typical work – if there is such a thing as typical Escher – in which a large farm horse is being paraded at an agricultural fair. A great pile of cloud rises to a peak behind the horse. Behind the animal there appears to be a plain, or possibly a wide, high-fenced field. The man leading the horse is having to work hard to keep up with it, running it seems, to prevent the horse running away with *him*. He is formally dressed, in a three-piece suit and a homburg. He looks at us from under the brim of his hat with shaded eyes. His dark moustache lends him a magisterial air but his free hand is extended towards us in a gesture hard to interpret. Maybe he doesn't want to be photographed. Maybe he is warning us to keep out of the way. And so we should, because the dark horse is extraordinarily powerful and its white noseband simply emphasises its power and darkness. It is clearly moving fast. Its mane is flowing and its right front hoof is a blur, throwing up what seems to be a cloud of black smoke.

On one level this photograph is an image of primordial energy only just under control, though we cannot be sure of the extent of that control. The horse is ageless, the man in front of him firmly fixed in time. The pile of cloud suggests approaching thunder, though it is chiefly the horse that is thundering for now. In less than two years an apocalyptic war will, we now know, break out, though Escher cannot be presumed to know that. And yet everything about the picture – proportion, focus, framing and contrast – implies premonition, a dream image about to enter a crucial moment.

Escher was forty-seven years old when he took this, already thirty years into a career as a photojournalist. The Irish hero Finn Mac Cool asks his followers: 'What is the finest music in the world?' One suggests the cuckoo calling from the hedge, another says the ring of a spear on a shield, another the baying of a pack of hounds, yet another the laughter of a happy girl. 'All good answers,' says Finn. 'Yes, but which is the best?' they ask. Finn responds: 'The music of what happens.'

The music of what happens is what the best photographs and poems provide. Even in an ordinary snapshot some inchoate noise that we interpret as music will offer itself to us, if only we strain to hear it, but unless the music has the formal and symbolic qualities that we recognise as music we tend not to notice. It is, we might argue, a composed music: much depends on the composer.

There is a moment in photography, a decisive moment, to use Cartier-Bresson's phrase, when all that happens is that light enters the camera and strikes a sensitised surface. At that moment nothing else can be done. The decisions taken before have been taken, the editorial decisions to come have not yet been made. At that moment the world is simply happening. Poets talk of the music of happening: here it is the merest cry. Light enters, registers, makes its mark. The photographer decides nothing:

A Horse, a Circus and a Small Case of Photographs | *George Szirtes*

the mechanism of light, material and chemistry take over.

The decisive moment that Cartier-Bresson meant is not *mechanical*, of course. He meant the moment in the world in front of the camera, the moment at which image and symbol coincide as form to tell us more than we or even the photographer might formulate as a thought. It is the moment when the fingers are at a critical distance from the handle of the door, when the shadow on the wall is just about to suggest a possibility we cannot quite define, when the blind violinist is crossing precisely the right part of the street to point us to possibilities beyond the evidential.

There is no equivalent moment in painting or the other visual arts. There is no equivalent in music or literature. Human agency is primary in these. If an accident occurs we know it to be an accident. A painting may contain accidents, may even consist of accidents, but we know them to be accidents. When we want such accidents we think of them, even ennoble them, as chance, but a photograph is not quite like that. Paint is a material object in the world. It may be used to record the appearance of appearances, but it is not in itself a representation. It records only itself. From photographs we expect something else. A record. A document, if you like, that may be used as evidence. But the material is also a record of something else. Like a footprint or a fingerprint, or DNA, the decisive moment is part of the music of what happens.

The greater the photographer, the more music there is. Some twelve years before Escher photographed the apocalyptic horse, another Hungarian photographer, André Kertész, took a photograph of a couple with their backs to us who, presumably, are looking through a hole in a fence (cat. 20). The fence, according to the title generally used for the picture, is that of a circus. We can see a screen of canvas, possibly the fringe of a big top, over the fence. The couple looking are quite young. He is slightly *louche*, hand in pocket, wearing a boater, she in a long, shapeless raincoat and quite an elegant shimmery headscarf whose shape, rather unnervingly, suggests an upside-down flame, the emblem of death, although that doesn't strike us immediately. We wonder what they are doing there. Can they both see through the fence? Is the hole big enough? Why would they be doing that anyway? Are they freeloaders to be deprecated? And then we might think of the act of unobserved looking: of voyeurism. What is it we hope to see when we look through a lighted window? What does the act of looking through signify? Do we find ourselves wanting to look over their shoulders at whatever desired object they are contemplating? But then we too are voyeurs. We are looking at their backs. Perhaps it will always be like that and has never been any different. What the voyeur sees, what we desire to see, is backs, just the back of things. The picture has its back to us but it is addressing us at the same time. It is 1920, five years before the thirty-one-year-old Kertész turned his back on Hungary, never to work there again.

There is premonition here too, not just in the subject and its questions, but in the same intriguing rightness of the composition, texture, tone and contrast.

An essay like this cannot hope to say anything worthwhile on all the remarkable photographers first brought to British notice in the 1987 show 'The Hungarian Connection: The Roots of Photojournalism' at the National Museum of Photography, Film and Television in Bradford. I travelled up from Hertfordshire to see it partly because I had a budding interest in photography as a form of poetic language and partly, and more importantly, because of my mother's connection with Escher. I had only recently picked up our lost links with Hungary and everything about my birthplace was of great interest to me. But Escher was a surprise. I had not imagined him to be so important, so various, so lyrical, so humane, so dreamlike, so moving, and so true. This, then, was the man my mother travelled all that way to see, to learn from and to work for. To explore just a small part of his work would take a whole book, I thought.

Indeed it would. The best I can do is to describe the world from which both he and Kertész emerged, and explore what is specifically Hungarian about them and the other major figures.

In order to do so I'd like to propose three specific tensions in Hungarian sensibility that might be useful in looking at the photographs. Let me lay them out. The apocalyptic horse, the voyeuristic couple and the small battered case of photographs are at the back of them. The first tension is between realism and dream, the second between the urban and the rural imagination, and the third between the international and provincial elements in Hungarian memory and ambition.

This is not an occasion for tracing the history of Hungary. Enough to say that her physical borders have varied from time to time. The country has always been threatened, unstable territory. It was the same with language. Though distantly related to Finnish and Estonian, Hungarian is a landlocked island in a sea of Romance, Slavic and Teutonic. Historically isolated and under pressure, it was, and remains, useless anywhere else. Everything had to be translated into it, little was ever translated out.

Historical vulnerability and linguistic isolation make for a threatened, unstable consciousness. The photographs in my mother's small battered case were points of landlocked stillness in a sea of unsteady motion: moments of happiness interrupted by years of loss. For the country – for its sense of selfhood, its consciousness as place – there have been nothing but exhausting decisive moments. The thunder of Escher's horse has long been a looming presence as the memory of an ominous energy beyond control. Kertész's apparently savvy couple staring into an unknown circus beyond the fence have long articulated a guess about life. The small case of photographs is what you carried with you when the horse ran away and

Fig. 34 (previous page)
Károly Escher, *The Horse of the Apocalypse*, 1937.
Silver gelatin print, 39.9 × 30 cm. Hungarian
Museum of Photography, Kecskemét

the circus packed up. And no one would care when it did.

What Franz von Löher, a professor at Munich University, wrote in his book *The Magyars and Other Hungarians* (Leipzig, 1874) hung like a shadow over Hungarian culture:

> The Magyars never have been and never will be a civilised people …
> [They] will always lag behind and merely imitate the major peoples.[1]

Photography was a new art that did not require the learning of a difficult language, nor did it need wealthy patrons or academies. Perhaps it wasn't even art, not exactly, but reportage of a sort. What it required was cheap magazines with big circulations in need of material.

The three tensions I have proposed, though noticeable elsewhere, are handily concentrated in less than a single lifetime, in the thirty years between 1890 and 1920. Those dates embrace both the highest and lowest points in modern Hungarian history. It is not by chance that most of the greatest and best-known Hungarian photographers of the twentieth century were born in the period: Escher in 1890, Kertész in 1894, Moholy-Nagy in 1895, Munkácsi in 1896 and Brassaï (Gyula Halász) in 1899. Those years formed the lives and sensibilities of all five and, in the cases of Kertész, Brassaï, Moholy-Nagy and Munkácsi, constitute most of their actual 'Hungarian' period. After 1920 they began to move away, the rest – and often the most notable – parts of their careers being spent abroad.

The 1890s seem to have been a propitious decade in which to be born, an age of expansion, optimism and confidence such as Hungary had not known for centuries. To crown it all the Hungarian state celebrated one thousand years of existence in 1896 with a World Fair in Budapest. As John Lukács tells us in the introduction to his book *Budapest 1900*:

> In 1900 Budapest was the youngest of the great metropolises of Europe (perhaps, except for Chicago, of the world). In twenty-five years its population had trebled and its buildings had doubled, and the city was pulsing with physical and mental vigour.[2]

The internationalism of the Austro-Hungarian Empire opened doors to Hungarians, particularly of the newly prosperous middle class. This flowering had been created by the entrepreneurial activities of a generation whose major gift to its children seemed – in Budapest at least – to be economic and moral liberalism, money, property, clutter, Biedermeier furniture, and, for the more consciously artistically minded, a folk-art-influenced Secessionism in architecture, and a literary and painterly Symbolism. It was a complex heritage. The folk motifs pointed to the romance of national history, while Symbolism indicated a consciously modern, international aesthetic. The World Fair added technology to the

mixture, offering Hungarians a place in modernity. Paris had erected the Eiffel Tower: Budapest now produced the world's second underground-railway system, following London but anticipating Vienna.

Before the 1890s Hungary had been a provincial partner to Austria. That provinciality, the sense of being suspended between power and weakness, between past and future, was perfectly articulated in the form of dream by one of the great writers of the earlier generation, Gyula Krúdy (1878–1933), particularly in his stories dealing with the adventures of Sindbad. Sindbad is a kind of ghostly Don Juan. Both man and ghost, handsome and gentle, wise in some ways, childlike in others, he is three hundred years old. Some of the time he is actually dead. He moves through a timeless Hungarian countryside, possibly the countryside of Krúdy's own childhood, revisiting his countless ex-lovers. The stories are dense with sensuous detail but everything else, including the very syntax, is tantalisingly unstable. Krúdy is, in effect, a magic realist *avant la lettre*. The fabric of certainty is breaking up beneath his feet; experiences bleed into each other. He remains an enormously popular writer even now.

The lyrical and magical elements in his stories were magnified in Zoltán Huszárik's enormously popular film *Szindbad* (1971), which filters them through a voluptuous visual and narrative language conditioned by Surrealism and the work of the filmmakers of the American underground. That love of the fantastic, the sybaritic, the surprising – the delight in reverie on the one hand and passionate fantasy on the other – represents one important aspect of the Hungarian imagination. It is there in the poetry, in the films, in the photographs too, as a kind of touchstone if nothing else. It is the dream-circus with the half-real, half-ghost horse circling the ring inside the big top.

The other side of the coin is social conscience and close observation. This has nothing to do with three-hundred-year-old amorists drifting magically through a lost world. It is reportage and photography. It reminds us that the idyllic 1890s were also an age of poverty resulting in mass emigration, chiefly from very poor rural areas, mainly to America. While Budapest was modernising itself and the social order, the rest of the country remained feudal, with the overwhelming proportion of land in the possession of great landlords.[3] Small farmers with just a strip or two to work were especially vulnerable. This *urbs–rus* division, the second of the major tensions, although it was common everywhere in Europe, was particularly severe in Hungary, and was soon to find cultural and political expression, to the extent that it became an important, sometimes decisive, factor in contemporary life. Budapest, from this point of view, was regarded as a sinful, godless, cosmopolitan machine. Its internationalism counted against it. The country did not care for such things, and regarded itself as honest, straightforward, hard-done-by and essentially Hungarian. The country –

still feudal, but living by habits that it considered ancient virtues – preferred being provincial.

The propitious years were not long. No sooner had confidence risen than the country was devastated by the First World War in 1914 and then by the post-war settlements of Versailles in 1919 and Trianon in 1920. The war and its consequences form the cradle of modern Hungarian consciousness.

The war entailed two revolutions, the first radical enough, but essentially liberal and reformist, the second communist, on the pattern of the Russian Revolution. Neither administration lasted more than a few months: both took office at a time of chaos and collapse. At the end of the second revolution, right-wing forces led by Admiral Horthy took control and White Terror succeeded Red Terror. Writers and artists tended to support the first revolution but many joined the second communist one, working in directorates to reorganise culture. Horthy put an end to that.

Horthy's first act on entering Budapest (cat. 65) was to list its crimes, calling it a polluter of the Hungarian realm but then announcing that he had forgiven the city. In this way the slumbering issue of the capital versus the rest, the internationalist versus the nationalist, the revolutionary versus the conservative, the corrupt, rootless cosmopolitan Jew versus the indigenous, faithful, straight-as-a-die Christian, was not only called into fully conscious being, but set as an official default position in both Hungarian politics and culture.

If the war was a disaster then the treaties that followed constituted a catastrophe. The victorious allies reduced the territory of Hungary by two-thirds, thereby reducing its population by one third. A third of Hungarians found themselves living in different countries with new, fiercely nationalistic governments. The ex-masters were now the hated minority. The resentments engendered by this are still burning on a low flame at the back of the amputated Hungarian imagination. Even now, the dream of a reunited Greater Hungary can easily be fanned into passionate life at the drop of a political hat.

Escher was born in the town of Szekszárd in the south of Hungary, Kertész in Budapest. The best introduction to Escher is the essay by Klára Tóry in the catalogue of the 1987 Bradford exhibition.[4] In the essay Tóry tells us that Escher moved with his parents to Budapest and that he did his elementary schooling there, but because his parents weren't rich he left school at fourteen to become a locksmith. He then trained as a technical draughtsman and learned to handle a camera. By 1916 he had turned to films and worked as a filmmaker during the war. He was, we know, a cinematographer at the time of the Hungarian Soviet Republic, producing newsreels and contributing to an eighty-minute compilation of revolutionary material, filming on Lake Balaton, even after the collapse of the government.

It is interesting to note what these filmmakers set out to do, because their programme formed the basis of much Hungarian documentary photography to follow. In an essay entitled 'The Red News-reel of the Tanácsköztársaság [Councils/Soviets]: History Dream and Cinema Imagination', Bruno de Marchi mentions Escher as one of the leading figures in the project and describes its aims and products as:

> … not at all a catalogue of ceremonials. On the contrary, it is a radiography: the radiography of the reaction of a group of 'real' men facing a real situation which is as short as it is rich in political, ideological, and artistic provocations.[5]

In talking of 'ceremonials' de Marchi wants to distance the aims of the 'red' cinematographers from that of their later fascist or Nazi equivalents, such as Leni Riefenstahl and her films of the Nuremberg Rally or the 1936 Berlin Olympics. Radiography is a pseudo-scientific term. The simple point is that Escher's concern at this time was to record the lives of the poor in the hope of improving their conditions. Rural Hungary is documented in terms of work and the lack of it. Escher was to carry this commitment through into his striking social-documentary work of the 1930s, the decade of the apocalyptic horse.

Kertész, the son of a Jewish tradesman in Budapest, received his first camera in 1912 at the age of eighteen, but it was his second, lighter camera that he took with him into action in 1914. The marvellous photograph he took of four soldiers on a hollow log deployed as a field latrine (cat. 54) must have been taken before he was injured in 1915, the year after he photographed himself in uniform (fig. 36). For Kertész, a city boy, the rural did not mean work: it meant excursion and idyll, especially after the horrors of the Great War. The immediately post-war pictures of his brother Jenő swimming, leaping, playing at faun and Icarus (fig. 37) are full of physical delight without social conscience. They are sheer relief. The photographs are the direct equivalent of poetic pastoral but the larking about has an elevated joyfulness. The artifice of the pastoral is re-experienced as dream.

The tension between realism and dream was not to be fully embodied in either Escher or Kertész – both men are far more than embodiments of tendencies. Kertész's true subject was the multifarious life of the city: the city as dream, surprise, game, pattern and Eros. They were also to show that the city in question is not Budapest, but a hotspot in the European imagination. In other words, the tensions between city and country, between internationalism and provincialism, are resolved in Kertész in favour of the former in both cases.

And so were they with most photographers, most of the time, eventually. Like Kertész, Robert Capa was born in Budapest, Escher and Moholy-Nagy in small towns in the south of Hungary, Brassaï in what was then

Fig. 36
André Kertész, *Self-portrait, Görz*, 1914.
Silver gelatin print, 6 × 4.5 cm. Médiathèque
de l'Architecture et du Patrimoine, Paris

Brasso to Hungarians and Kronstadt to Germans but became Brasov when Transylvania was ceded to Romania in 1919, and Munkácsi in my mother's home town of Kolozsvár, also known as Klausenburg to the Germans but Cluj to the Romanians. As everywhere, in order to achieve anything you needed to be seen in the capital, but in Hungary, for the reasons I have given, the contrast between Budapest and the rest was considerably greater. Everyone did in fact gravitate to Budapest. Once in Budapest the revolutions and the politics followed. Like Kertész, Moholy-Nagy joined the army, and, like Kertész, he was injured. He was an active supporter of the Soviet Republic in 1919, and on its defeat retreated briefly to Szeged before emigrating. Brassaï joined the Red Army in 1919. He was taken prisoner, moved to Berlin, then went on to Paris.

Most of the now-famous photographers left Hungary after the war. They were not the only ones to go of course. John Lukács lists some forty well-known names in various fields: composers, musicians, mathematicians, philosophers, chemists, economists, psychoanalysts and many others. Five out of six Hungarian winners of the Nobel Prize were among them. All kinds of intellectuals emigrated, at least for a while, but the writers generally returned once it was safe to do so, however difficult life might be, because their business was with the Hungarian language.

The photographers did not return. Their language was international: they could take their Hungarian with them. There were those who needed to leave because of their political associations and others who left because the prospect of life outside an authoritarian, proto-fascist state seemed more attractive. Despite his revolutionary background, Escher somehow remained and survived. The first anti-Jewish law in twentieth-century Europe, the so-called Numerus Clausus, which limited the number of Jewish students in higher education, was passed in Hungary in 1920, and anti-Semitism was common and rising. Before the war Jewish people were accused of being on the side of international capital and of exercising far too much influence on the country's affairs. Budapest was slyly referred to as *zsidópest* – Judapest. But then most of the Bolshevik leaders in the following Soviet revolution against that system were also Jewish, so Jewish people lost both ways. Many of the intellectuals who left were themselves Jewish. Internationalism, the charge levelled against Budapest in 1896, now became a direct practical option, far preferable to the hostile nationalism of the new régime.

What did the photographers take with them? They took their youth and the experience of those thirty odd years into which they had managed to compress several lifetimes. They took the national memory of flux and instability that they had inherited from previous generations, the excitement of the beginnings of new hope in a new era, the savagery of war, the chaos of two revolutionary régimes and the sense of a country shutting down. They took their tensions – the dream that would lead Kertész into his adventures

Fig. 37
André Kertész, *My Brother as Icarus*, Duna Haraszti, June 1919. Silver gelatin print, 3.8 × 5.1 cm. National Gallery of Art, Washington DC, 1999.122.8. Gift of the André Kertész Foundation

with Surrealism, the realism that led Brassaï to explore the underworld of Paris, the love of urban life that led Munkácsi to explore the energies of the active human figure in sport and fashion but also to keep a weather eye on the rise of fascism in Germany. Moholy-Nagy took the excitements of technology and Constructivism that he found in the revolutions. The adventure of the war he had missed took Capa into various war zones and eventually to his death.

Escher remained behind, unnoticed abroad, recording the entire field: Budapest, the poverty of the 1930s, the paraphernalia and rituals of the Horthy régime, the soldiers of the equally disastrous Second World War, shooting portraits, scenes from theatre and funfairs, even an exploration of the gentle Surrealism that Kertész so loved.

What Franz von Löher had refused to give the Hungarian people credit for was their ingenuity, imagination, endurance and curiosity. The thirty hot-house years between 1890 and 1920 accelerated ambition and desire. Opportunities were there to be seized, in Budapest, in America, in Vienna, or in the other major cities of Europe. Photography was opportunity. No need to waste life in provinces and suburbs. Here, ingenuity, imagination, endurance and curiosity could be given proper scope. Anything was possible.

Some of that vigour and wonder are broadly European: post-war, post-machine, post-revolution, post- the fall of various *anciens régimes*, post- the redrawing of borders, post- the collapse and reconstitution of the shocked pre-war order into patterns tending towards fascism on the one hand and Bolshevism on the other. Constructivism, Futurism, Vorticism, Cubism, Surrealism, the feverish accumulation of rival manifestos and -isms, the scattering of cultures all over Europe, their gathering in Paris or Berlin or Zürich. The Bauhaus, De Stijl, the Weissenhof estate, the Villa Savoie… not to mention the modernist monuments of literature, philosophy, medicine, psychology and the sciences. The intoxicating, almost febrile energy that was released after the Great War was only to be sapped, reined in and darkened by the Great Crash of 1929.

And what of the women photographers? My mother would have wanted to know. That, after all, would have been her ambition in working for Escher. Would she have known the work of Kata Kálmán, the producer of marvellous working-class portraits, children and industrial poverty (cats 41–42, 132), of Judit Karász (1912–1977), a student at the Bauhaus with a particular interest in texture and form, and of the short-lived Kata Sugár (cats 37–39)? What of Kati Horna (cat. 101), the close friend of Robert Capa, who taught and helped him, who photographed the Spanish Civil War, then married and settled in Mexico where her friendship with Leonora Carrington and Remedios Varo led her towards a playful form of Surrealism? What, more recently, of the lyrical work of Sylvia Plachy

(cat. 182), assistant and apprentice to Kertész in New York, to whom Kertész affectionately referred as his 'little snot-nosed kid'? Plachy's family was, like mine, among the refugees of the 1956 Hungarian Uprising.

The three areas of tension worked their way through all the photographers in their sometimes long up-and-down careers that entailed more wars, more uprooting, more shifting, more packing of small cases full of photographs. Anxiety, flight and isolation haunted them all. The love of realism and fine detail on the one hand, the flirtation with Surrealism and dream on the other; the bustle of the city versus the suspect idyll of the land; international high style versus the residual Hungarian sensibility – all these contrasts made them what they were. The alienated turning away into the observation of something that cannot be seen, the distant noise of a circus of sorts, and the thundering of the big apocalyptic horse are the ground bass of the music of what happened and went on happening.

In 1914 photography in Hungary – like other forms of art in a country yoked to Austria – was firmly under the influence of European practice. In that year, the leading Hungarian photographer Rudolf Balogh wrote: 'We need photographs to communicate our particularities and our national character.' His words marked the beginning of a long period when Hungary's photographers led the world in their field. Some – including Brassaï, Capa, Kertész, Moholy-Nagy and Munkácsi – left their native country to make their names in Germany, France, Britain and America. They are now universally known for the profound changes they brought about in photojournalism and art photography. Others – less internationally famous – also settled abroad. Some stayed behind.

Kertész and Munkácsi were photographers before they left Hungary, the former still an amateur, the latter already a highly paid professional. Samples of their early work – very different from each other – appear here (cats 1, 12, 14, 16–17, 19–20, 24, 26, 50), as do pictures by sixteen other photographers, four of them women. Among the most important of these photographers, who would surely have become famous had they not remained in Hungary, are Angelo (cats 45–46), Balogh (cats 2, 7–8, 30, 47–48), Károly Escher (cats 11, 18, 23, 40, 51–52), Kata Kálmán (cat. 41), József Pécsi (cats 21, 25, 31, 33, 36), Dénes Rónai (cat. 35), Kata Sugár (cats 37–39) and

Ernő Vadas (cats 9, 49).

Balogh's call for a particularly Hungarian photography led to a flowering of the 'Hungarian style', invoking a nostalgic notion of Hungary's bucolic character and brilliantly exemplified in Balogh's three 1930s photographs (cats 2, 7–8). In the fast-growing, sophisticated city of Budapest, illustrated magazines made increased use of photographs for reporting political events, sports activities and advertising. They were among the first in the world to publish picture stories combining text and photographs: the basis of what came to be called photojournalism. One such publication was *Pesti Napló* (*Pest Diary*), which inaugurated its illustrated Sunday supplement in 1925. This published the work of many photographers, including Balogh, Escher, Munkácsi, Vadas, Lucien Aigner and Imre Kinski. Stefan Lorant (István Reich), who played such a prominent role in the development of such magazines in Germany and England, was briefly its editor, from December 1933 to March 1934.

After the First World War, the Austro-Hungarian monarchy collapsed, and nearly three-quarters of Hungary's territory and 64% of its population were apportioned to Romania, Czechoslovakia and Yugoslavia by the 1920 Treaty of Trianon. Tens of thousands of ethnic Hungarians, finding themselves suddenly residents of 'foreign' lands, hastily moved into what was left of Hungary itself, which led to

overcrowding, poverty and political unrest. However, it also enriched the country's cultural climate, bringing together artists of many kinds and from many backgrounds. There was a consequent explosion in almost all the arts – including photography.

While pictorialism, with its taste for soft-focus nostalgia and aspirations to rival fine art, was especially popular with the amateur members of the many camera clubs then coming into being, social documentary also flourished. The more tentative beginnings of the New Photography or the New Objectivity, encompassing experimentation with lighting, cropping and angles, can more often be seen in the work of professionals. All groups had a particular liking for overhead views, taken from 45 degrees or so above the ground, a device that removed all sense of a horizon and thus allowed photographers to give even the busiest of scenes a strong sense of abstraction (cats 9, 18, 48–49).

1

Hungary 1914–1939

1 | **André Kertész**
Boy Sleeping
Budapest, 1912
Silver gelatin print, 1967,
25.2 × 20.3 cm

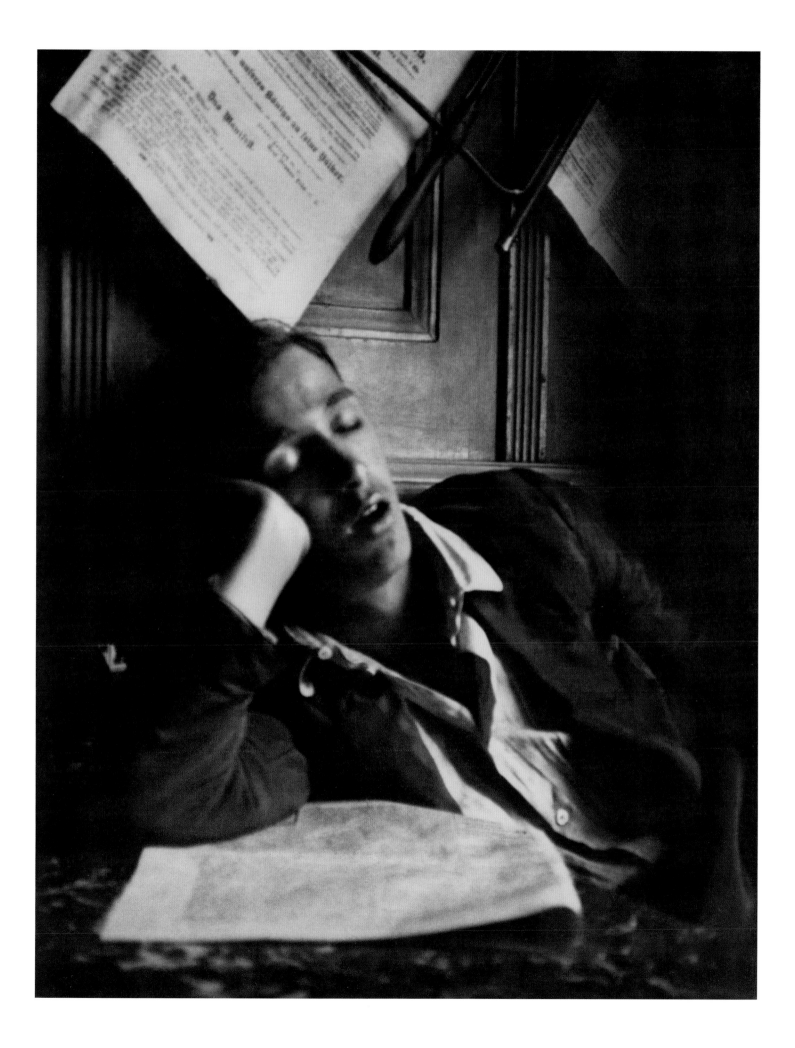

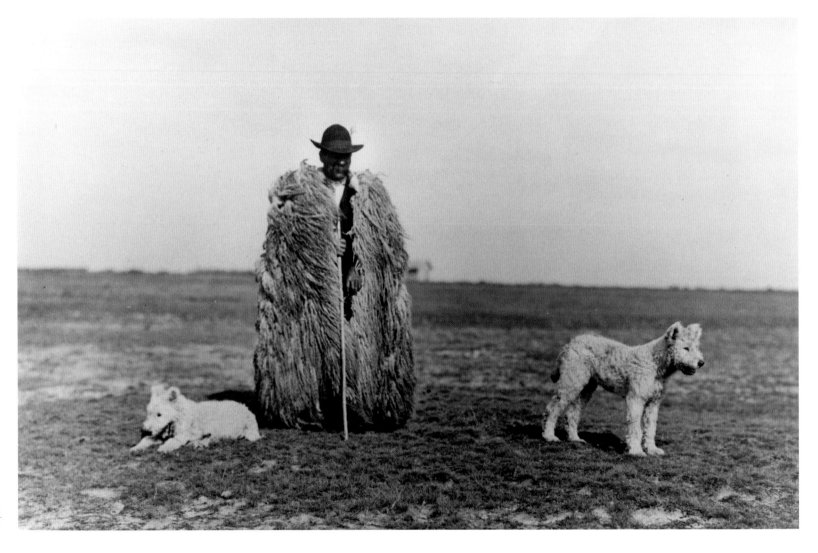

2 | **Rudolf Balogh**
Shepherd with His Dogs
Hortobágy, *c.* 1930
Vintage silver gelatin print,
18 29 cm

3 | **André Kertész**
Untitled
Hungary, *c.* 1918
Vintage silver gelatin contact print,
8.3 × 10.8 cm

4 | **André Kertész**
Pomáz
Hungary, 11 June 1916
Vintage silver gelatin contact print,
3.8 × 4.8 cm

5 | **André Kertész**
Untitled
Hungary, *c.* 1918
Vintage silver gelatin contact print,
3.2 × 4.5 cm

6 | **André Kertész**
Braïla
1918
Vintage silver gelatin contact print,
3.8 × 5.1 cm

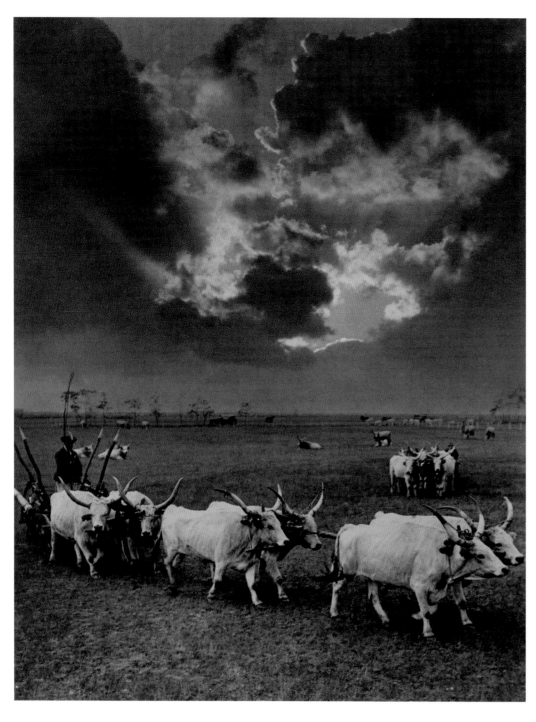

7 | **Rudolf Balogh**
Six Cattle
Hortobágy, 1930
Vintage silver gelatin print,
29.1 × 22.5 cm

8 | **Rudolf Balogh**
Stud
Hortobágy, 1930
Vintage silver gelatin print,
38 × 28.3 cm

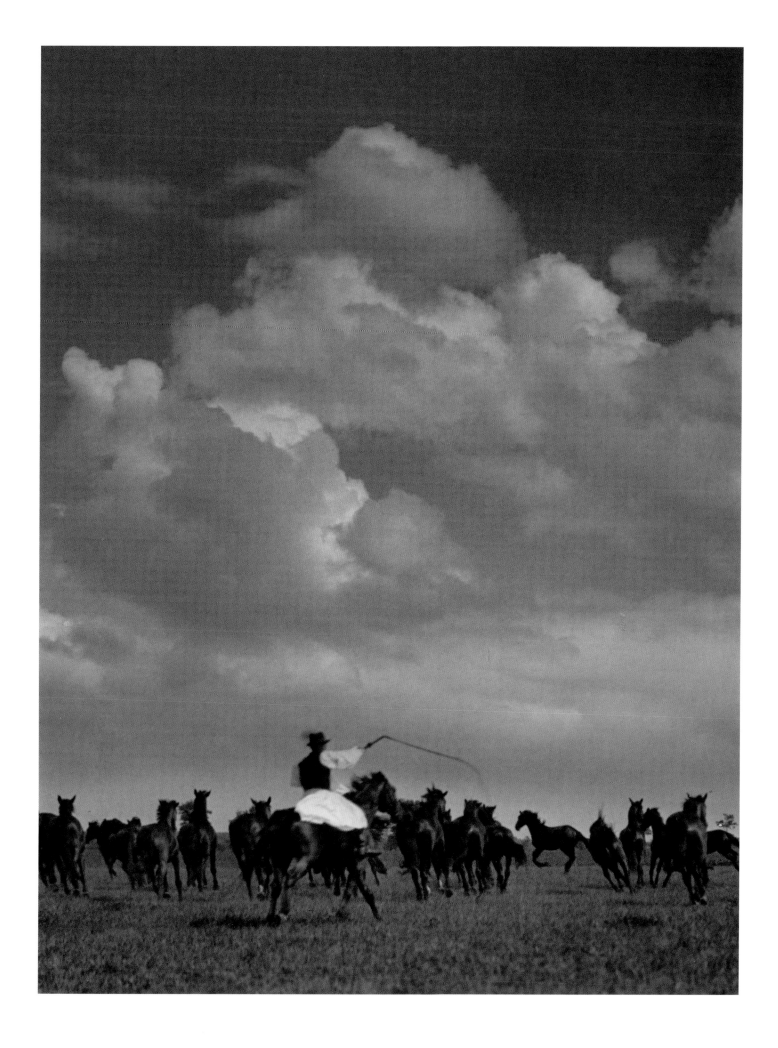

9 | **Ernő Vadas**
Harvest
Hungary, 1937
Vintage silver gelatin print,
29.5 × 40.2 cm

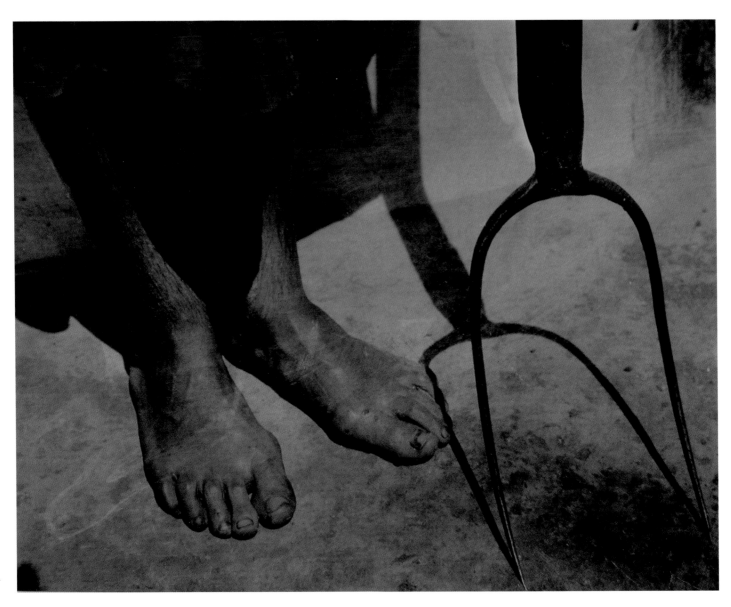

10 | **Ferenc Haár**
Labourer During Midday Break
1931
Vintage silver gelatin print,
24.1 × 30.5 cm

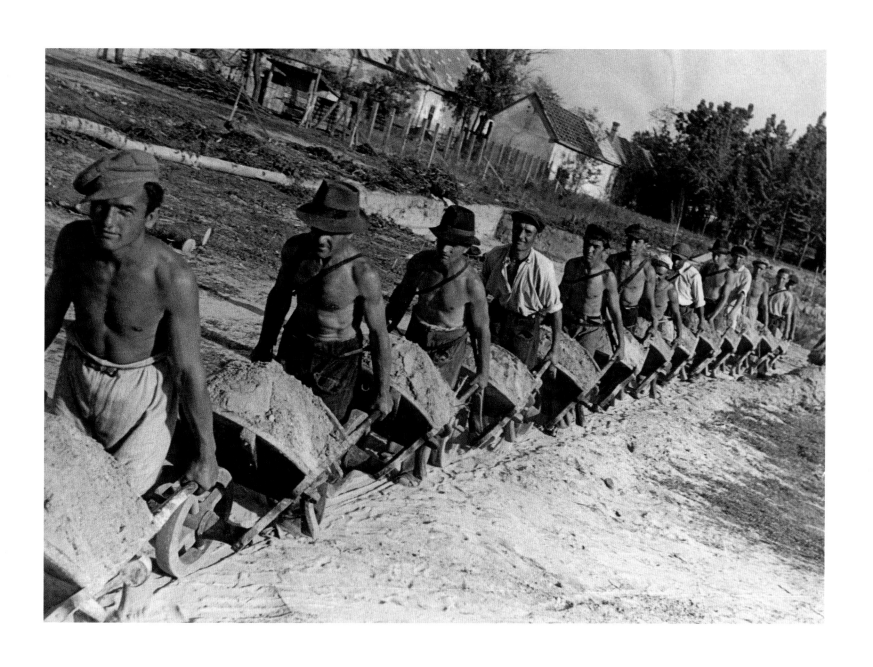

11 | **Károly Escher**
Navvies
Channel Sió, 1946
Silver gelatin print, 1964,
28.5 × 39.5 cm

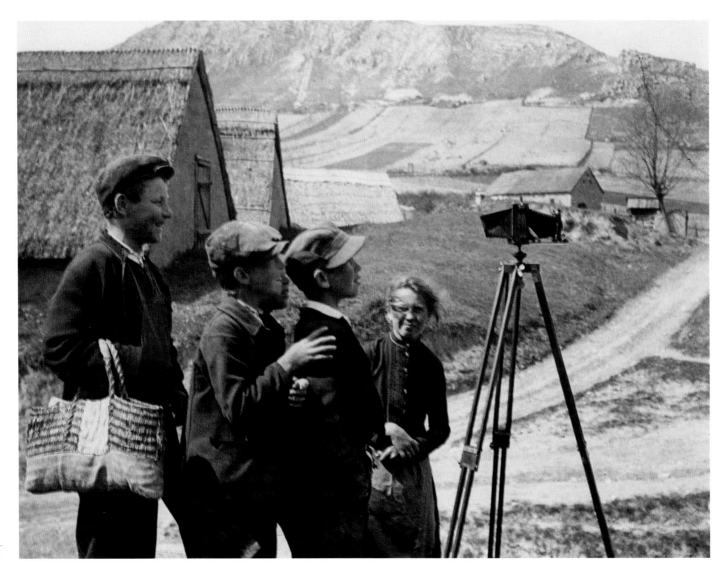

12 | **André Kertész**
Children Admiring My Camera
Budafok, 1919
Silver gelatin print, 1967,
20.4 × 25.3 cm

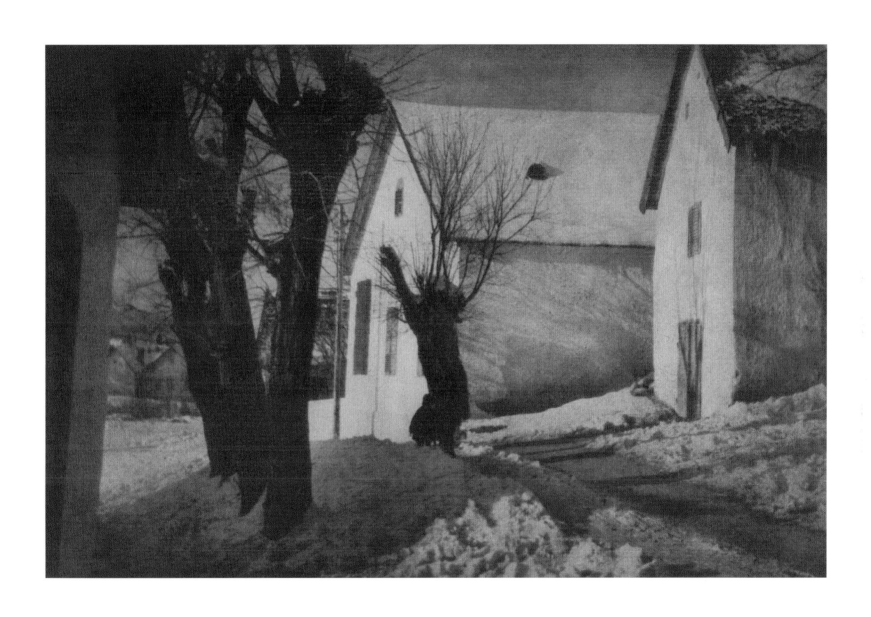

13 | **József Pécsi**
Winter
Budapest, 1928
Vintage oil print,
18 × 27.5 cm

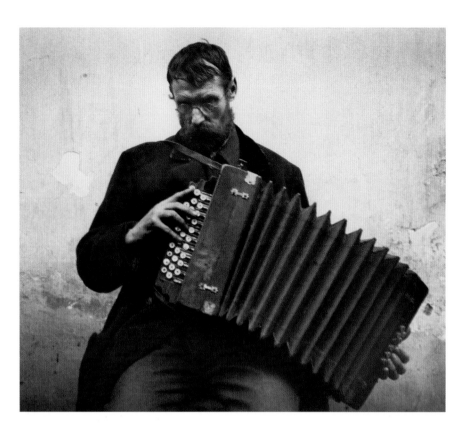

14 | **André Kertész**
Accordionist
Esztergom, 21 October 1916
Silver gelatin print, 1967,
20.4 × 25.3 cm

15 | **Éva Besnyő**
Child with 'Cello
Balatonlelle, 1931
Silver gelatin print, 1998,
23 × 18.8 cm

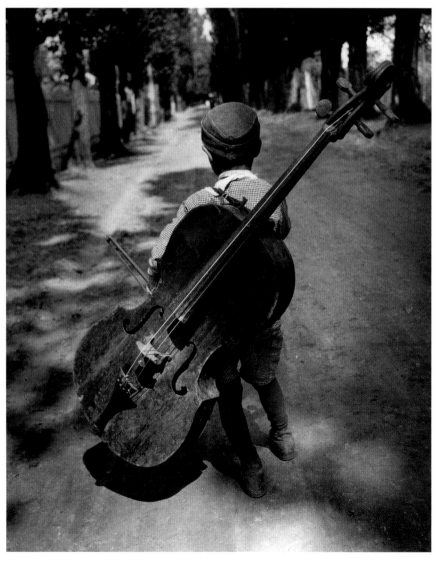

16 | **André Kertész**
Wandering Violinist
Abony, 19 July 1924
Silver gelatin print, 1967,
25.3 × 20.4 cm

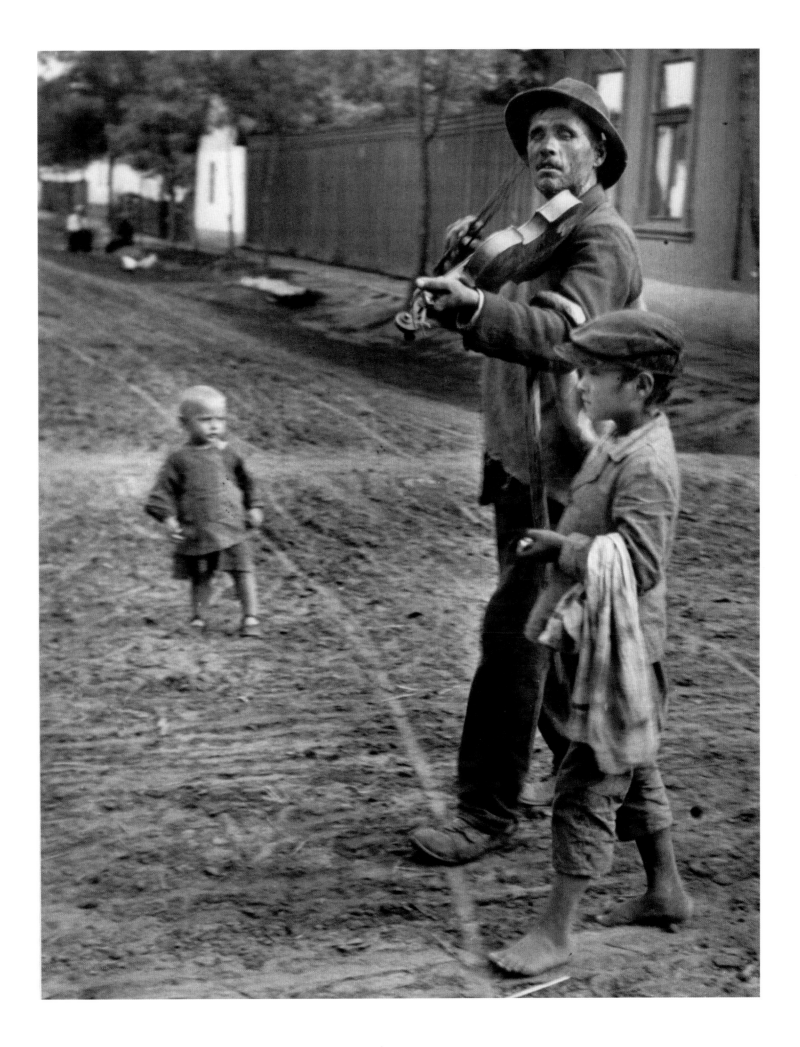

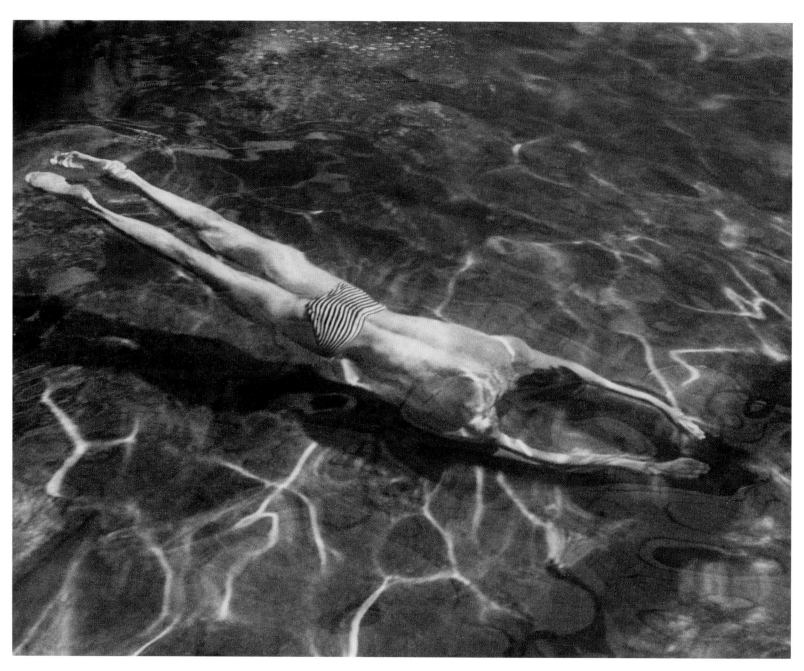

17 | **André Kertész**
Underwater Swimmer
Esztergom, 31 August 1917
Silver gelatin print, 1970s,
19.2 × 24.3 cm

18 | **Károly Escher**
Bank Manager at the Baths
Budapest, 1938
Silver gelatin print, 1964,
39.2 × 29 cm

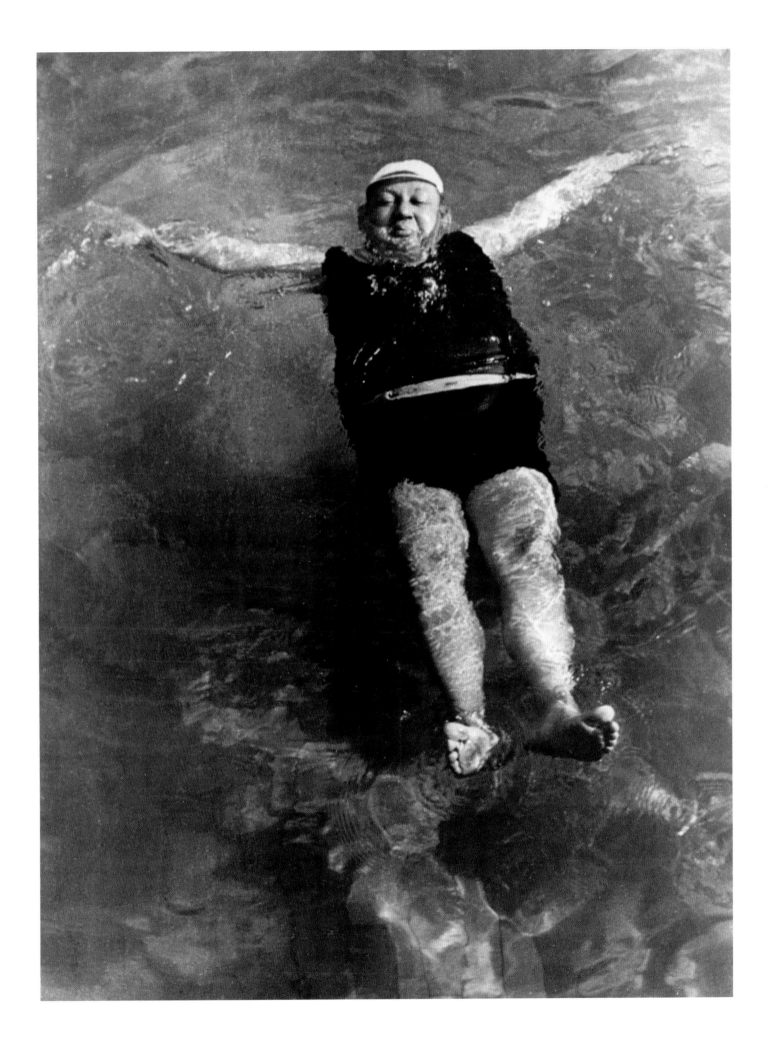

19 | **André Kertész**
Lovers
Budapest, 1915
Silver gelatin print, 1967,
20.3 × 25.3 cm

20 | **André Kertész**
Circus
Budapest, 19 May 1920
Silver gelatin print, 1967,
25.2 × 20.3 cm

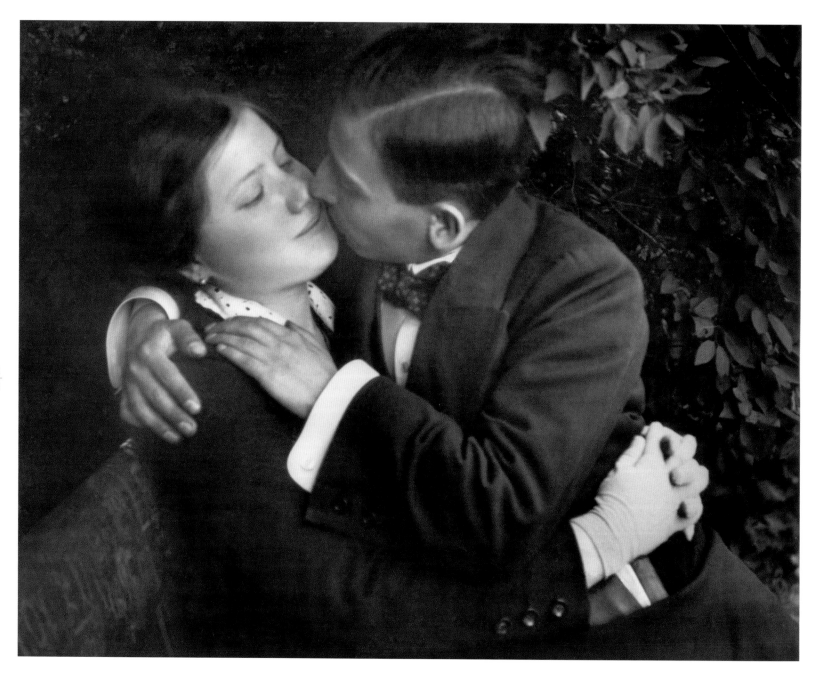

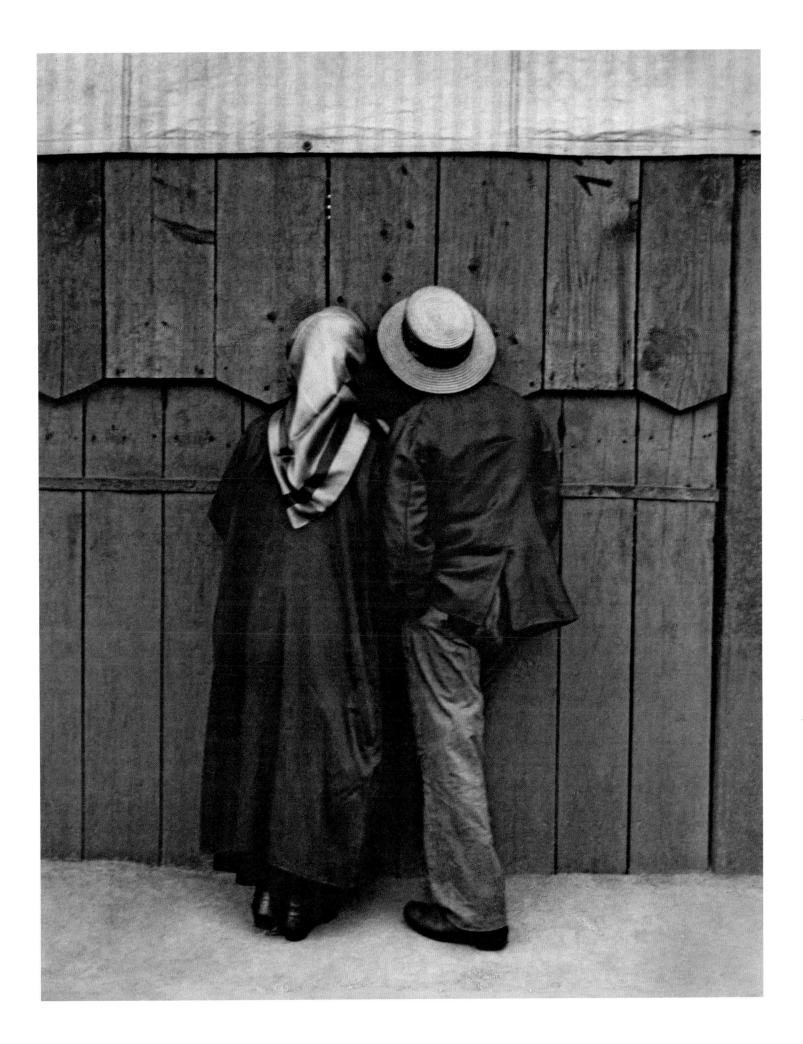

21 | **József Pécsi**
Fashion
Budapest, 1936
Vintage silver gelatin print,
38.5 × 28.5 cm

22 | **Dénes Rónai**
The Evening: A Woman Holding a Cigarette
Budapest, 1929
Vintage silver gelatin print,
39.9 × 29.5 cm

23 | **Károly Escher**
The Angel of Peace
Budapest, 1938
Silver gelatin print, 1964,
39.3 × 28.7 cm

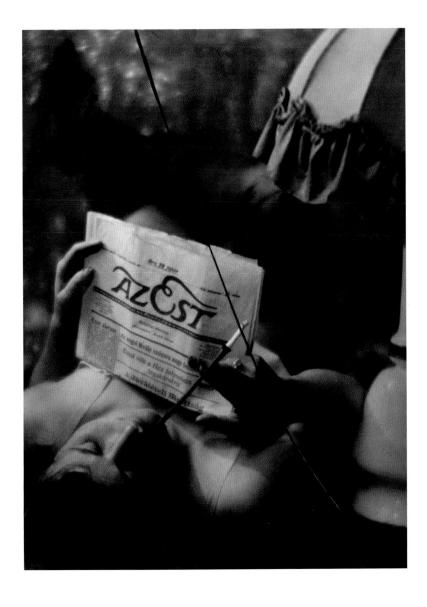

24 | **Martin Munkácsi**
Sunshade
Hungary, 1923
Silver gelatin print, 1994, from original
negative, 35.5 × 27.5 cm

25 | **József Pécsi**
Evening
Budapest, 1927
Vintage oil print,
40.5 × 28.9 cm

26 | **Martin Munkácsi**
*Workhouse (Children Dance on the
Street to Music of Record Player)*
Budapest, 1923
Silver gelatin print, 1995, from original
negative, 35.5 × 27.5 cm

27 | **Imre Kinszki**
Morning Light
Budapest, 1931
Vintage silver gelatin print,
18 13.3 cm

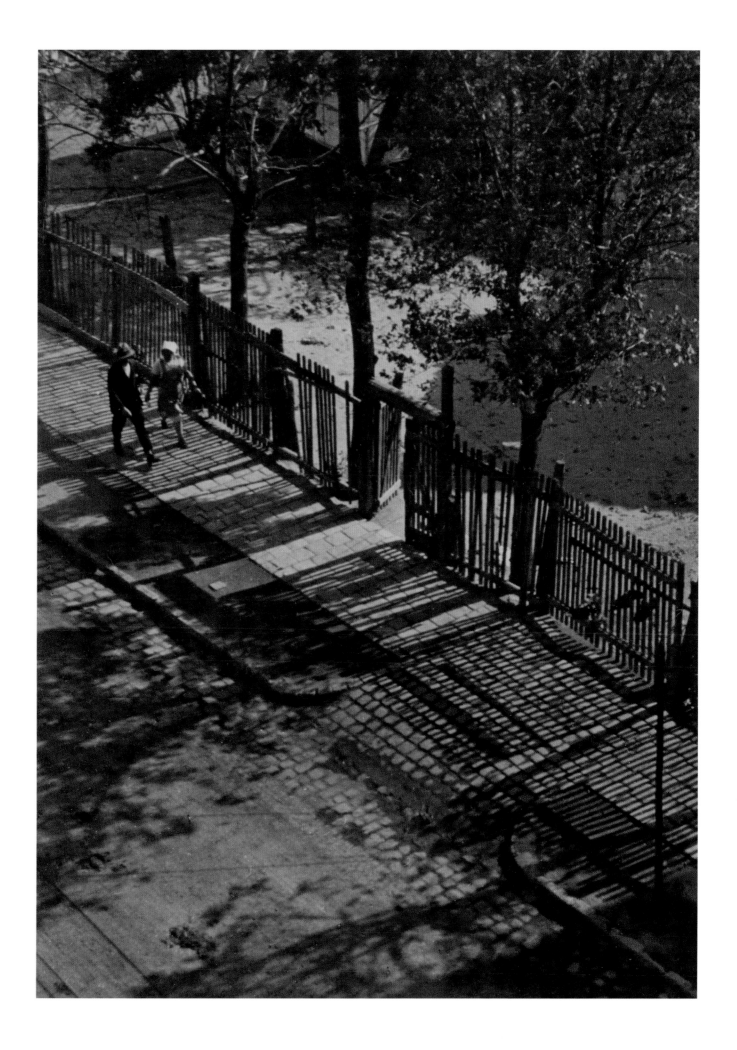

29 | **István Kerny**
Still-life
Hungary, 1925
Vintage silver gelatin print,
29.7 × 39.4 cm

28 | **Nándor Bárány**
Balance
Budapest, *c.* 1933
Vintage silver gelatin print,
49.5 × 40 cm

30 | **Rudolf Balogh**
Still-life with Grapes
1930s
Vintage silver gelatin print,
39.5 30 cm

31 | **József Pécsi**
Table Laid
Budapest, 1930
Vintage silver gelatin print,
15.7 × 23.8 cm

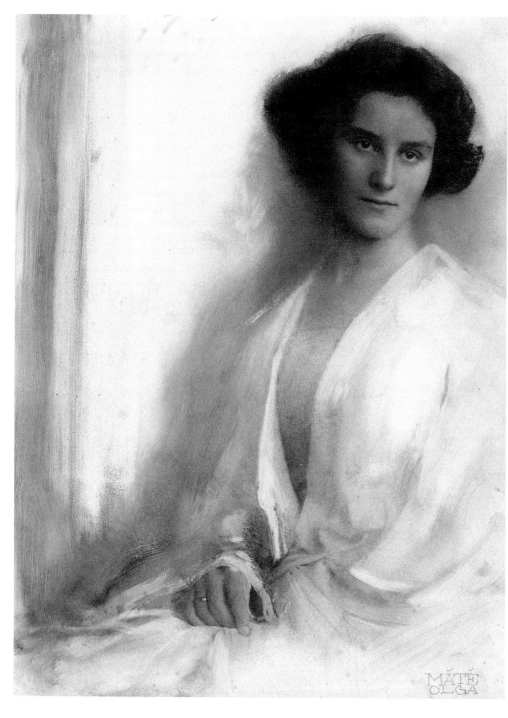

32 | **Olga Máté**
Portrait of a Woman Dressed in White
Budapest, *c.* 1920
Vintage oil print,
22 × 16.5 cm

33 | **József Pécsi**
Kodak Camera Advertisement
Budapest, 1928
Vintage pigment print,
27 × 19.5 cm

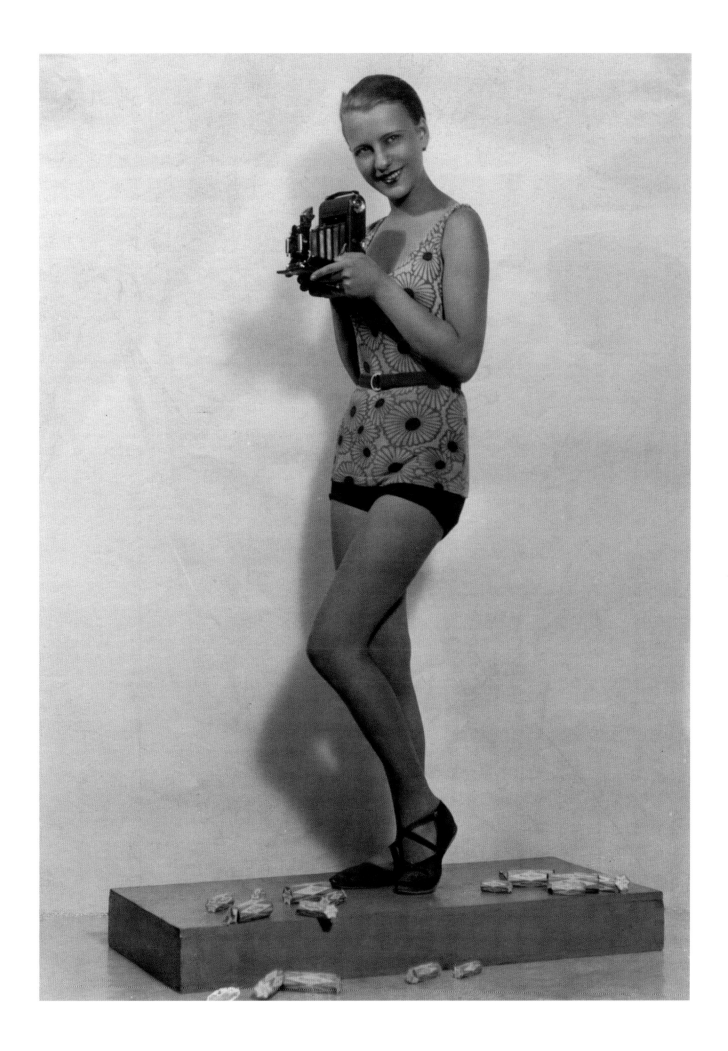

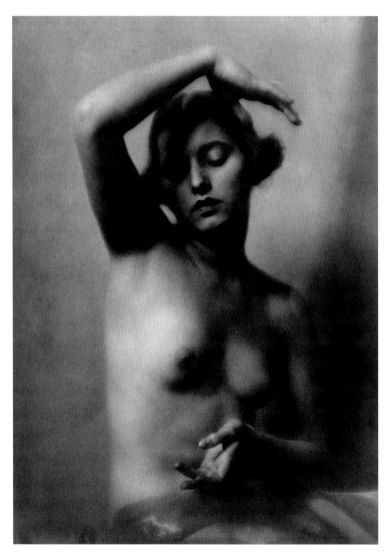

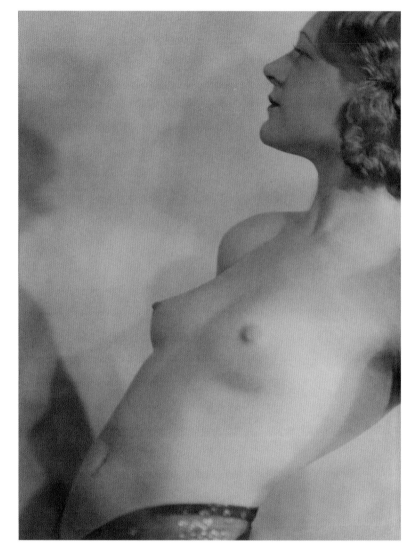

34 | **Olga Máté**
Nude with Dance Movement
Budapest, *c.* 1920
Vintage silver gelatin print,
23.5 × 17.2 cm

35 | **Dénes Rónai**
Dance: Salome
Budapest, 1930s
Vintage silver gelatin print,
38.6 × 28.3 cm

36 | **József Pécsi**
Nude Study
Budapest, *c.* 1930
Vintage pigment print,
38 × 28.5 cm

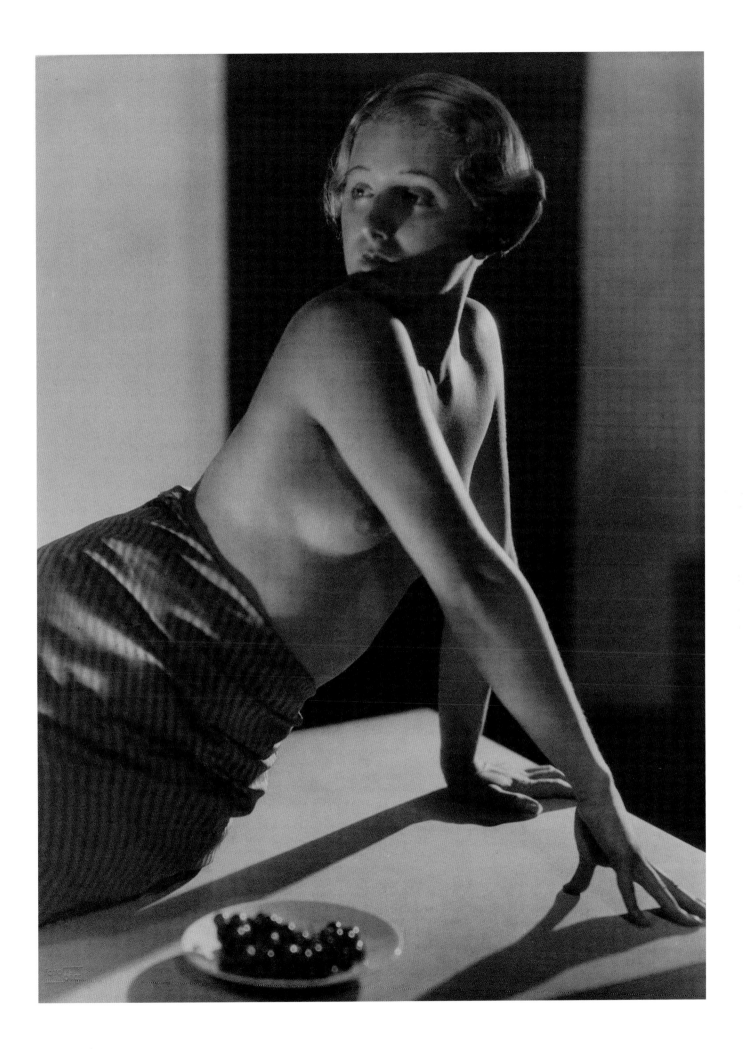

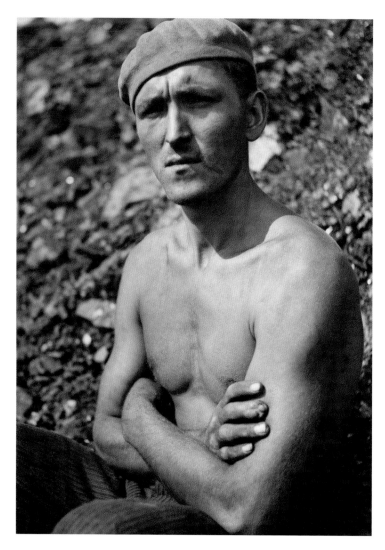

37 | **Kata Sugár**
Young Miner (Louis the Great)
Zagyvapálfalva, 1938
Vintage silver gelatin print,
24 × 17 cm

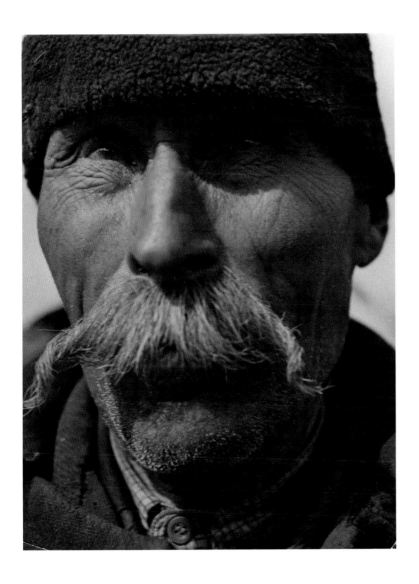

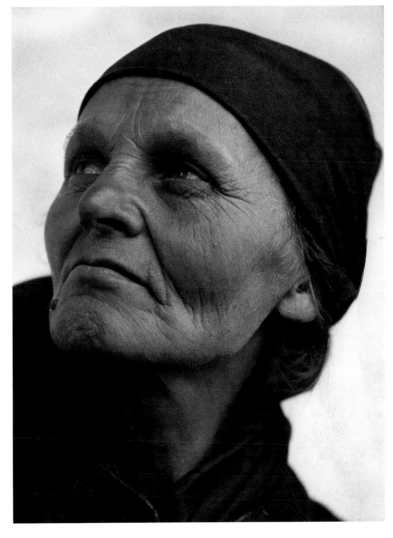

38 | **Kata Sugár**
Paul Szabó, Peasant
Budapest, 1937
Vintage silver gelatin print,
24 × 18 cm

39 | **Kata Sugár**
Mrs Miklós Szabó
Hollókő, 1938
Vintage silver gelatin print,
20 × 15.2 cm

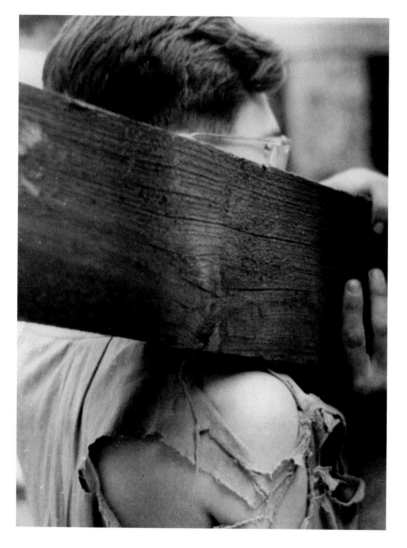

40 | **Károly Escher**
Jobless Professional Doing Manual Labour
1930s
Vintage silver gelatin print,
22.5 × 17 cm

41 | **Kata Kálmán**
Laci Varga, Four Years Old
Budapest, 1931
Silver gelatin print, 1968,
24 × 18.2 cm

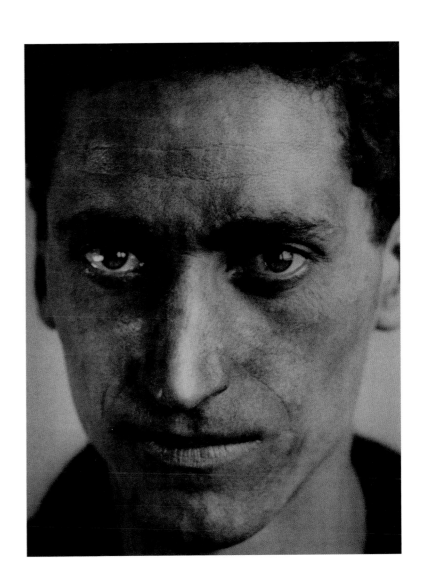

42 | **Kata Kálmán**
Ernő Weisz, Factory Worker
Budapest, 1932
Silver gelatin print, 1968,
24 × 18.3 cm

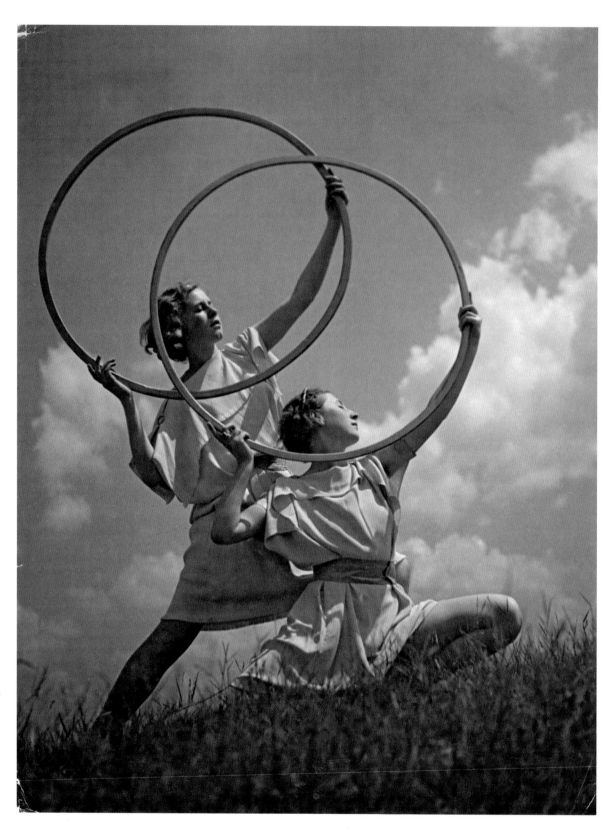

43 | **Tibor Csörgeő**
Sparta (Hoop III)
1936
Vintage silver gelatin print,
37 × 28.5 cm

44 | **Rudolf Járai**
The Archer
1943
Vintage silver gelatin print,
37.2 × 29.7 cm

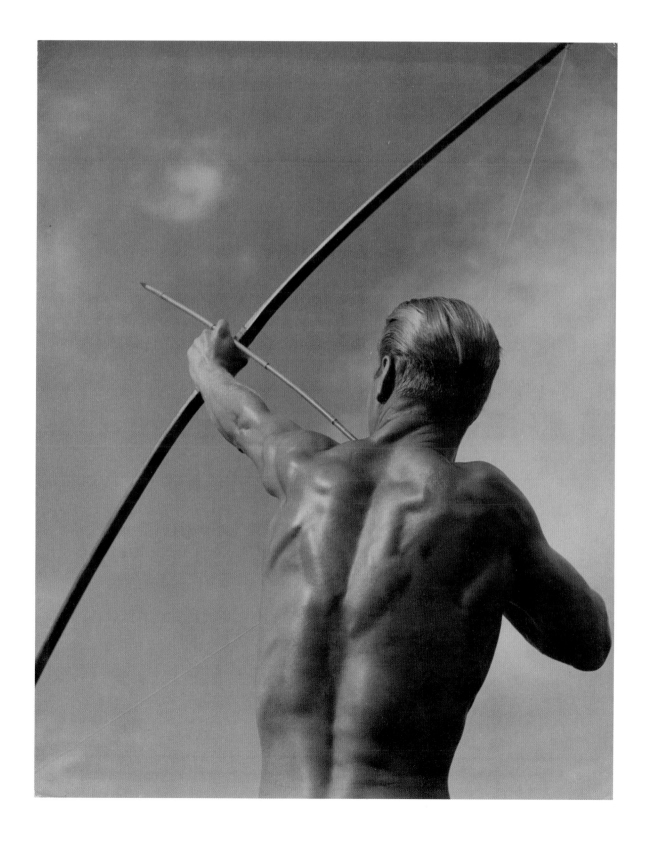

45 | **Angelo**
Spiral I (Column)
1930
Vintage silver gelatin print,
24.4 × 18 cm

46 | **Angelo**
Airport Steps
Italy, 1936
Vintage silver gelatin print,
40 × 30 cm

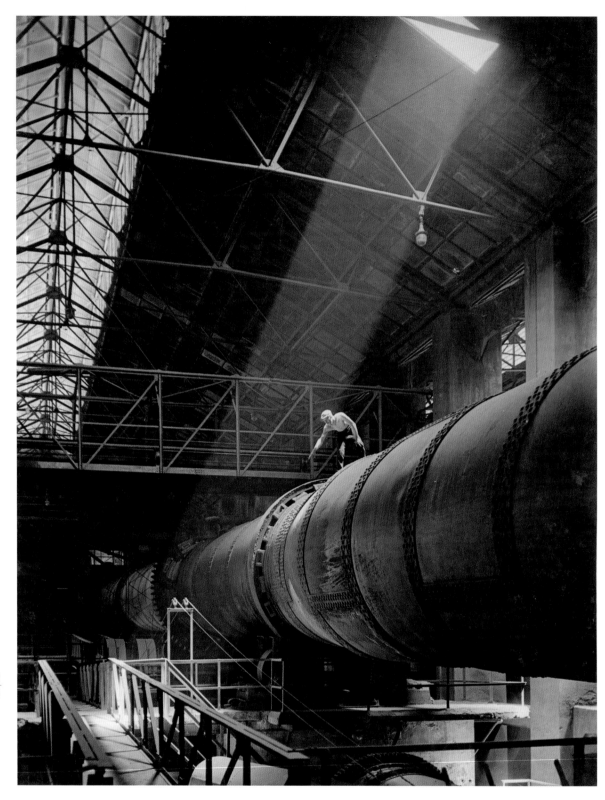

47 | **Rudolf Balogh**
To the Factory
Budapest, 1932
Vintage silver gelatin print,
30 × 24 cm

49 | **Ernő Vadas**
Procession
Budapest, 1934
Vintage silver gelatin print,
39.5 × 30 cm

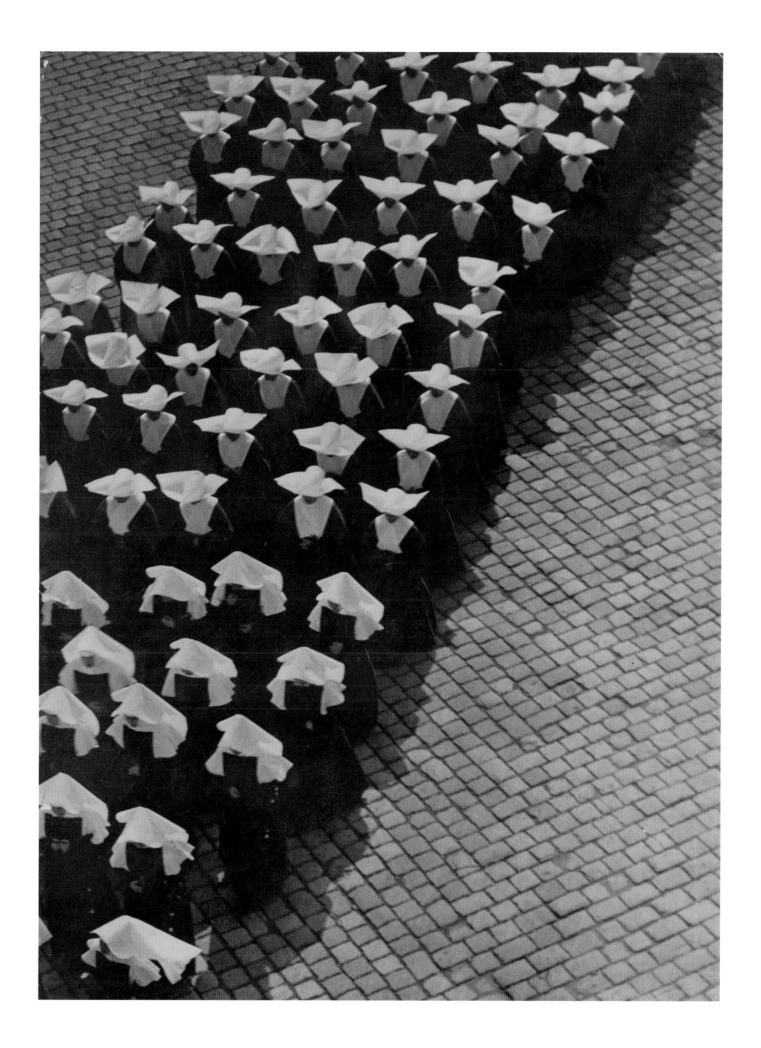

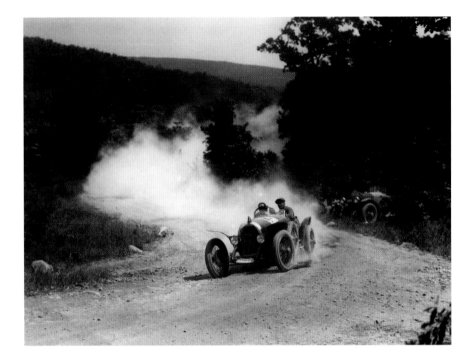

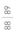

50 | **Martin Munkácsi**
| *Car Racing*
| Mátra, 1929
| Silver gelatin print, 1994, from original
| negative, 27.7 35.5 cm

51 | **Károly Escher**
| *Cyclists*
| c. 1930
| Silver gelatin print, 1964,
| 27.5 × 39.5 cm

52 | **Károly Escher**
| *Swing Boat*
| 1930
| Silver gelatin print, 1964,
| 60 × 49.1 cm

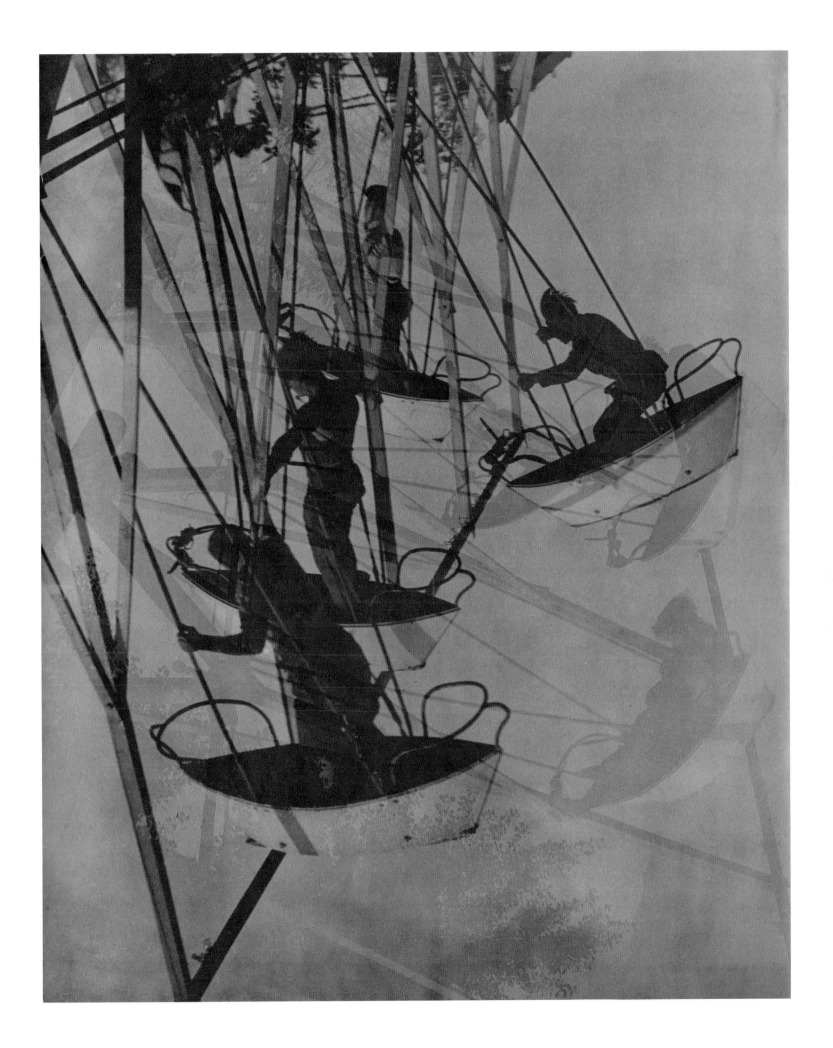

All five of the major names in this exhibition were alive at the time of the First World War, but only Kertész – still an amateur and a beginner – took photographs during the conflict. Brassaï and Moholy-Nagy served in the Austro-Hungarian army, but were not yet photographers, although Moholy-Nagy made some of his first drawings while convalescing after having been wounded. Capa was less than a year old when war was declared; Munkácsi was eighteen, but somehow stayed out of the army. The seasoned professional Rudolf Balogh was an official war correspondent with the army, and took dramatic photographs of battle scenes, life in the trenches and the horrors resulting from war (cat. 64). These show him in a very different light from the romantic 'Hungarian style' pictures for which he is usually remembered.

In many ways, the most striking and pioneering record of the Austro-Hungarian army's experience in the war was assembled by the Budapest newspaper *Az Érdekes Uság* (*Interesting Newspaper*), first published in March 1913. For a time, the uncle of the great picture editor Stefan Lorant edited the paper; Lorant himself called it 'the first modern pictorial magazine', and one of his photographs was used on its cover towards the end of the war, when he was aged only sixteen.

Six months after the outbreak of hostilities, *Az Érdekes Ujság* invited serving soldiers to submit previously unpublished photographs to a competition with generous cash prizes. Some of the best of the 1,599 entries were published in Austrian, German, Dutch and Spanish newspapers. After this success, *Az Érdekes Ujság* boasted that '…these pictures will tell the world at large about Hungarian triumphs on the battlefield; the bravery, dedication and resolution of Hungarian soldiers; and the endurance and perseverance of the nation at home.'

A second competition, which drew 1,400 entries, was followed by a third. *Az Érdekes Ujság* was confident that it now had 'the most beautiful and interesting' archive of the war and its 'horrid yet majestic nature', which also provided 'evidence of the good humour and character of Hungarian soldiers'. In a fourth competition with 1,796 entries, Kertész first had a photograph published, on 25 March 1917. In the last year of the war, *Az Érdekes Ujság* ran a fifth and final competition, and issued beautiful illustrated portfolios of all the winning entries (see cats 55–58). Other published photographers whose work can be seen here include Janos Müllner (cats 61, 63) and Revész and Biro (cat. 60).

These competitions and portfolios represent a remarkable and, outside Hungary at least, largely unknown moment in the history of photography. Here was a newspaper deciding that it wanted photographs taken at the front line, and that the best people to provide these were the soldiers themselves. Enough had cameras with them to permit the supply of a very large number of pictures from which selections could be made. Unlike during wars in our own time (and in other countries during the First World War), nobody tried to stop them taking photographs, or censored them. The result is an extraordinary, unrivalled record of war, by turns beautiful and moving.

After 1920, when Admiral Miklós Horthy (cat. 65) was declared Head of State (a position he held until he was deposed in October 1944), photojournalism continued to grow in the illustrated magazines, reporting on the rapid, uncomfortable progression from monarchy to republic (cats 60, 65) to virtual dictatorship. In due course, the depression of the 1930s was to present them with many more grim photo opportunities.

2

The First World War and Its Aftermath

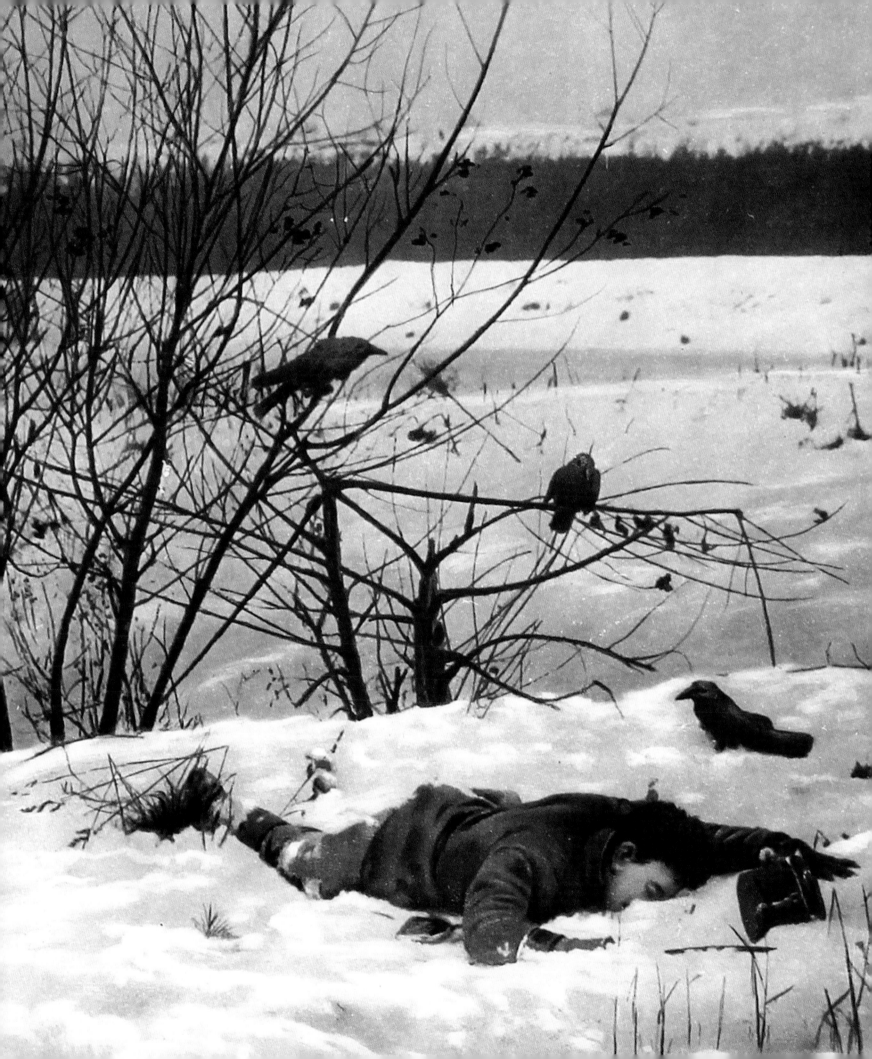

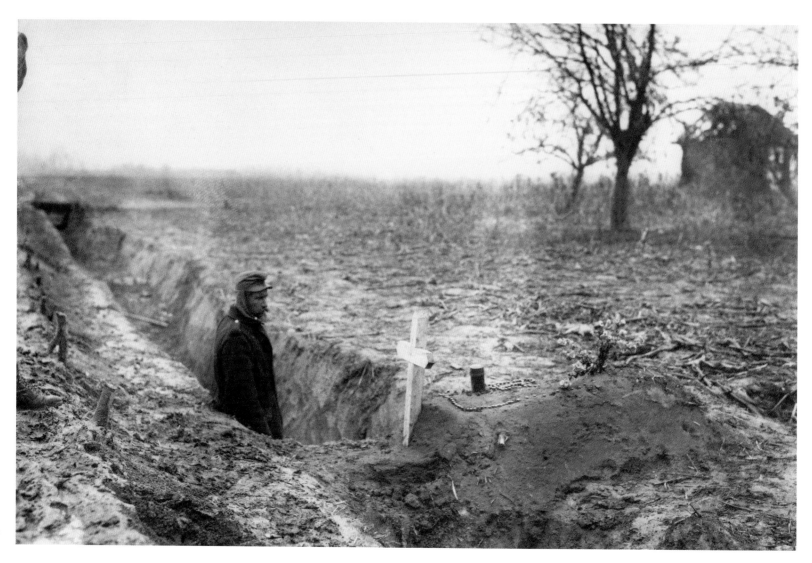

53 | **Rudolf Balogh**
Soldier's Grave
Serbia, 1914
Silver gelatin print, 1989, from original
negative, 19.6 × 29.6 cm

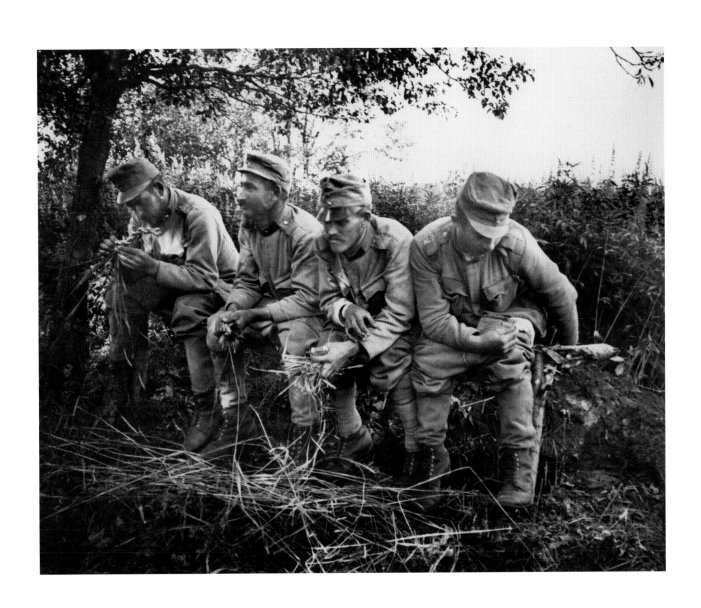

54 | **André Kertész**
Latrine
Poland, 1915
Silver gelatin print, 1967,
20.3 × 25.2 cm

55 | **Gusztàv Aigner**
Bridge Building
No. 5 from portfolio I,
Az Érdekes Ujság, 1915
Photogravure, 28.3 × 35.8 cm

56 | **Camillo Schottner**
*March Through a Russian Village
in Flames*
No. 6 from portfolio IV,
Az Érdekes Ujság, 1916–17
Photogravure, 28.5 × 34.8 cm

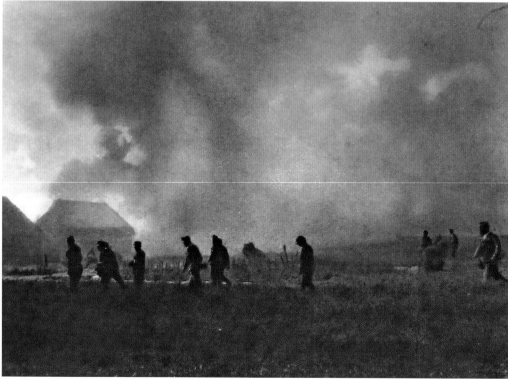

57 | **János Kugler**
The Hero of the Air
No. 1 from portfolio II,
Az Érdekes Ujság, 1915–16
Photogravure, 35.5 × 28.5 cm

58 | **Tibor Schoen**
Ravens
No. 1 from portfolio I,
Az Érdekes Ujság, 1915
Photogravure, 34.6 × 28.3 cm

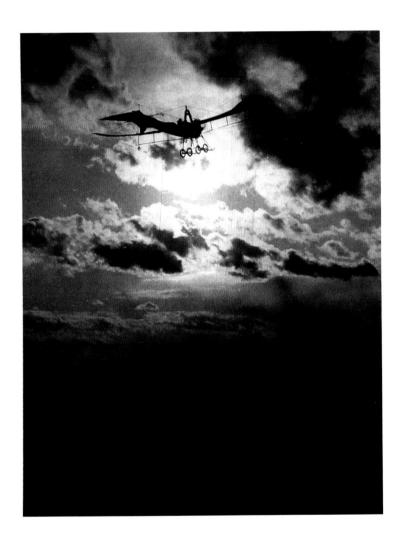

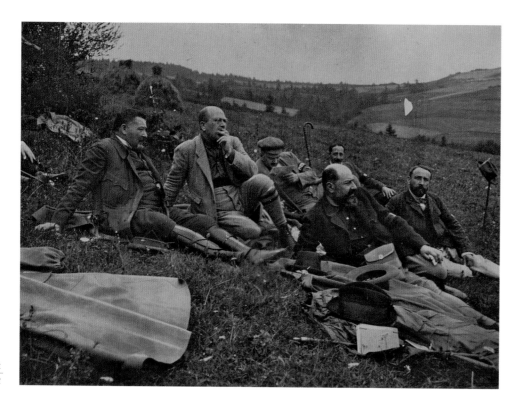

59 | **Gyula Jelfy**
The Reporters of the Pest Papers
1914
Vintage silver gelatin print,
8 × 12 cm

60 | **Révész and Bíró**
*Cameramen and Photographers
at the Proclamation of the
Republic in Front of Parliament*
Budapest, 16 November 1918
Vintage silver gelatin print,
15 × 19.5 cm

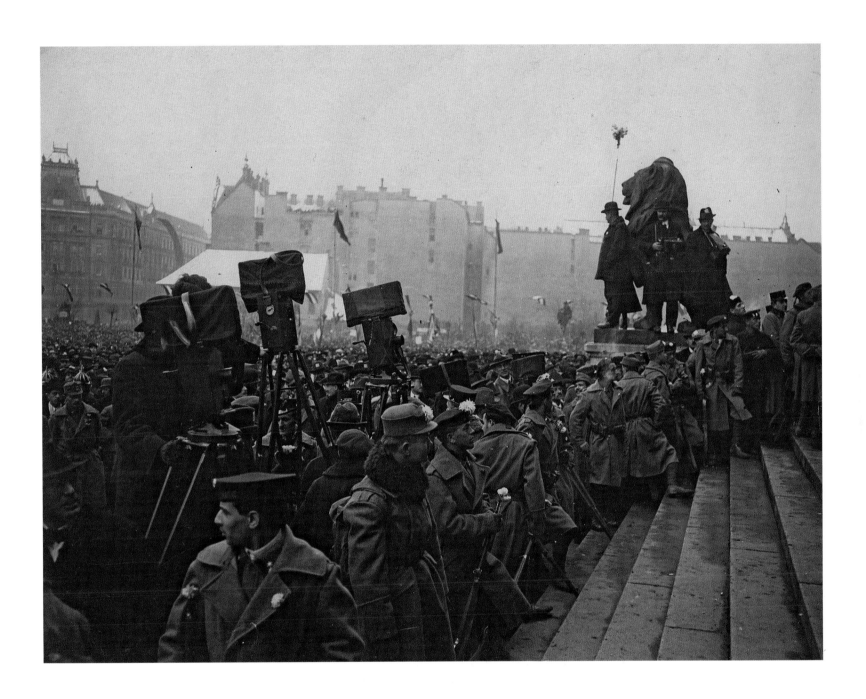

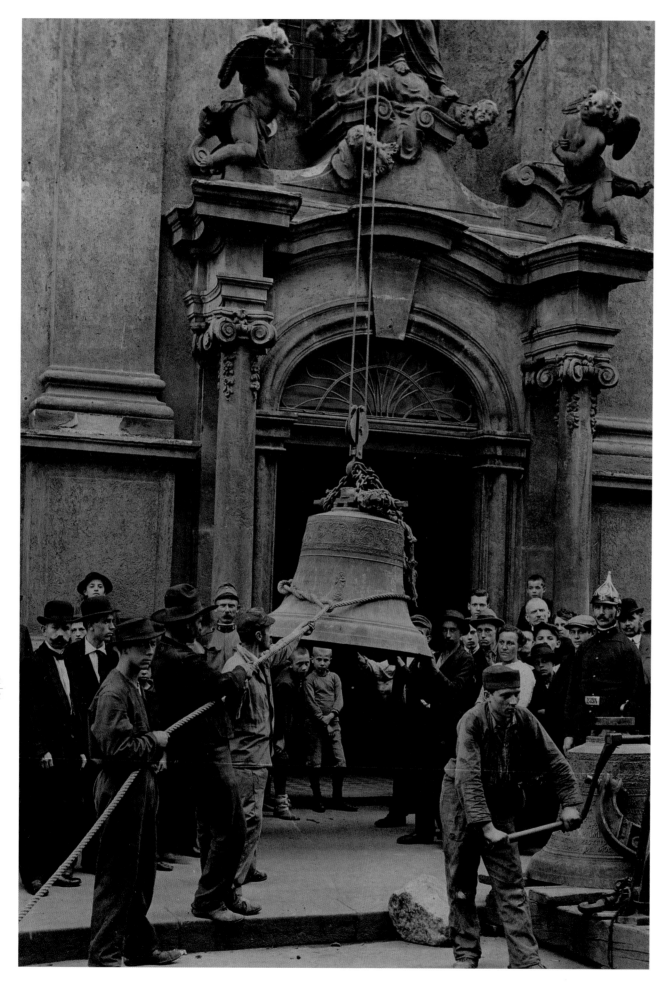

61 | **János Müllner**
Bell Being Dismantled from a Church
1916
Vintage silver gelatin print,
23 × 16.5 cm

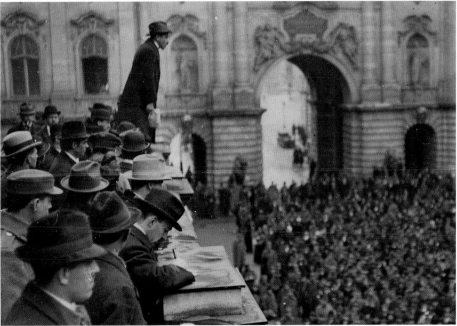

62 | **André Kertész**
Officer Being Stripped of His Badges,
at the Beginning of the Commune
Budapest, 21 March 1919
Silver gelatin print, 1967,
20.3 × 25.3 cm

63 | **János Müllner**
Meeting of the Unemployed
in the Courtyard of the Royal Palace
Budapest, 19 March 1919
Vintage silver gelatin print,
16.5 × 22.9 cm

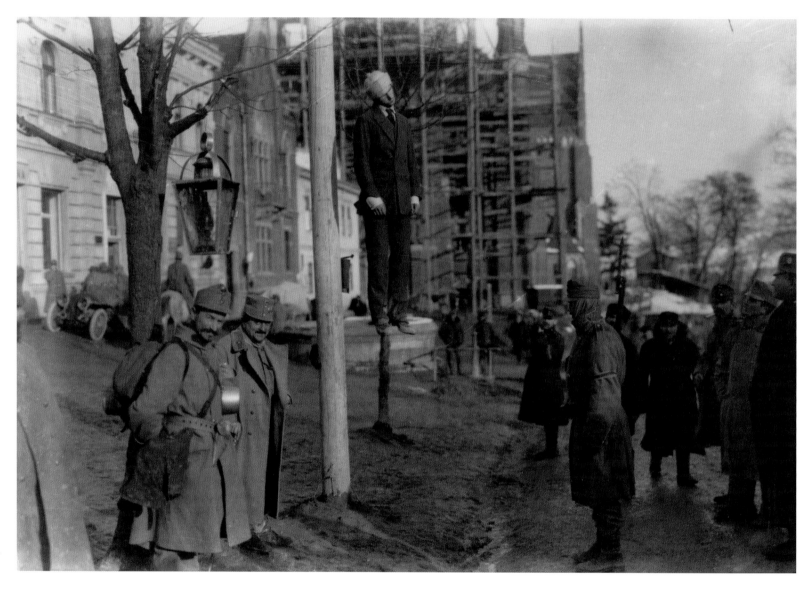

64 | **Rudolf Balogh**
Hanged Civilian
Budapest, 1919
Silver gelatin print, 2000, from original
negative, 18.2 23.7 cm

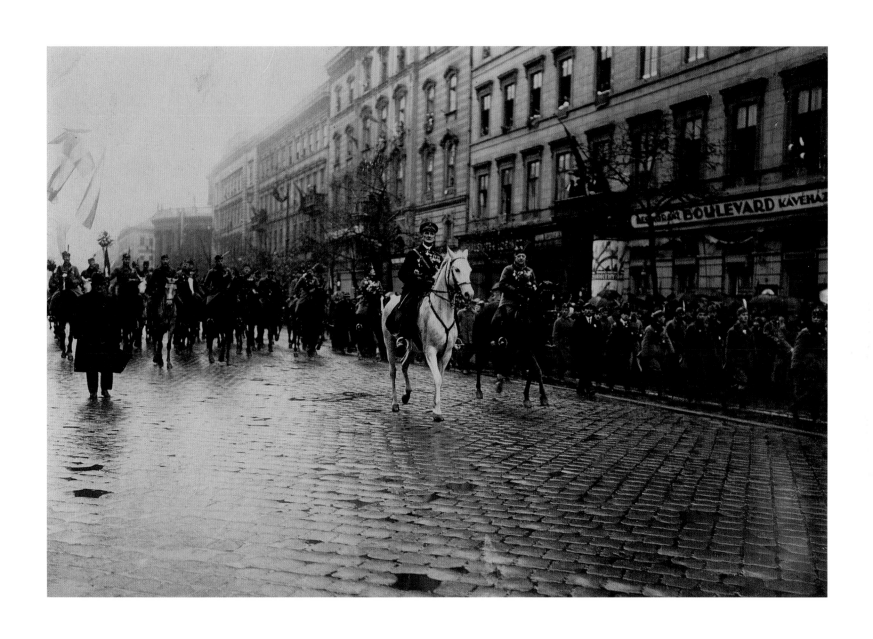

65 | **Unknown photographer**
Miklós Horthy Marches into Budapest
16 November 1919
Vintage silver gelatin print,
11.5 × 16.7 cm

The facts that Hungary lost 72% of its territory and 64% of its population after the First World War, and that its government became increasingly fascist and anti-Semitic in the 1920s, meant that thousands of its inhabitants fled the country in that decade. Many talented Jewish people felt they could only further their careers, or even get a university education, outside their native land. The many photographers who left influenced modern photography in Europe and America.

André Kertész arrived in Paris in 1925 carrying, it is said, little but a camera and a Hungarian peasant's flute in his luggage. His accomplished pictures of street life, with their innate sense of composition (e.g. cat. 93), soon brought him success and, within two years, he had his first one-man exhibition. By 1929 the Budapest newspaper *Pesti Napló* (*Pest Diary*) was writing of him that he was 'the head of the new wave of photography … his numerous nudes and landscapes … have made his name known and admired by the readers of the most prestigious reviews of Europe and America'. He got to know Lucien Vogel, editor of *Vu*, who published many of his photographs, the first in the fifth issue of the magazine. When Vogel organised a photography salon (the 'Salon d'Escalier') in 1928, he included more photographs by Kertész than by anyone else.

Brassaï had arrived in Paris the year before Kertész, and it was

Kertész who introduced him to the idea of becoming a photographer. Brassaï's book *Paris de Nuit* (fig. 3) made his name, and he stayed in the city for the rest of his life. Henry Miller, who called Brassaï 'the eye of Paris', based the photographer in his novel *Tropic of Cancer* (1934) on him. Both Brassaï and Kertész took some of the most revealing portraits of the city's great artists (cats 95–98), as well as taking accomplished photographs of the city by night and day (cats 85–88).

Capa travelled to Berlin via Vienna (where a number of Hungarian photographers were already established, among them Lucien Aigner, Paul Almasy, Kati Horna and Lucien Hervé), Brno, Prague and Dresden. Such famous Hungarian film-makers as Michael Curtiz, Alexander Korda, Peter Lorre and Béla Lugosi, among others, were also in Vienna. Capa then moved on to Berlin and Paris. In Paris, he was commissioned by Vogel to photograph the Spanish Civil War for *Vu*. Capa's sympathies were fiercely Republican. His famous 1936 photograph *Death of a Loyalist Militiaman* (cat. 108) made him one of the most famous photographers in the world. When *Picture Post* published his Spanish pictures, the accompanying text said of Capa: 'He is a passionate democrat, and he lives to take photographs.' Capa's brother Cornell took a number of photographs in or near London (cats 112, 114) before moving to America.

Moholy-Nagy also went to Vienna, in 1919, before going to

Berlin a year later. He became an important designer and teacher at the Bauhaus in Weimar, where he and his first wife Lucia made many experiments in photography, with and without a camera (cats 70–72). But he soon saw the growing power of fascism, and moved to Paris and then to London. György Kepes (cat. 75), who had left Budapest to work alongside him in 1930, followed him there, as did Ferenc Berkó (cat. 106), who had left Hungary after his mother died when he was only two years old. Despite being commissioned to take photographs for three books (figs 15–17), Moholy-Nagy did not feel accepted in England, and moved to America before the war started, to become Director of the New Bauhaus in Chicago. Berkó and Kepes both joined the staff there and continued to take photographs, but Moholy-Nagy's duties left him little time for photography. After the New Bauhaus closed for lack of financial support, he opened the School of Design in 1939 (this became the Institute of Design in 1944). He died of leukaemia shortly after the end of the war.

If not the greatest artist then certainly the most accomplished of the émigré photojournalists, Munkácsi took the skills he had honed in Budapest for eighteen years to Berlin and then on to New York. In both cities he found himself at the top of a profession he had practically invented. His experience as a sports photographer and his mastery of the camera's capacity to

capture dynamic movement (cat. 78) allowed him to produce innovative fashion shots for *Harper's Bazaar* (fig. 19). Also in New York, Kertész was working for *House and Garden*, but he continued to take the kind of pictures privately that had made him successful in Paris (cats 116, 125–29). Cecil Beaton summed it up perfectly: 'Kertész was always awaiting the unfamiliar and, using different angles, presented odd compositions … which combine tenderness with amusement.'

3

Moving Away: Paris, Berlin, London, New York

66 | **László Moholy-Nagy**
Oskar Schlemmer's Children
Ascona, *c.* 1926
Vintage silver gelatin print,
38.3 × 30 cm

67 | **László Moholy-Nagy**
*Lucia Among the Trees of the Masters'
Houses in Dessau*
1925
Silver gelatin print, 1995, from original
negative, 33 × 22.5 cm

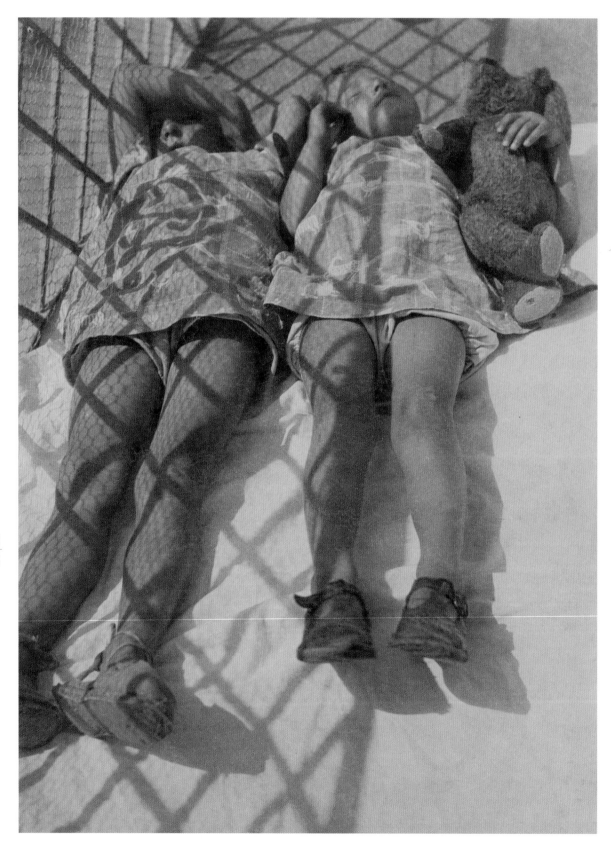

68 | **László Moholy-Nagy**
Construction
1922
Vintage silver gelatin print,
29.8 × 38.6 cm

69 | **László Moholy-Nagy**
Berlin Radio Tower
1928
Silver gelatin print, 1973, from original
negative, 26 × 20.4 cm

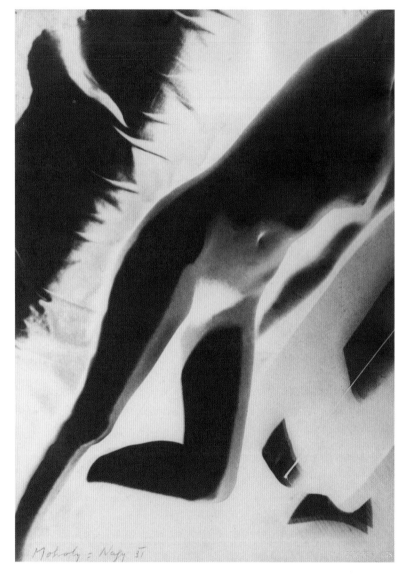

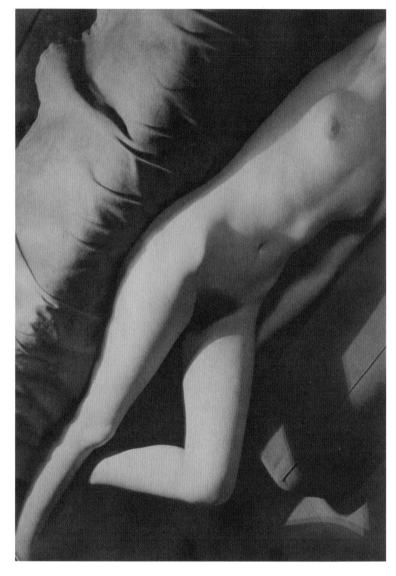

70 | **László Moholy-Nagy**
Negative Nude
Germany, 1931
Silver gelatin print, 1995, from original
negative, 40.4 29 cm

71 | **László Moholy-Nagy**
Positive Nude
Germany, 1931
Silver gelatin print, 1995, from original
negative, 40.4 × 29 cm

72 | **László Moholy-Nagy**
Photogram
Germany, 1925
Silver gelatin print, 1995, from original
negative, 35.5 × 28.5 cm

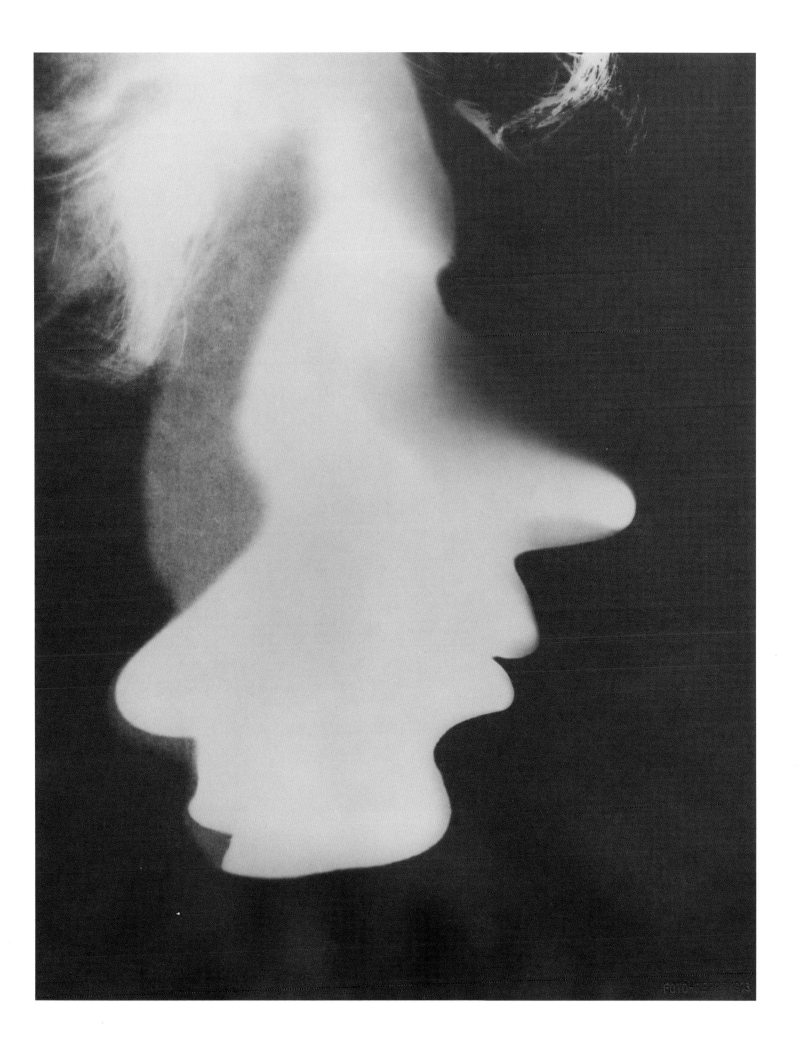

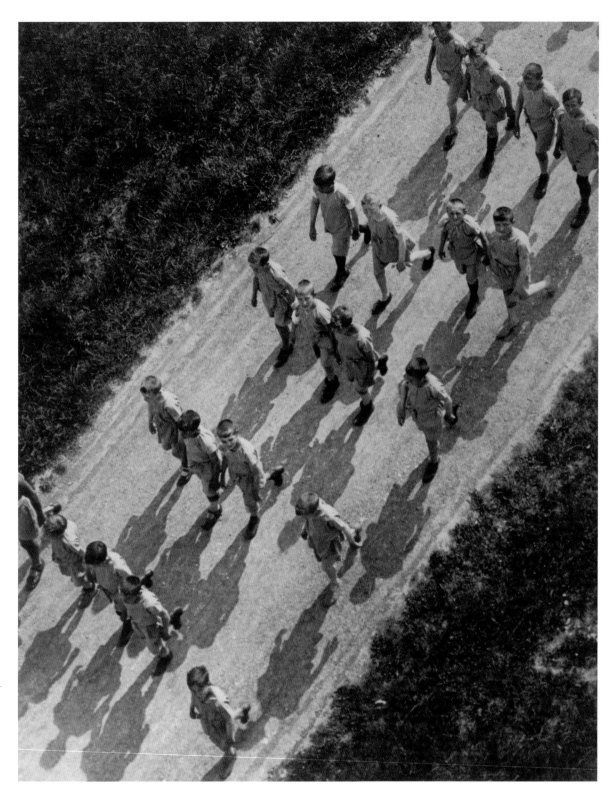

73 | **Martin Munkácsi**
Boys Marching
Germany, c. 1930
Silver gelatin print, 1994, from original
negative, 35.5 × 27.7 cm

| **Martin Munkácsi**
Joke for Breakfast
Berlin, 1933
Silver gelatin print, 1994, from original
negative, 35.5 × 27.7 cm

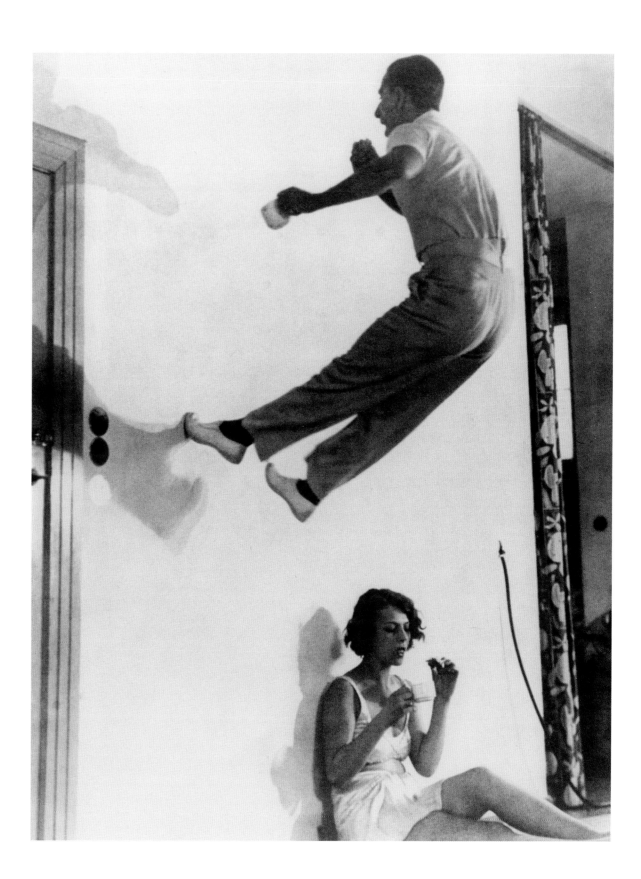

75 | **György Kepes**
Juliet Shadow Cage (Vision II)
1939
Silver gelatin print, 1987,
25.7 × 20 cm

76 | **László Moholy-Nagy**
Lucia on the Beach
Germany, *c.* 1920
Silver gelatin print, 1995, from original
negative, 35.5 × 28.5 cm

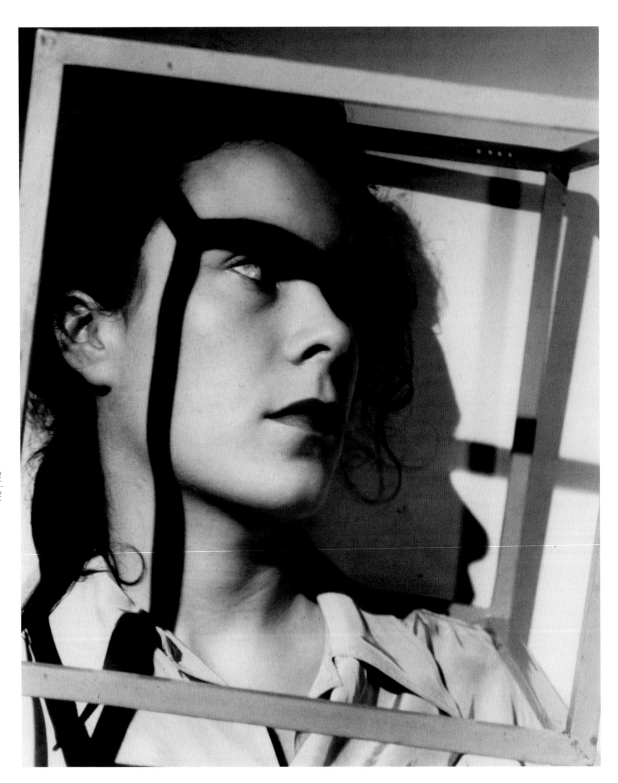

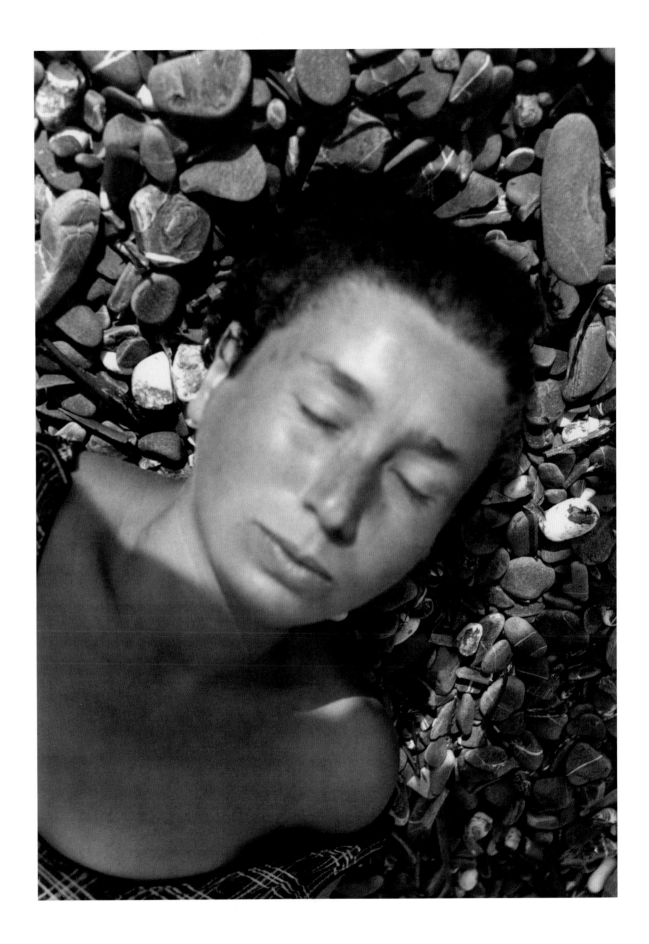

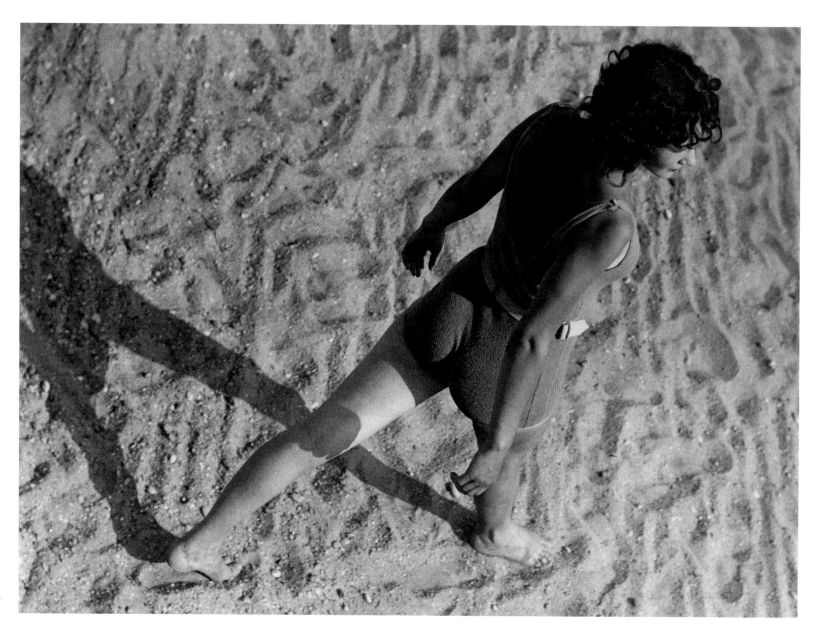

77 | **Martin Munkácsi**
Beach!
c. 1930
Silver gelatin print, 1994, from original
negative, 27.7 × 35.5 cm

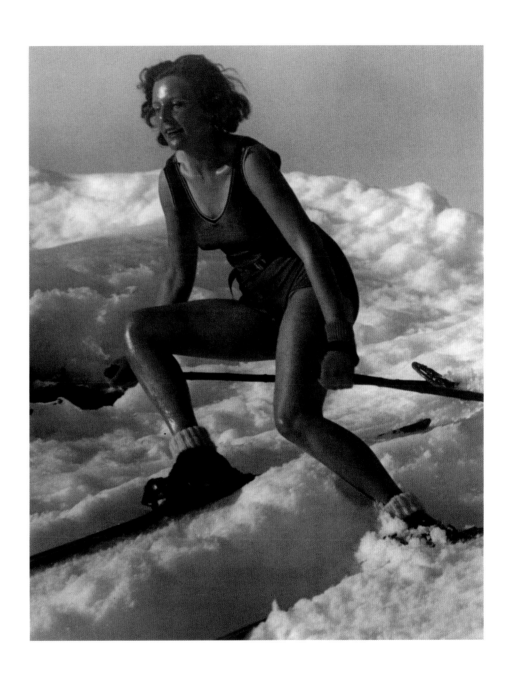

78 | **Martin Munkácsi**
Leni Riefenstahl
Germany, 1931
Silver gelatin print, 1994, from original
negative, 35.5 × 28.5 cm

79 | **László Moholy-Nagy**
Paris
1925
Silver gelatin print, 1995, from original
negative, 35.5 × 27.5 cm

80 | **László Moholy-Nagy**
Port Transbordeur
France, c. 1925
Silver gelatin print, 1995, from original
negative, 33 × 22.5 cm

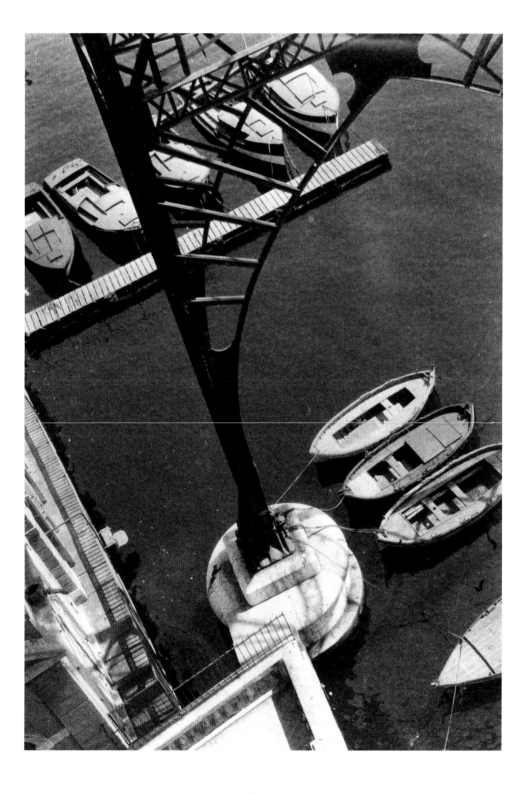

81 | **Brassaï**
Barge
Paris, 1935
Vintage silver gelatin print,
23.6 × 17.7 cm

82 | **László Moholy-Nagy**
Boat, Negative
c. 1925
Silver gelatin print, 1995, from original
negative, 38.7 × 29 cm

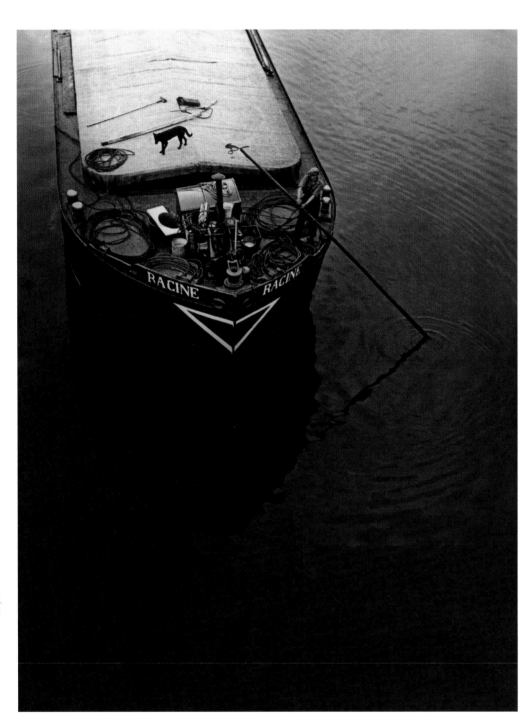

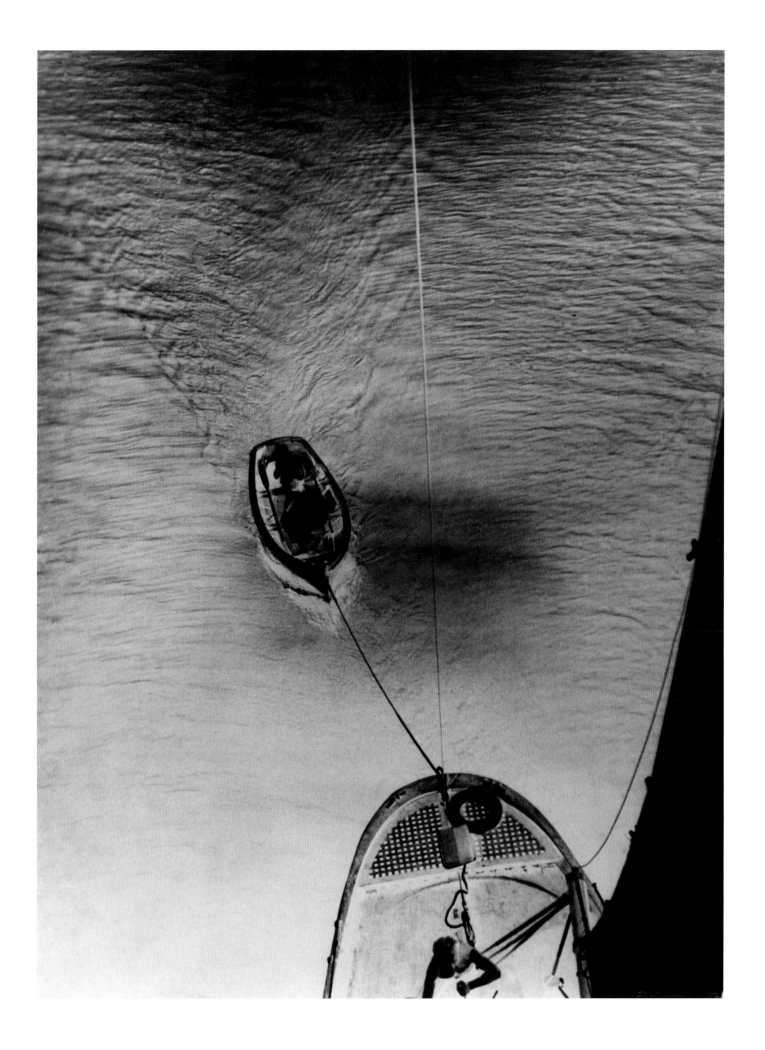

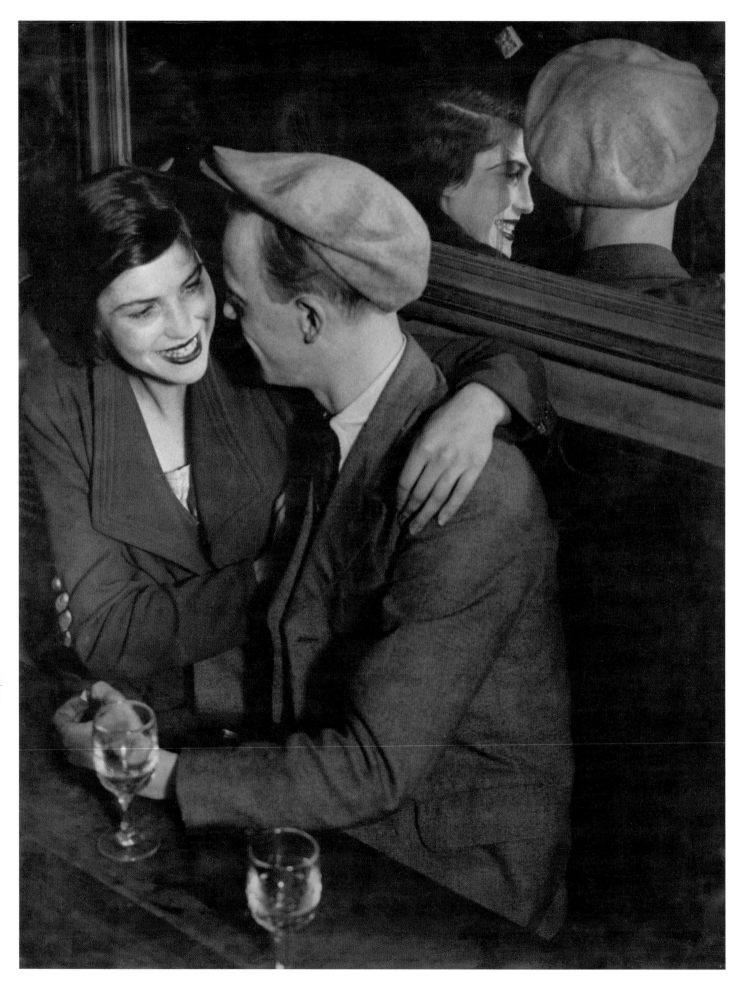

83 | **Brassaï**
Parisian Couple at the Quatre Saisons
Dance Hall (Rue de Lappe)
1932
Vintage silver gelatin print,
29.5 × 23 cm

84 | **André Kertész**
Hôtel des Clochards
Paris, 1927
Silver gelatin print, 1967,
25.3 × 20.4 cm

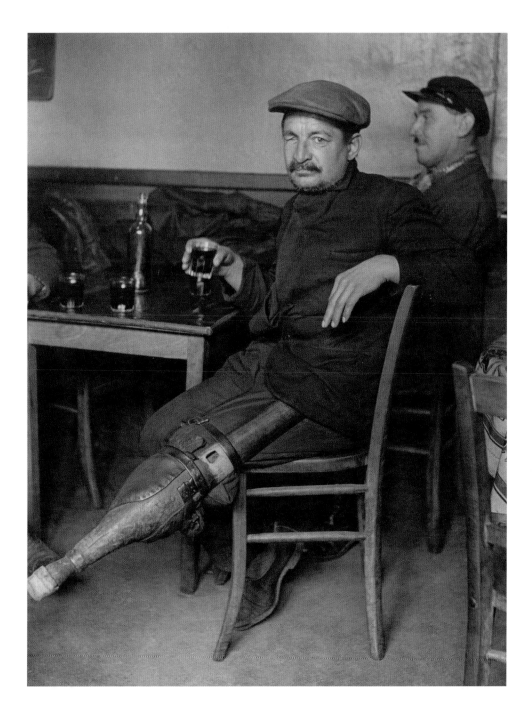

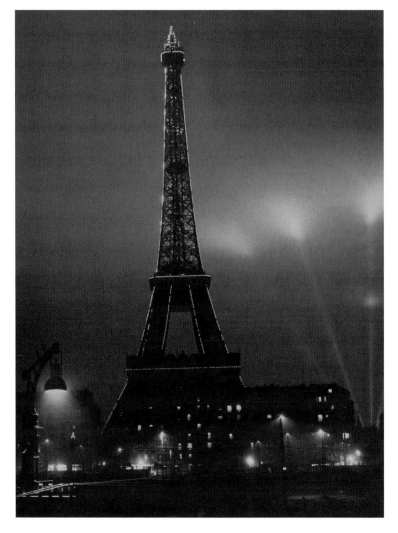

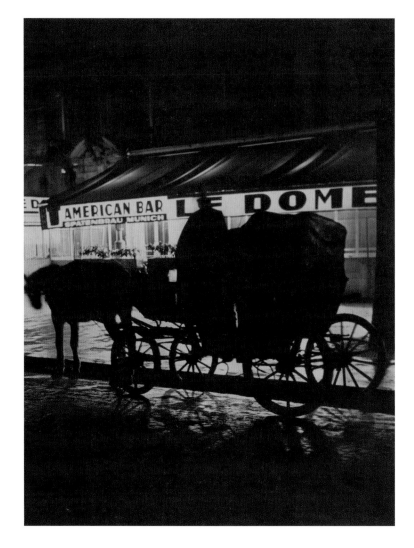

85 | **Brassaï**
Eiffel Tower
Paris, 1930s
Silver gelatin print, 1949,
25.5 × 19.7 cm

86 | **Brassaï**
Fiacre, Montparnasse
Paris, 1930s
Silver gelatin print, 1949,
23.7 × 17.8 cm

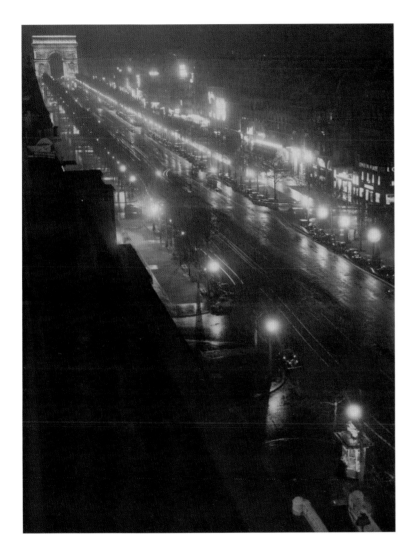

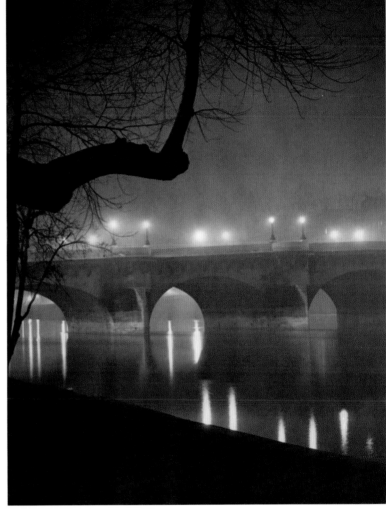

87 | **Brassaï**
Champs-Elysées
Paris, 1930s
Silver gelatin print, 1949,
23.8 × 17.8 cm

88 | **Brassaï**
Bank of the Seine
Paris, 1931
Vintage silver gelatin print,
28.5 × 22 cm

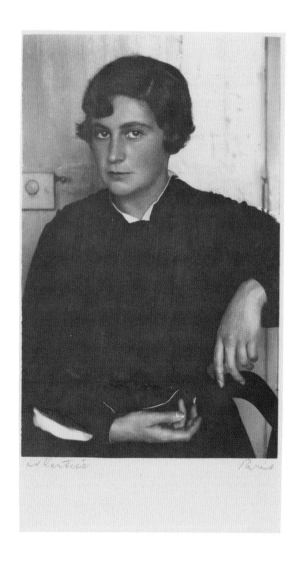

89 **André Kertész**
Portrait of a Young Woman
Paris, 1926
Vintage silver gelatin print
(carte postale), 15.5 × 7 cm

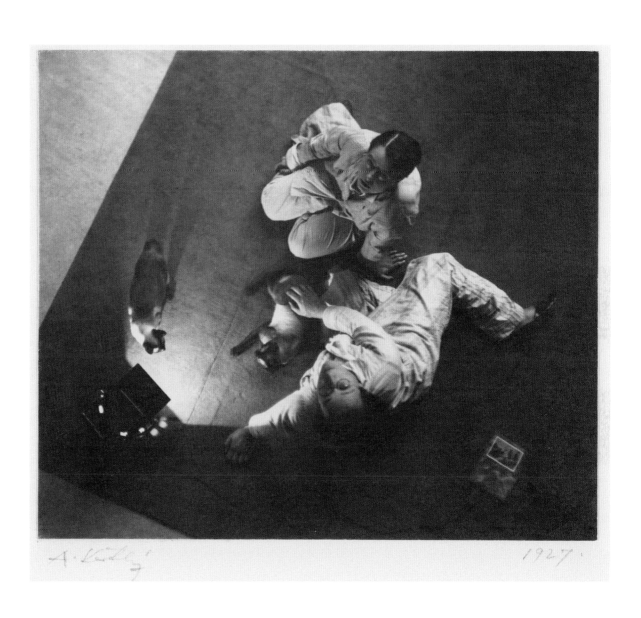

90 | **André Kertész**
Mr and Mrs Rosskam
Paris, 1927
Vintage silver gelatin print,
16.3 × 19.2 cm

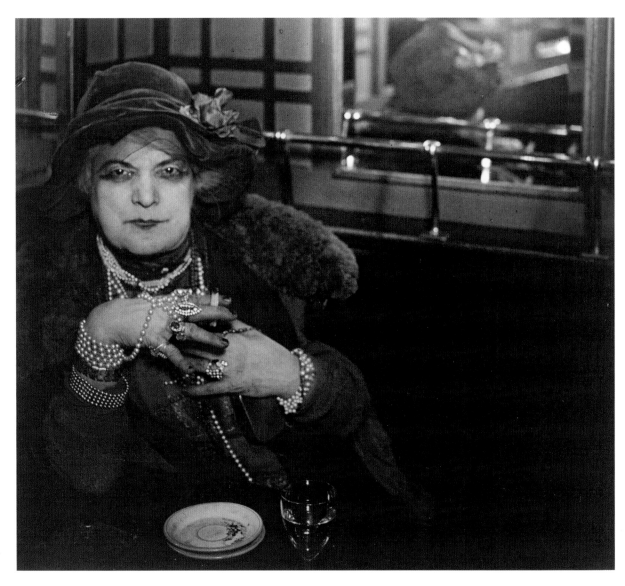

91 | **Brassaï**
Bijou of Montparnasse
Paris, 1932
Silver gelatin print, 1973,
23.5 × 25.5 cm

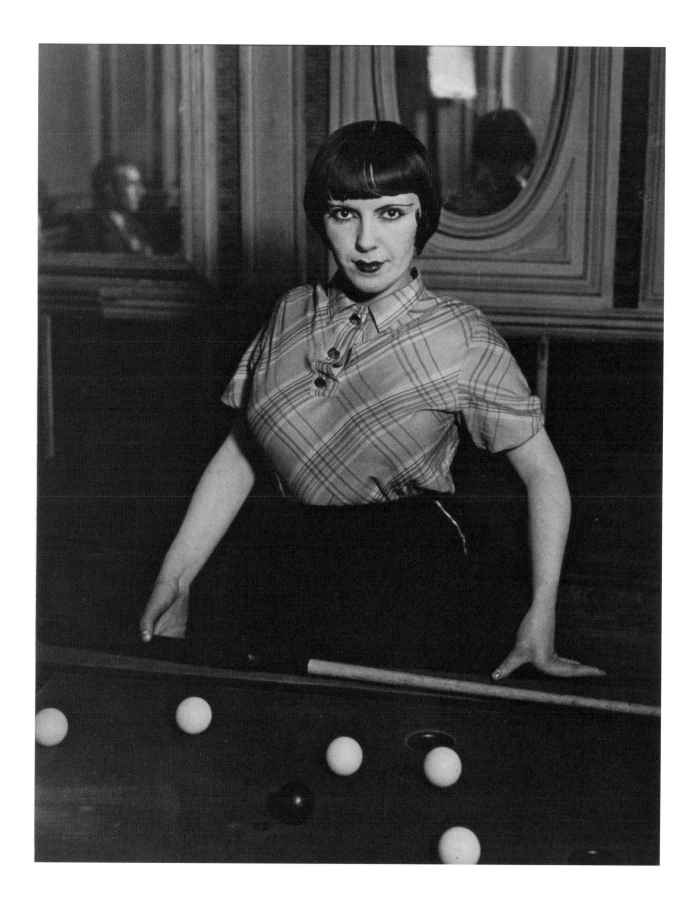

93 | **André Kertész**
Meudon
Paris, 1928
Silver gelatin print, 1967,
25.3 × 20.4 cm

94 | **Brassaï**
Suburban Apartment House
Paris, 1930s
Silver gelatin print, 1949,
29.5 × 23.2 cm

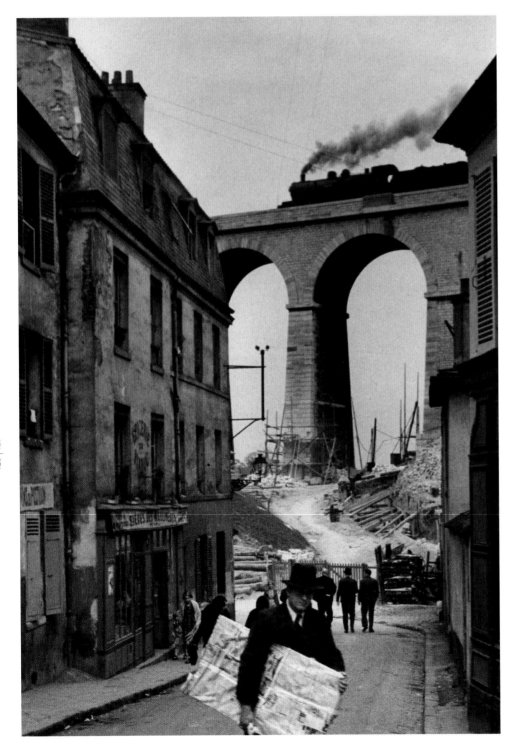

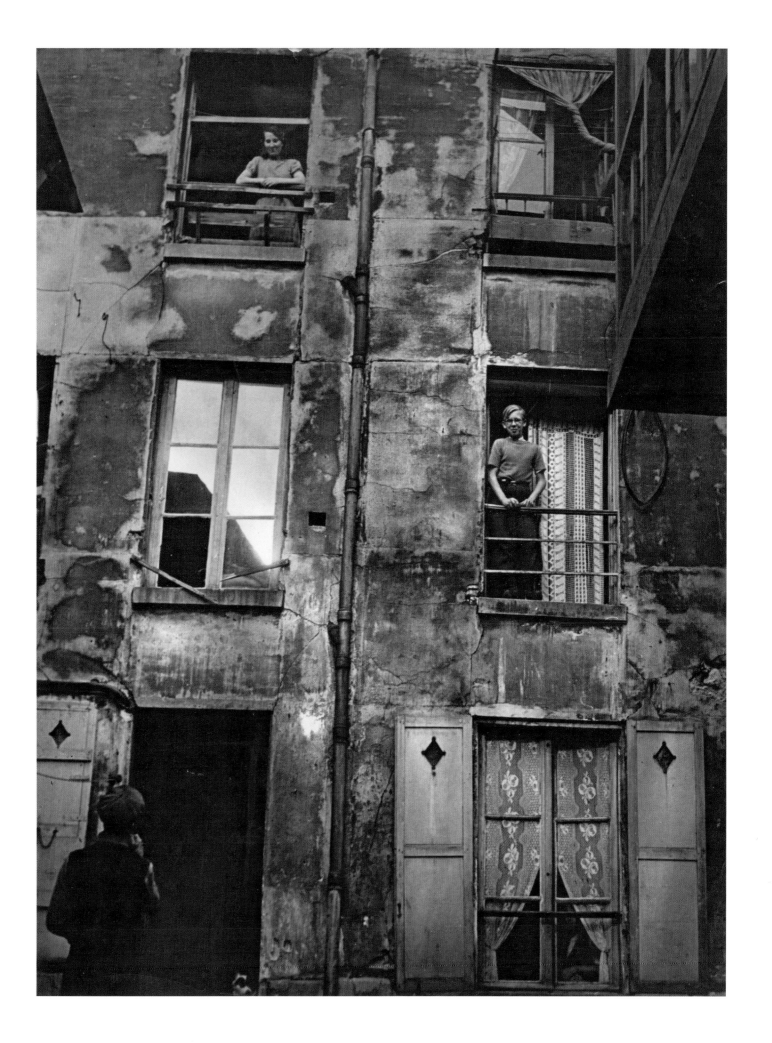

95 | **Brassaï**
In Picasso's Studio, Rue des Grands Augustins
Paris, 1939
Vintage silver gelatin print,
30 × 23 cm

96 | **André Kertész**
Chez Mondrian
Paris, 1926
Silver gelatin print, 1967,
25.3 × 20.3 cm

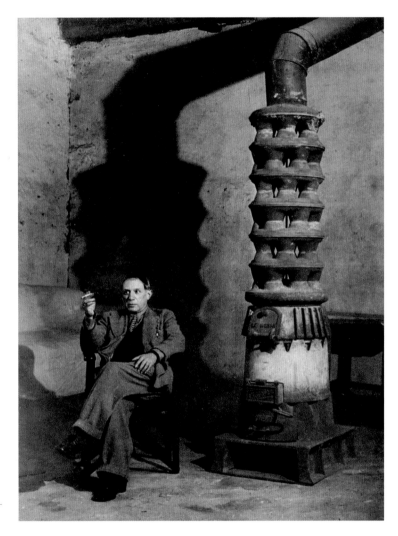

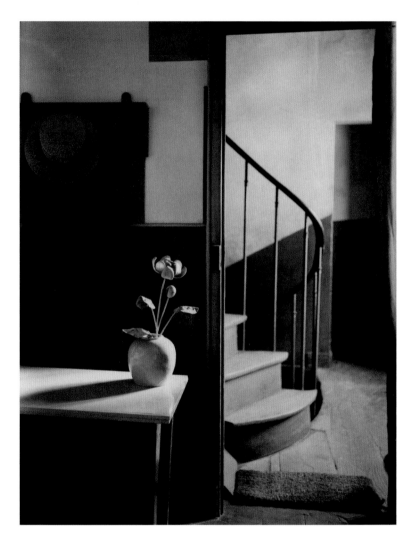

97 | **Brassaï**
Matisse with His Model
Paris, 1939
Silver gelatin print, 1973,
23.5 × 27.5 cm

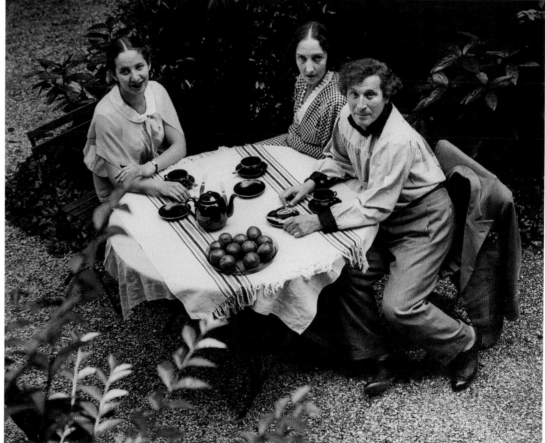

98 | **André Kertész**
Chagall and Family
Paris, 1933
Silver gelatin print, 1967,
20.3 × 25.3 cm

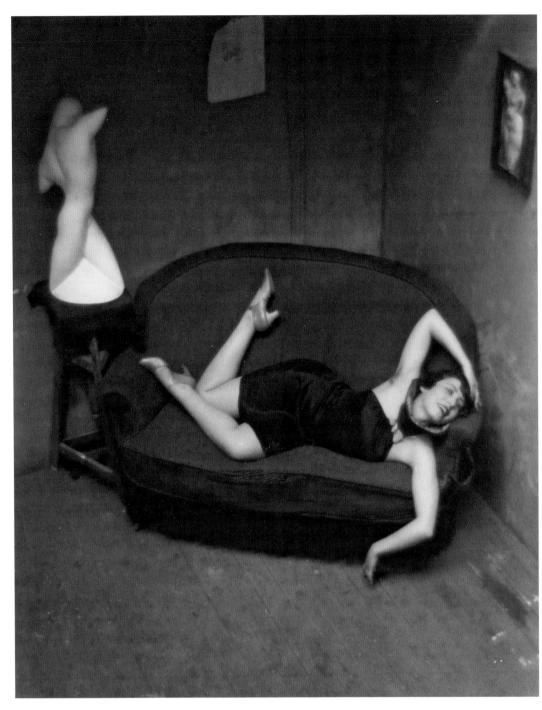

99 | **André Kertész**
Satiric Dancer
Paris, 1926
Silver gelatin print, 1967,
25.2 × 20.3 cm

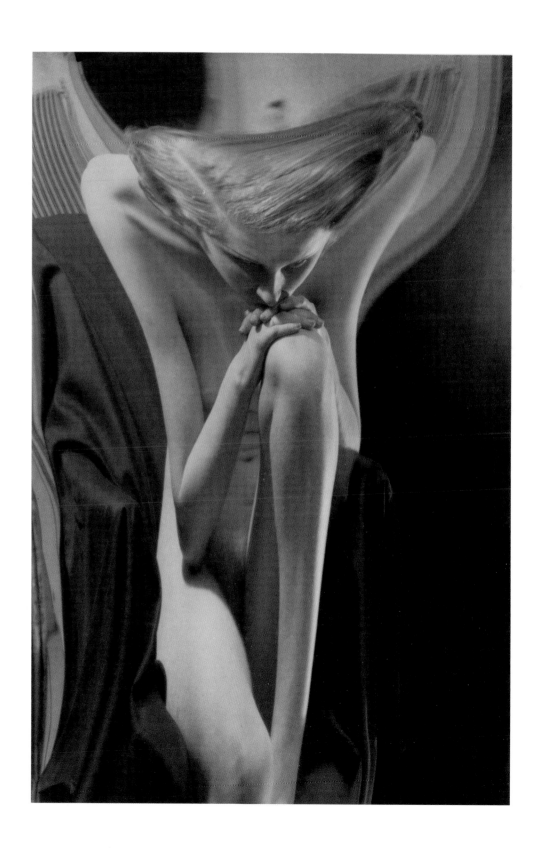

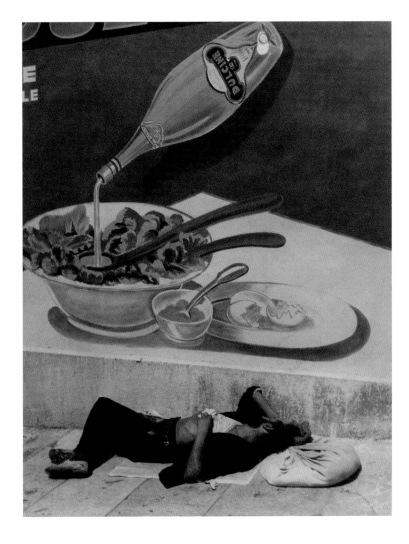

101 | **Kati Horna**
Stairway to the Cathedral
Spain, 1937
Photomontage,
25.4 × 20.3 cm

102 | **Brassaï**
Tramp
Marseilles, 1930s
Vintage silver gelatin print,
30 × 23 cm

103 | **Brassaï**
Meadows in the Isère Valley
Date unknown
Silver gelatin print, *c.* 1980,
29.5 × 23 cm

104 | **Brassaï**
Festivities in Bayonne
c. 1936
Vintage silver gelatin print,
29 × 23 cm

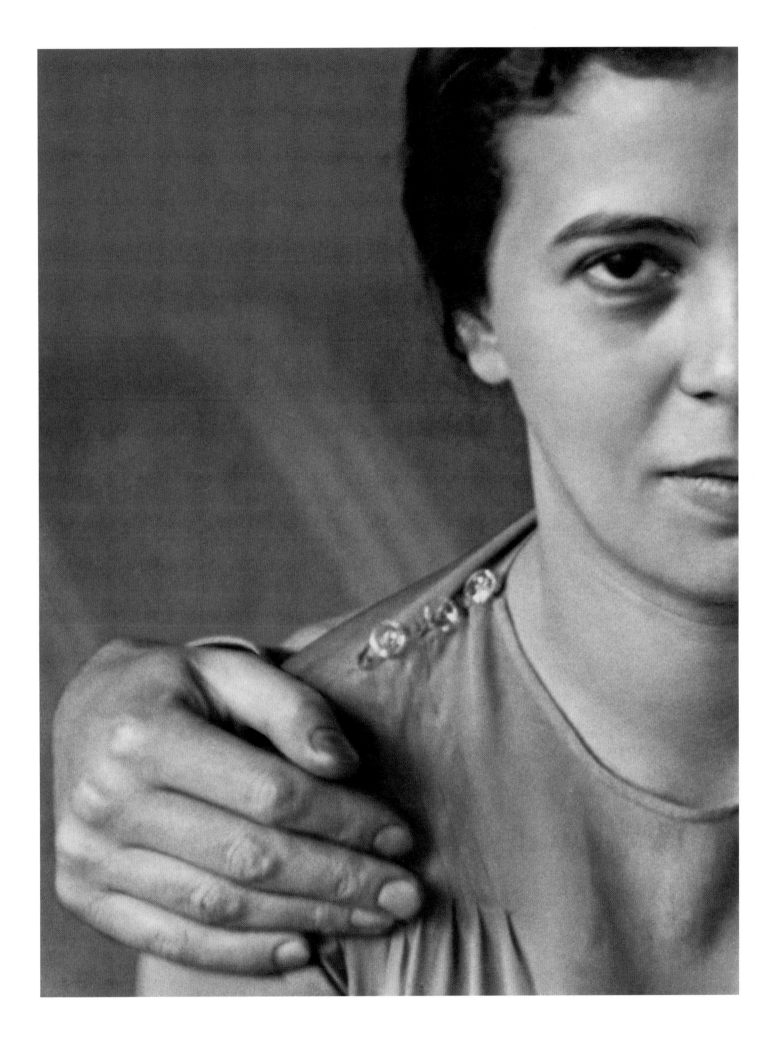

106 | **Ferenc Berkó**
Trouville: Beach Scene
1937
Silver gelatin print, 2000,
35.2 × 27.7 cm

107 | **Martin Munkácsi**
Four Boys at Lake Tanganyika
c. 1930
Silver gelatin print, 1994, from original
negative, 35.5 × 27.5 cm

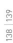

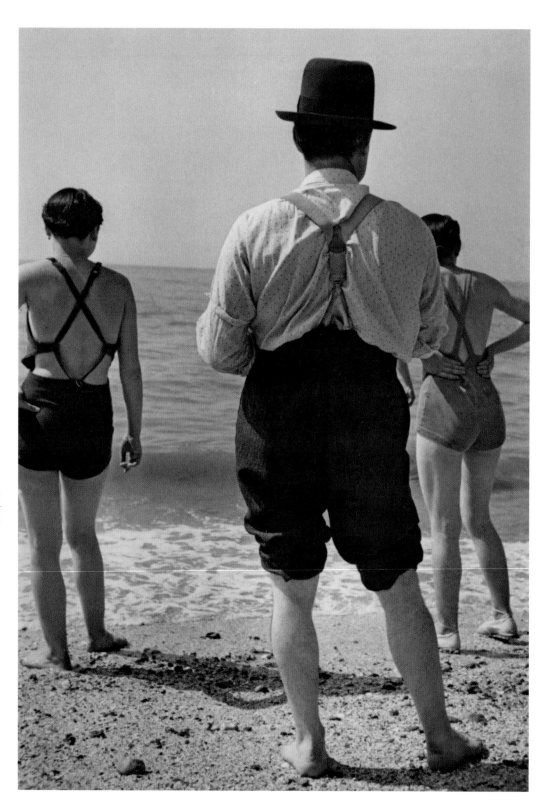

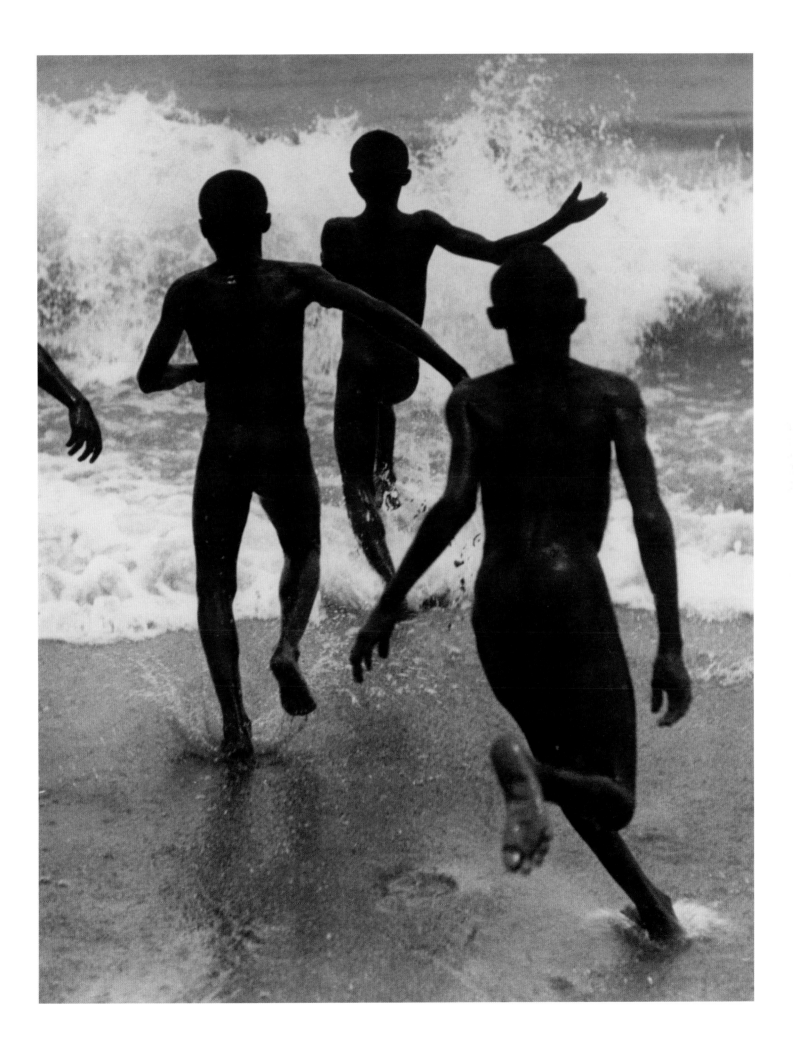

108 | **Robert Capa**
Death of a Loyalist Militiaman
Cerro Muriano, Cordoba, 1936
Silver gelatin print, 1970, from
original negative, 28 × 36 cm

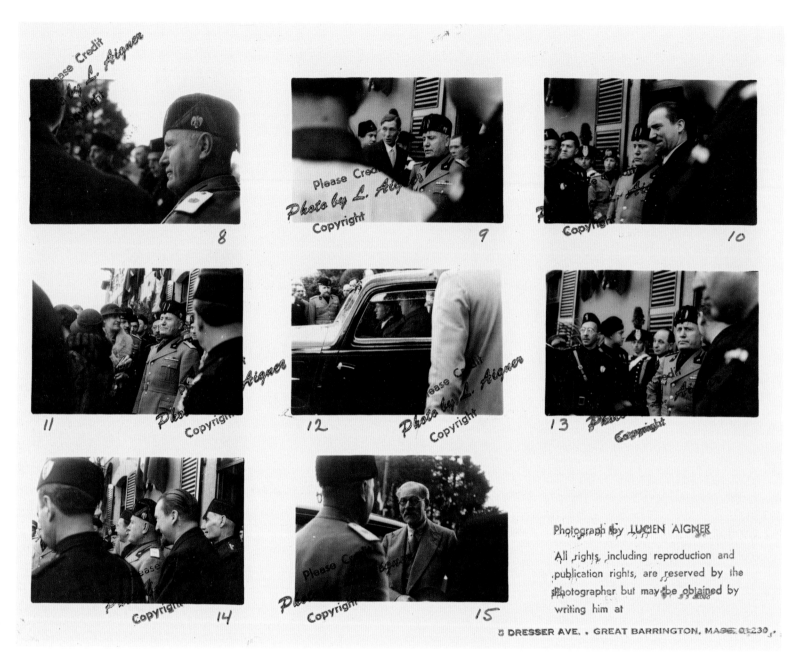

Photograph by LUCIEN AIGNER

All rights, including reproduction and publication rights, are reserved by the Photographer but may be obtained by writing him at

5 DRESSER AVE. · GREAT BARRINGTON. MASS. 01230.

109 | **Lucien Aigner**
Contact sheet, nos 8–15: *Mussolini at Stresa*
1935
Silver gelatin print, 1970s
20.7 × 25.4 cm

110 | **Lucien Aigner**
Mussolini at Stresa
1935
Silver gelatin print, 1970s,
35.7 × 27.8 cm

111 | **László Moholy-Nagy**
Sackville Street, London
1936
Silver gelatin print, 1995, from original
negative, 35.227.8 cm

112 | **Cornell Capa**
Winchester College
1951
Silver gelatin print, 1970,
40.5 × 50.5 cm

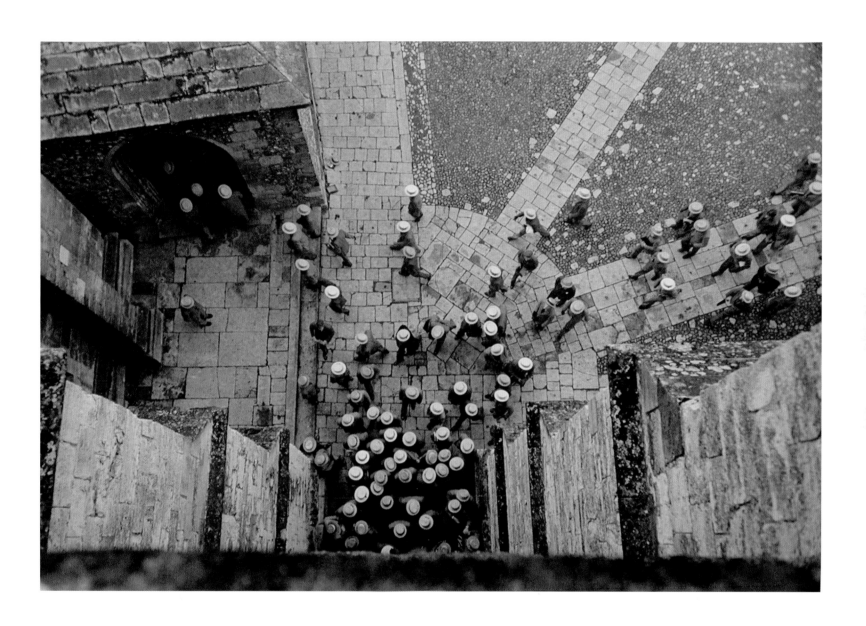

113 | **László Moholy-Nagy**
Eton, Playing Fields
1936
Silver gelatin print, 1973, from original
negative, 21 × 26.7 cm

114 | **Cornell Capa**
Hyde Park
London, 1951
Vintage silver gelatin print,
34.9 × 24.8 cm

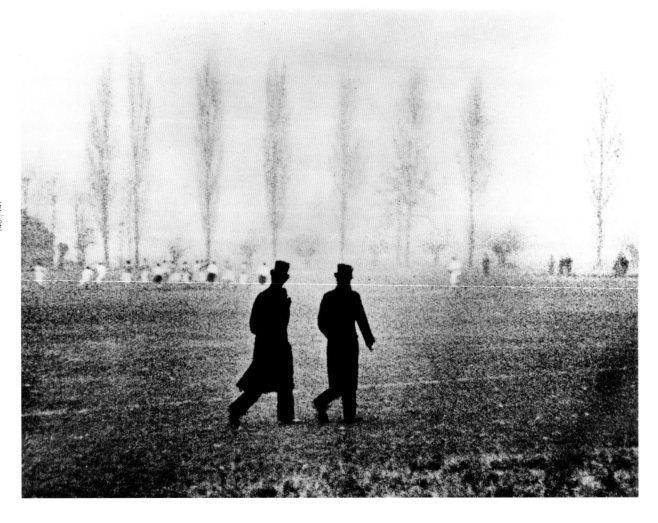

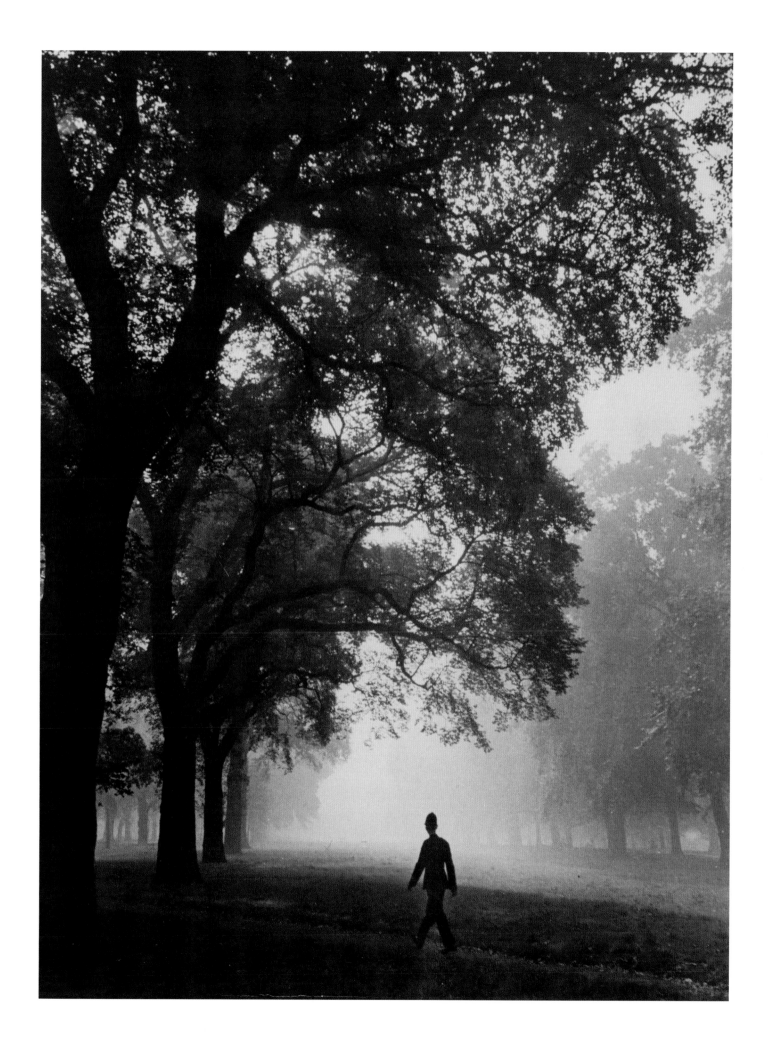

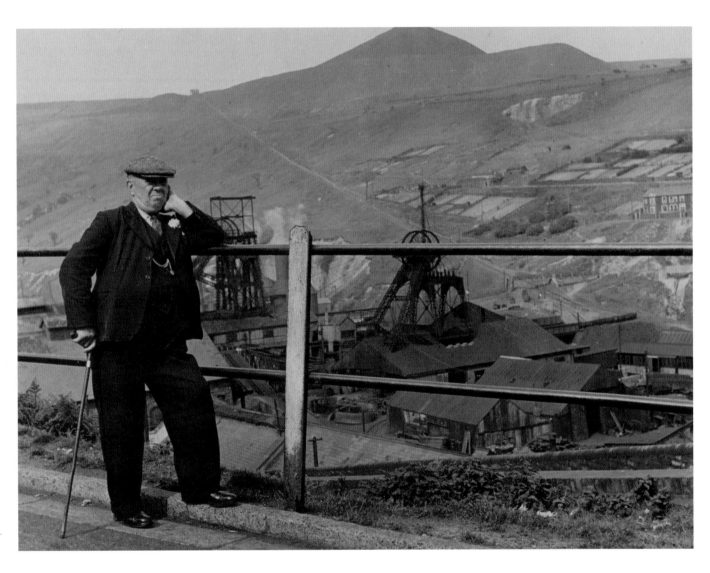

115.1 | **Robert Capa**
Pit Heads and Heaps
Glamorgan, 18 July 1942
Vintage silver gelatin print,
20.1 23.2 cm

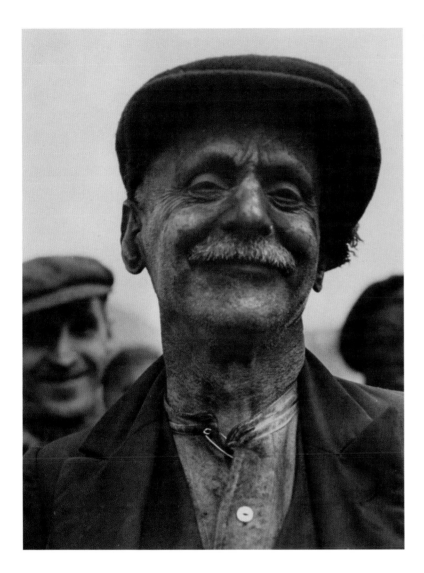

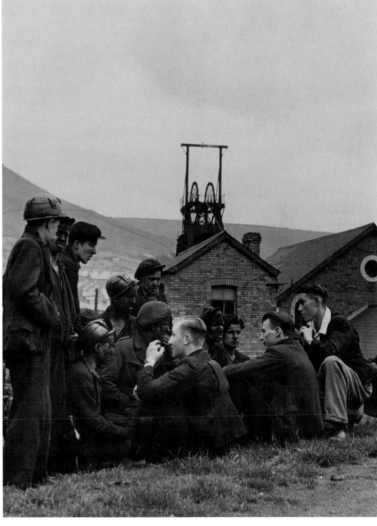

115.2 | **Robert Capa**
Nearly Completed Thirty Years Underground
Glamorgan, 18 July 1942
Vintage silver gelatin print,
22 × 20.4 cm

115.3 | **Robert Capa**
Let's Bring That Up at the Meeting Tonight
Glamorgan, 18 July 1942
Vintage silver gelatin print,
21 × 20.3 cm

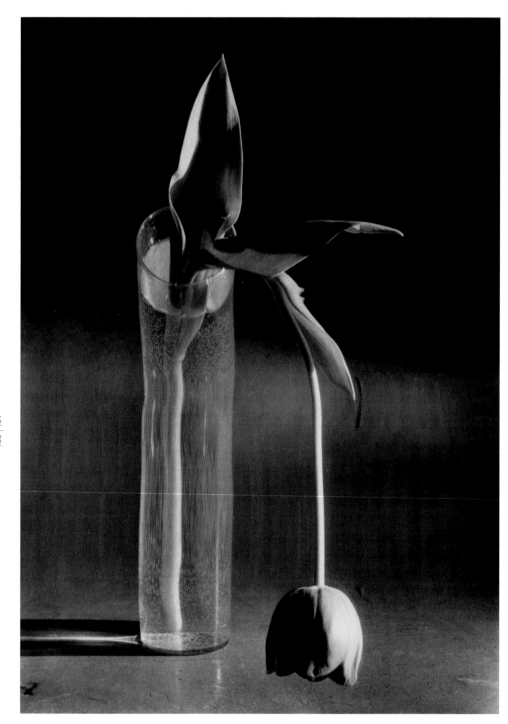

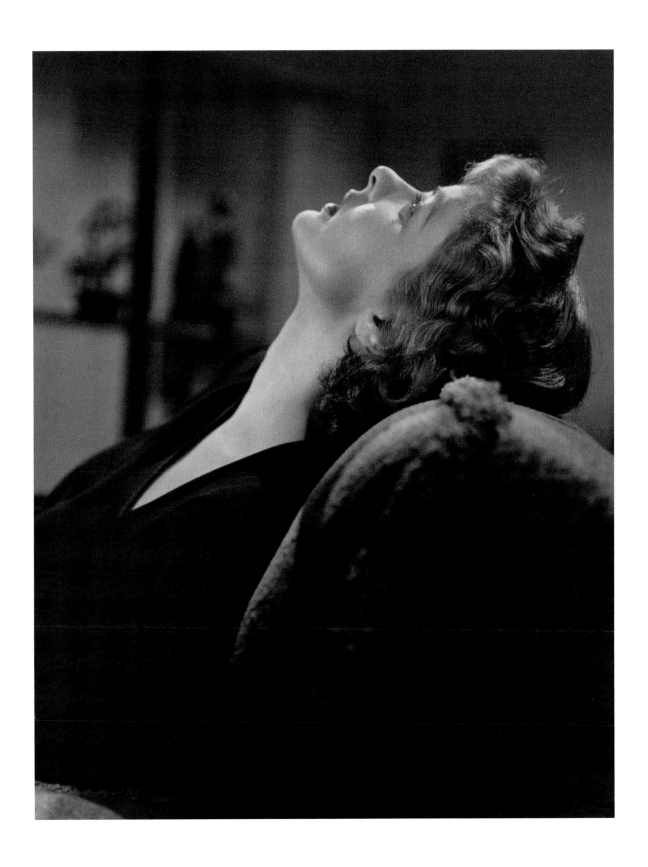

117 | **Robert Capa**
Ingrid Bergman During the Filming
of 'Arch of Triumph'
Hollywood, 1946
Silver gelatin print, 1970, from original
negative, 36 × 28 cm

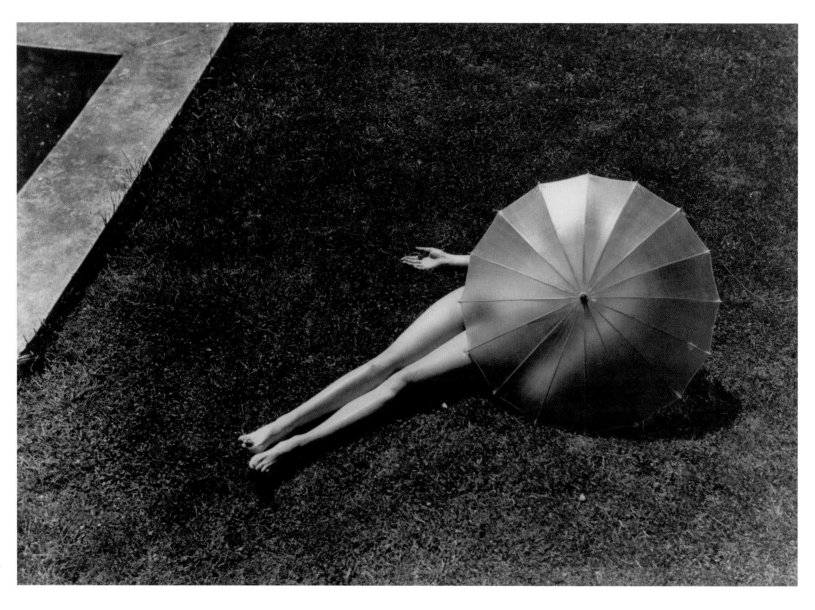

118 | **Martin Munkácsi**
Nude
America, 1935
Silver gelatin print, 1994, from original
negative, 27.7 × 35.5 cm

119 | **Martin Munkácsi**
The First Fashion Photo for Harper's Bazaar
(Lucile Brokaw)
America, 1933
Silver gelatin print, 1994, from original
negative, 35.5 × 27.5 cm

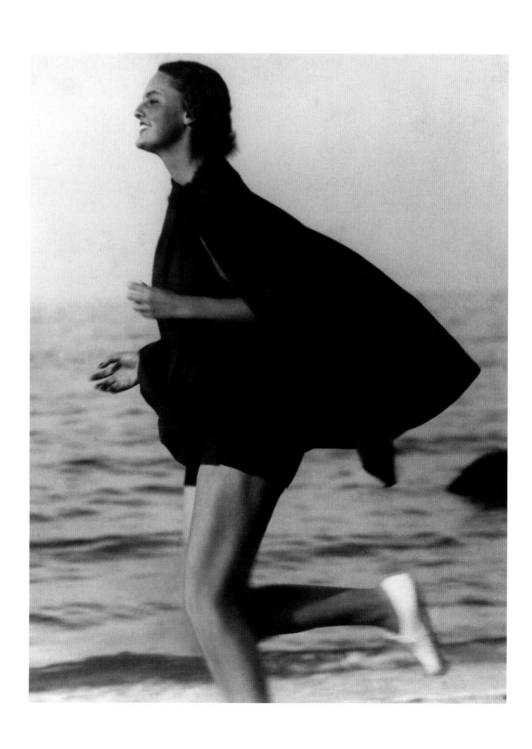

120 | **Martin Munkácsi**
Swimsuit
America, 1935
Silver gelatin print, 1994, from original
negative, 28.5 × 35.5 cm

121 | **Martin Munkácsi**
Nude in Straw Hat
America, 1944
Silver gelatin print, 1994, from original
negative, 35.5 × 27.5 cm

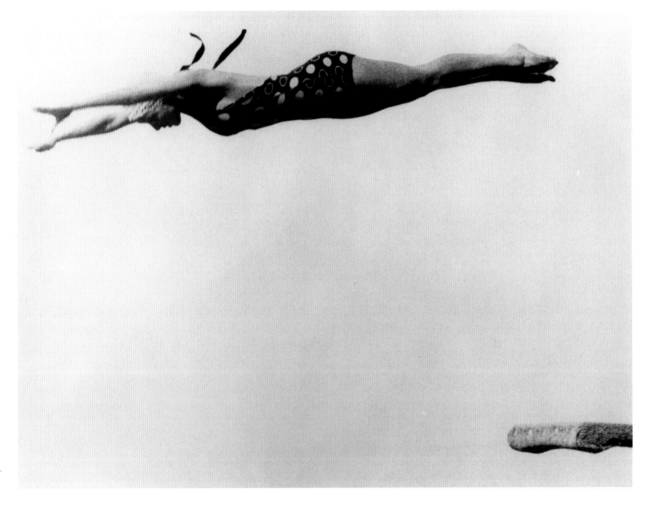

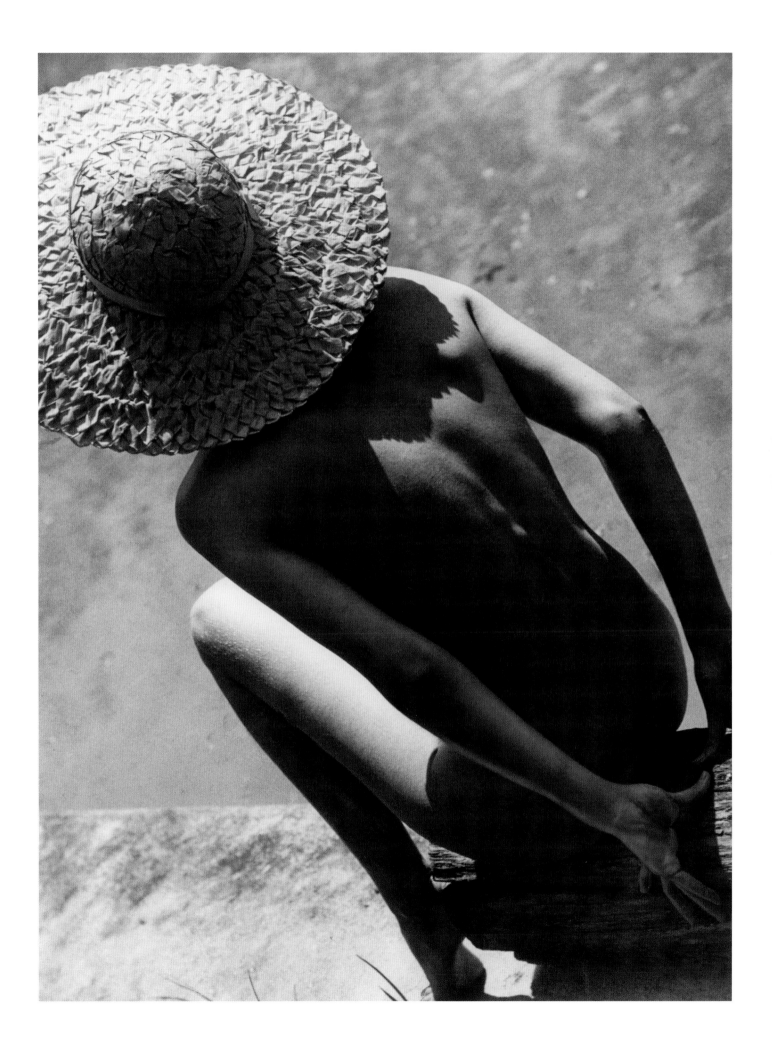

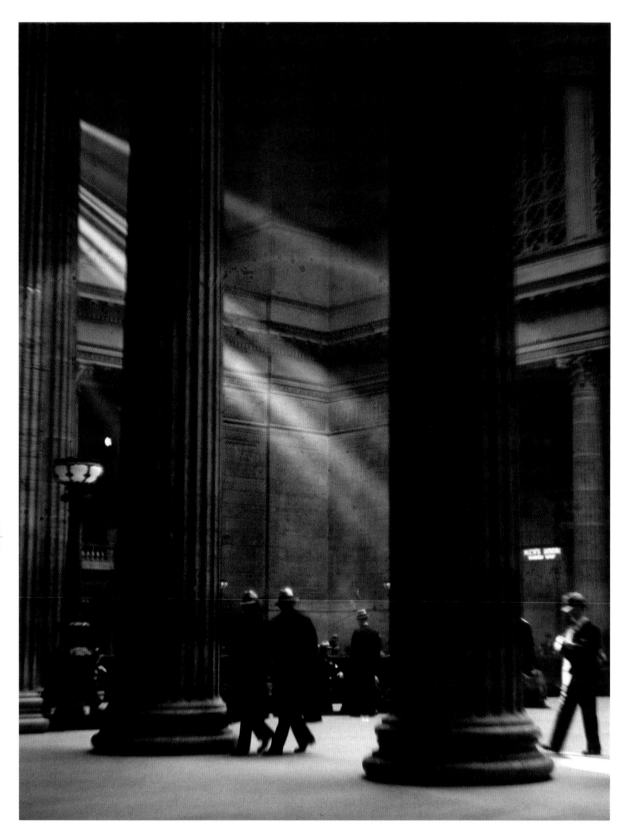

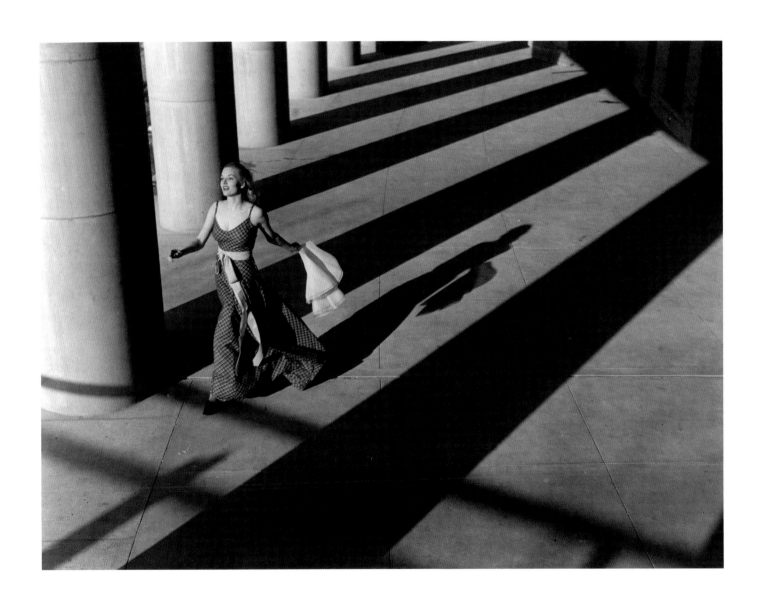

123 | **Martin Munkácsi**
Harper's Bazaar Fashion Plate
America, c. 1940
Silver gelatin print, 1994, from original
negative, 28.5 × 35.5 cm

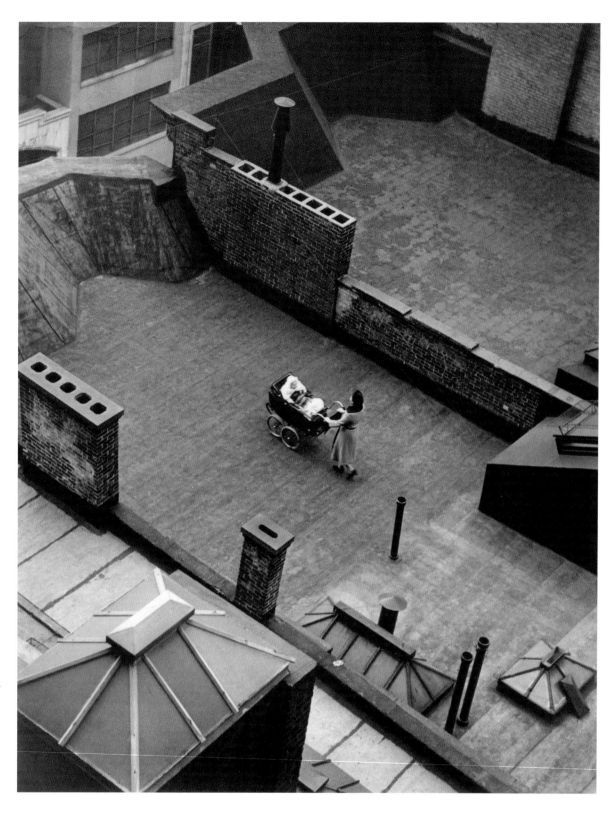

124 | **Martin Munkácsi**
Baby on the Roof
New York, 1940
Silver gelatin print, 1994, from original negative,
35.5 × 27.5 cm

125 | **André Kertész**
Homing Ship
New York, 13 October 1944
Silver gelatin print, 1967,
25.3 × 20.3 cm

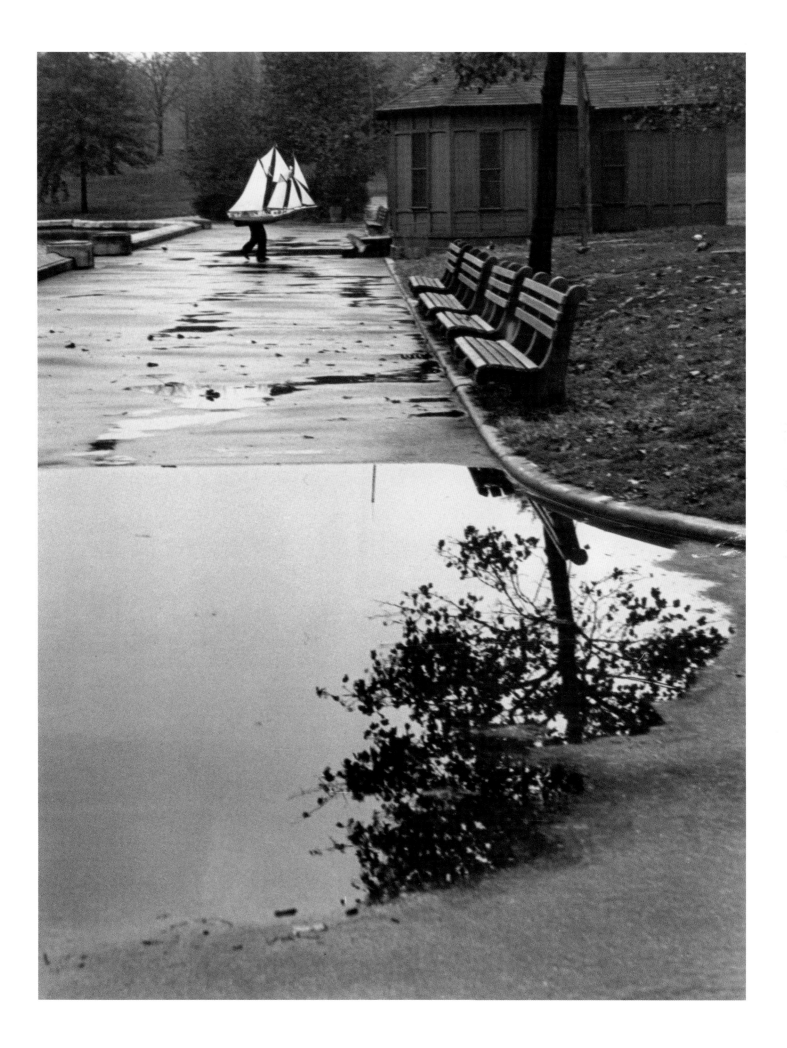

126 | **André Kertész**
McDougal Alley
New York, 1965
Silver gelatin print, 1967,
22.3 × 25.3 cm

127 | **André Kertész**
Washington Square
New York, 9 January 1954
Silver gelatin print, 1967,
25.3 × 20.3 cm

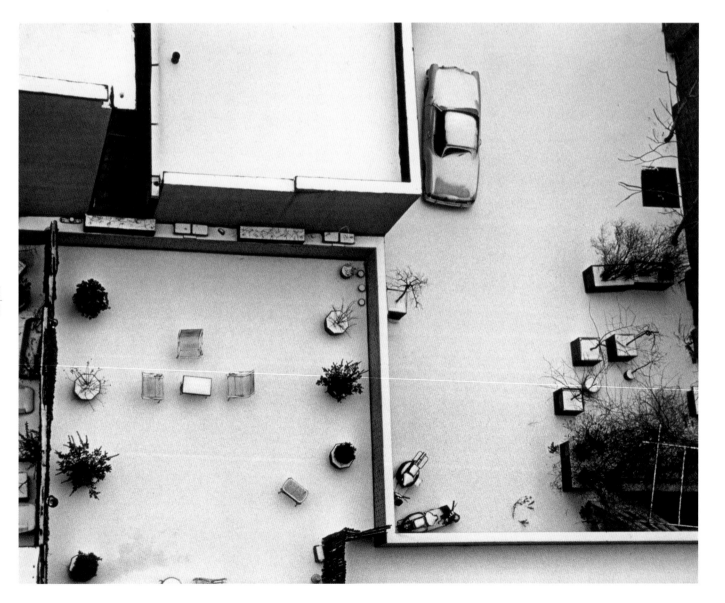

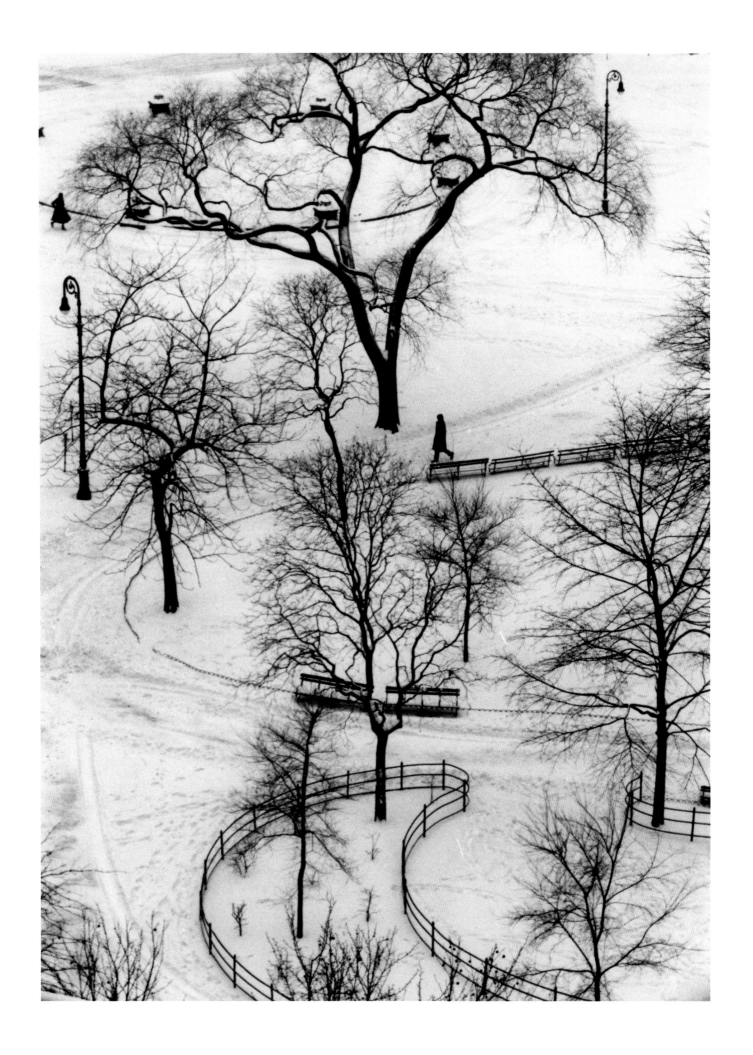

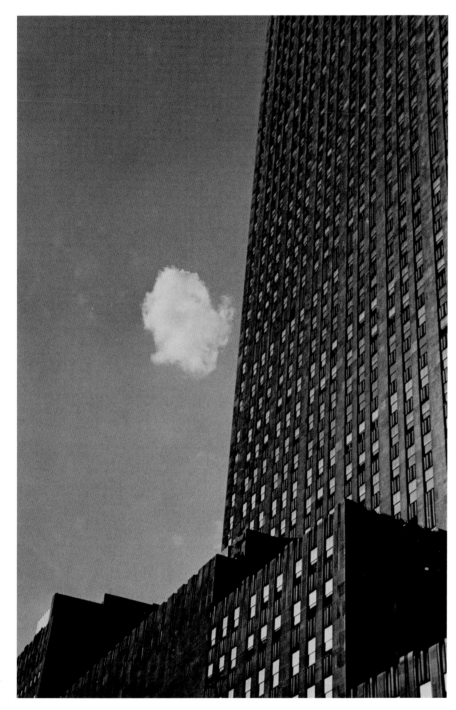

128 | **André Kertész**
Lost Cloud
New York, 2 March 1937
Silver gelatin print, 1970s,
25 × 20.3 cm

129 | **André Kertész**
Landing Pigeon
New York, 1960
Silver gelatin print, 1967,
25.3 × 20.3 cm

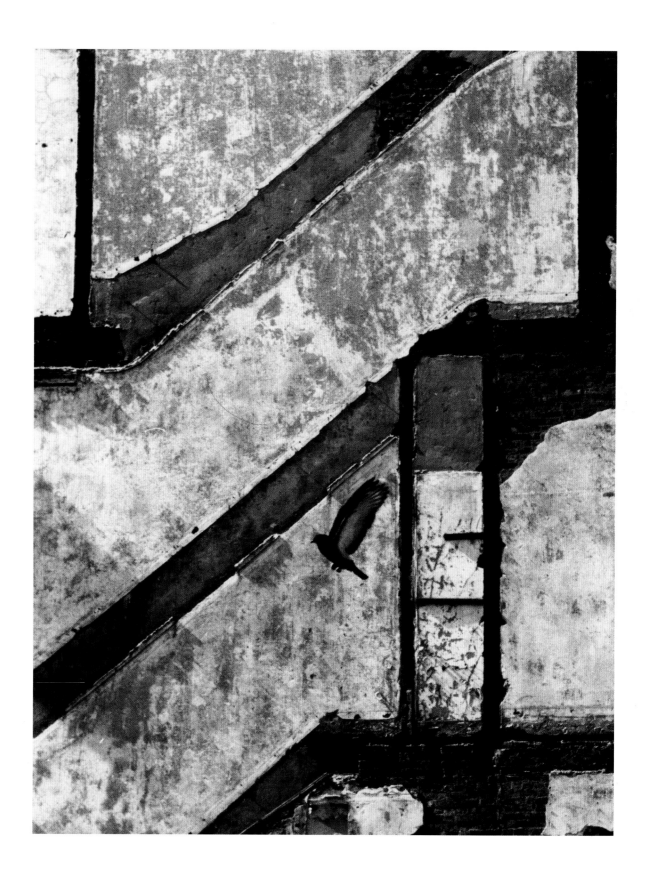

130 | **André Kertész**
Martinique
1 January 1972
Vintage silver gelatin print,
25.3 × 20.3 cm

131.1–9 | **André Kertész**
Untitled
New York, 1979–82
Colour SX-70 Polaroids,
each 7.9 × 7.9 cm

Had so many photographers not left Hungary before the Second World War began, they would certainly have suffered. When Germany occupied the country in March 1944, it immediately put Jewish people into ghettos, before sending them to prisons and concentration camps. In the last few months of the war, 40,000 were killed. In October 1944, the Arrow Cross party of nationalists took over the government. In less than five months, between 10,000 and 15,000 Jewish people were killed, among them four of Munkácsi's brothers and sisters. In 1946 Munkácsi published a bitter short story about his loss, 'Margit Is Dead', in the *New York Post*. During the war, his health deteriorated, and he felt more and more cut off from his homeland. In 1943 he suffered the first of a number of the heart attacks that were to force him to give up photography.

Kertész was also deeply affected by the war. He had left Paris for New York in 1936, and considered himself trapped in a country in which he never quite felt at home. His situation, like that of all émigré Hungarians, was made worse when Hungary declared war on the Allies in 1941. For a time, his professional activities were curtailed, and he could not easily obtain photographic supplies. Like Munkácsi's, his health suffered.

Even Capa, who had by now established an international reputation as a war photographer, was in trouble. For a time, his cameras were confiscated. When he finally managed to get them back with the help of some influential American friends, he flew to Britain, believing that the Allies would soon invade Europe. He then had to endure months of waiting, in which he shot such picture stories as that of the Welsh coalminers in the Rhondda Valley (cats 115.1–3). He had met Richard Llewellyn, author of the bestselling novel about the area *How Green Was My Valley*; John Ford's film version of the story won the Oscar for Best Picture in 1941.

D-Day finally came on 6 June 1944. Soon after 4 am, Capa jumped from a landing craft and waded ashore, dodging German bullets. He found a scene of such chaos that he was forced to take shelter. Over the next hour and a half, however, he managed to shoot two rolls of film before jumping onto a landing craft taking wounded soldiers back to a ship. As soon as he landed in Portsmouth, he had the films sent to the London office of *Life*. There, the picture editor urged his darkroom staff to develop and print the negatives as fast as possible in order to put them on a plane to New York in time for the magazine's next issue. In the event, they worked too fast, putting the 72 negatives into an overheated drying cabinet. All but eleven were ruined, and even these were blurred (cat. 137). But the results turned out to be some of the most memorable photographs of that extraordinary day: the blurring only makes them more dramatic. After the war, America recognised

Capa's achievements when President Eisenhower gave him a peace medal.

Before the German army left Budapest, it blew up all the bridges across the Danube (cat. 147). When Capa revisited the city of his birth in 1948, most had still not been rebuilt (cat. 148). Escher's moving photograph of a defeated soldier in 1947 (cat. 134) shows how much human beings had suffered; comparison of this with his portrait of a confident soldier departing for the front in *c.* 1940 (cat. 133) is a deeply moving indictment of the horrors of war.

The Second World War and Its Aftermath

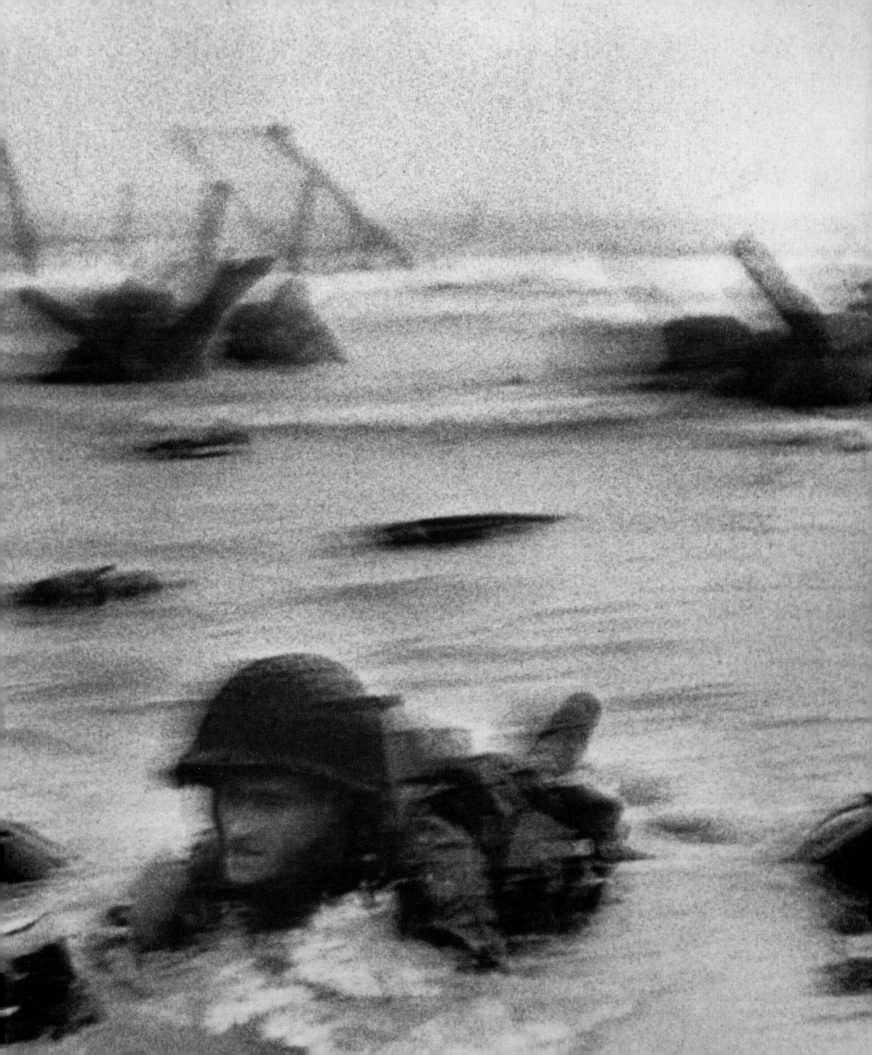

132 | **Kata Kálmán**
Transporting Snow on the Banks of the Danube
Budapest, 1940
Silver gelatin print, 1991,
23.7 × 18.1 cm

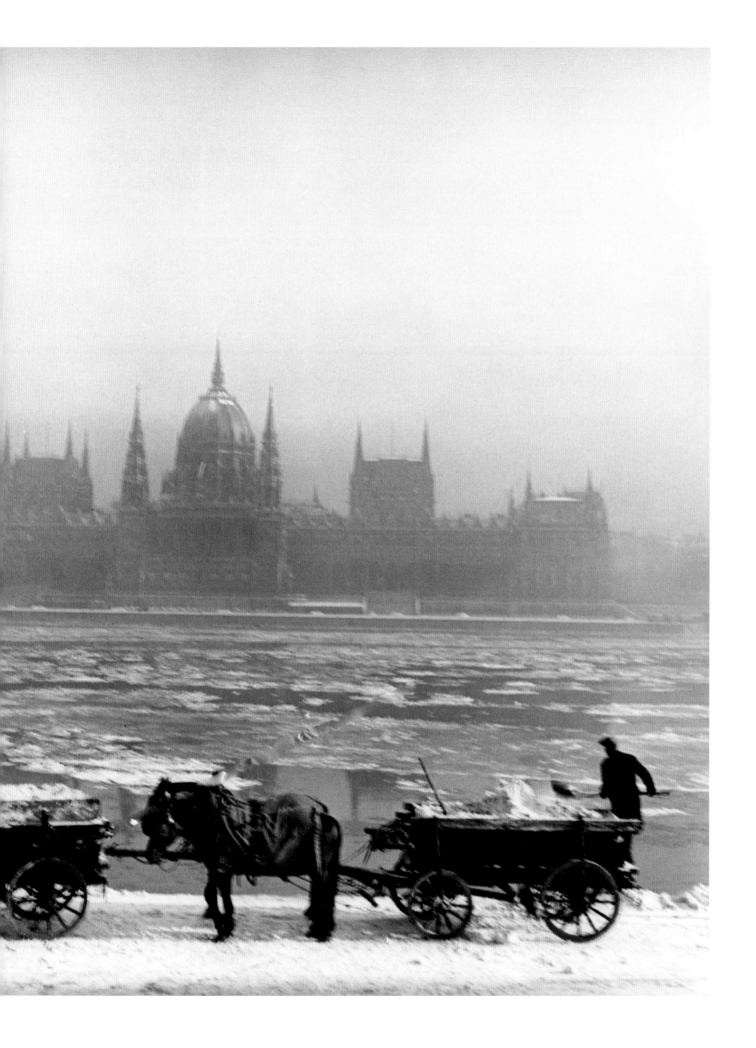

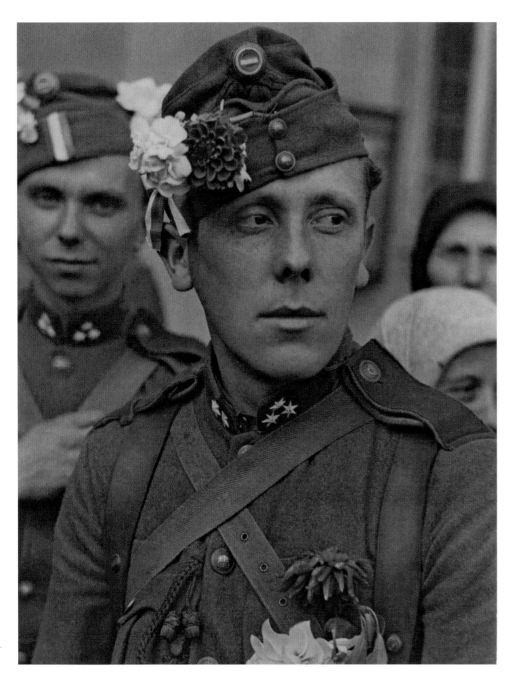

133 | **Károly Escher**
*Hungarian Soldier Entering
the Re-annexed Territories*
c. 1940
Vintage silver gelatin print, 1942,
24 × 18 cm

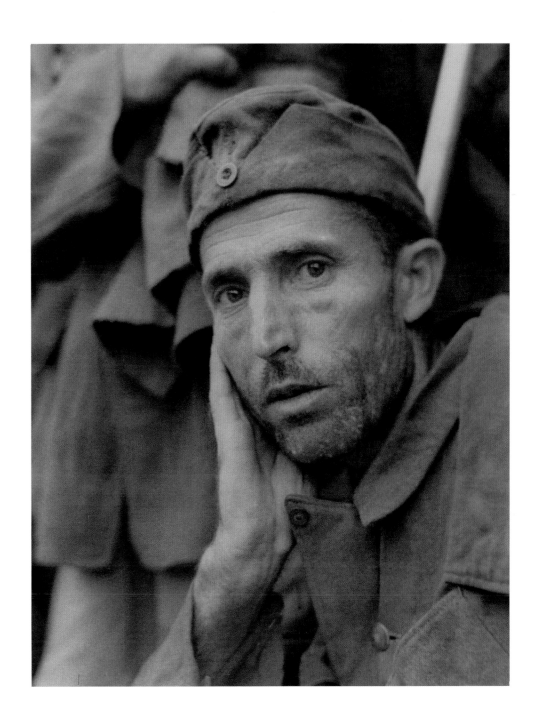

134 | **Károly Escher**
Soldier Portrait
1947
Vintage silver gelatin print,
24.3 × 18 cm

135 | **Unknown photographer**
Miklós Horthy and Hitler Disembarking
from a Ship
Hamburg, August 1938
Vintage silver gelatin print,
20.8 × 14.2 cm

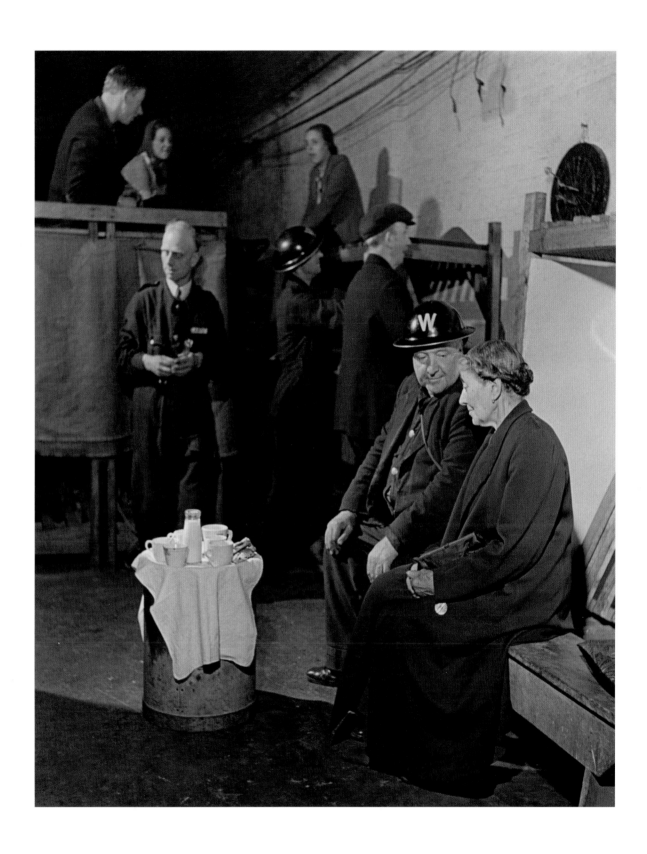

136 | **Robert Capa**
Drinking Tea at the Refuge
London, 1941
Silver gelatin print, 1970, from original
negative, 36 × 28 cm

137 | **Robert Capa**
American Soldier Landing on Omaha Beach, D-Day
Normandy, 6 June 1944
Silver gelatin print, 1970, from original negative,
28 × 36 cm

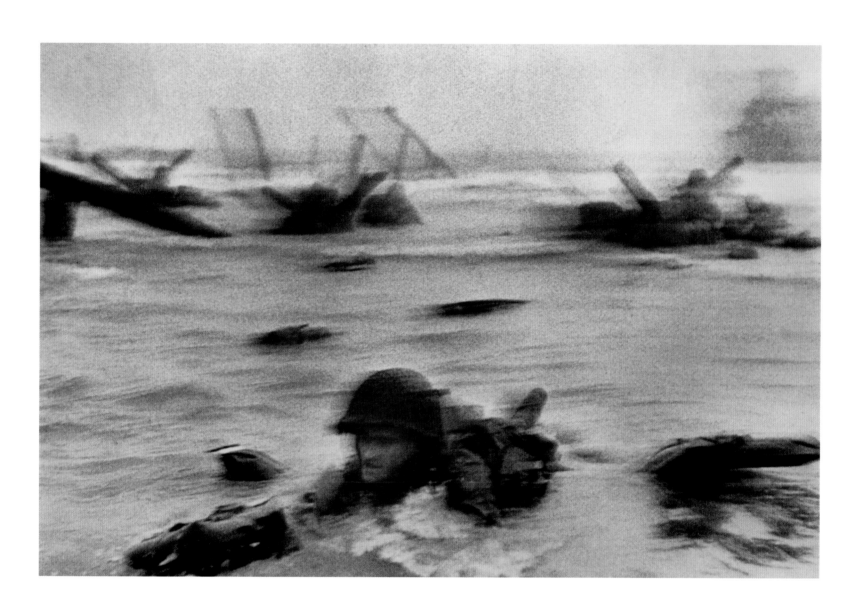

| **Robert Capa**
American Soldiers Arrest German Generals
Normandy, 1944
Silver gelatin print, 1970, from original
negative, 39 × 39.5 cm

140 | **János Babai**
*Jewish People in Köszeg
at the Railway Station*
18 June 1944
Silver gelatin print, 1955,
12.8 × 17.5 cm

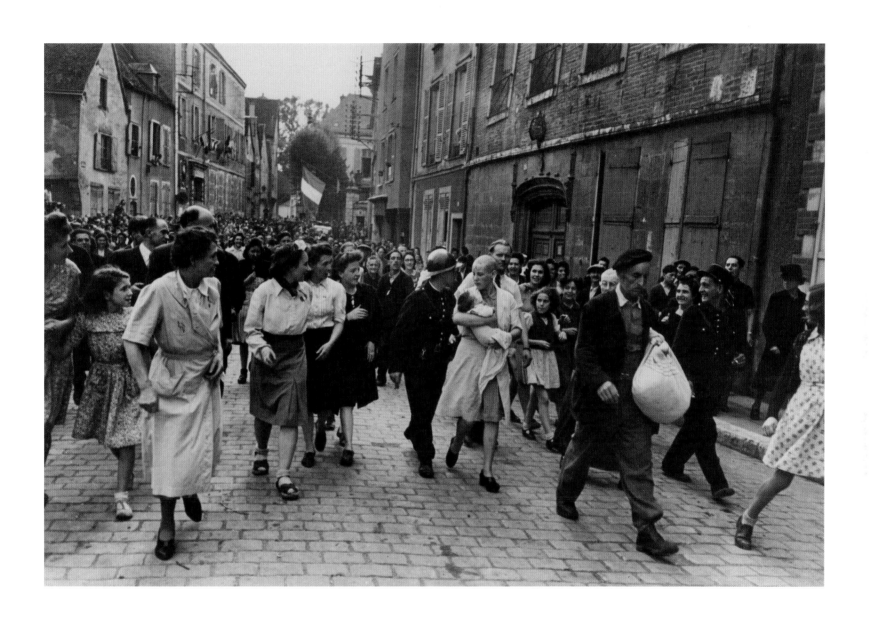

141 | **Robert Capa**
Woman, Who Had a Child with a German
Soldier, Being Marched through the Street
Chartres, August 1944
Silver gelatin print, 1970s, from original
negative, 33 × 49 cm

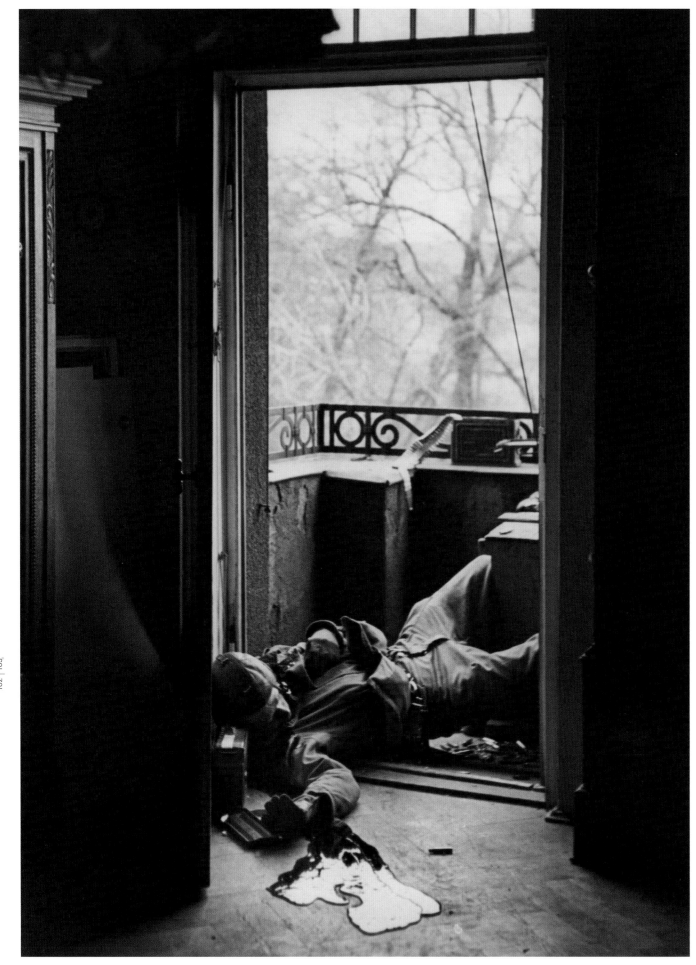

142 | **Robert Capa**
The Last Victim of the War
Leipzig, 1945
Silver gelatin print, 1970, from original
negative, 36 × 28 cm

143 | **Sándor Ék**
*The Corpses of Arrow Cross Victims
Are Exhumed in the Grounds of the
Jewish Hospital in Maros Street*
13 April 1945
Vintage silver gelatin print,
19.3 × 17 cm

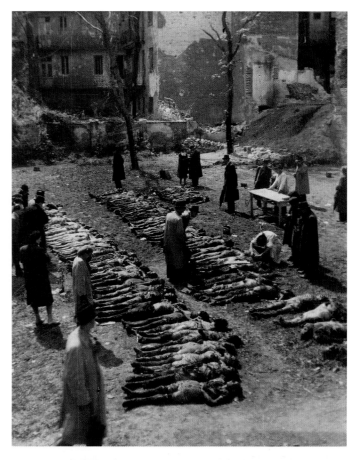

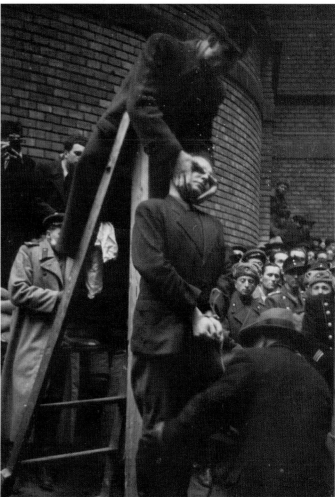

144 | **Sándor Bojár**
*Arrow Cross Leader Ferenc Szálasi's
Execution*
Budapest, 12 March 1946
Silver gelatin print, 1964,
13 × 9 cm

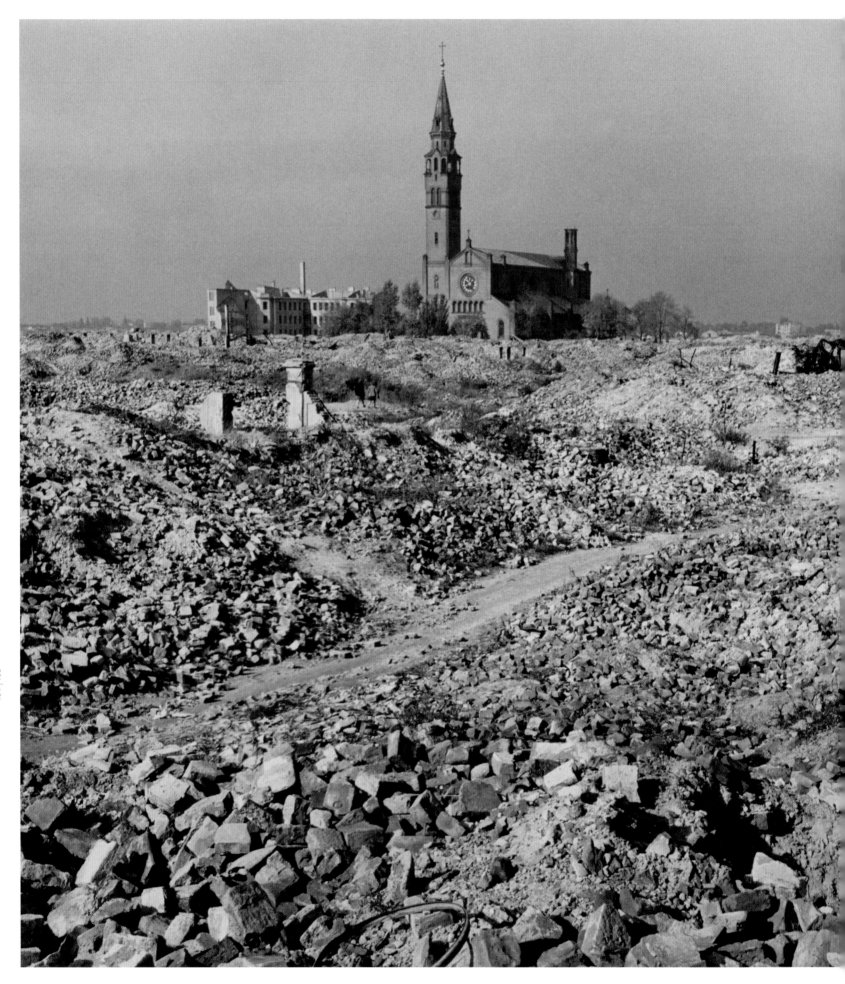

145 | **Robert Capa**
Ruins of the Warsaw Ghetto
1945
Silver gelatin print, 1970, from original
negative, 28 × 36 cm

146 | **Robert Capa**
Refugees in Front of the Sha'ar Ha'Aliya
Refugee Camp, Haifa
1950
Silver gelatin print, 1970, from original
negative, 39 × 49 cm

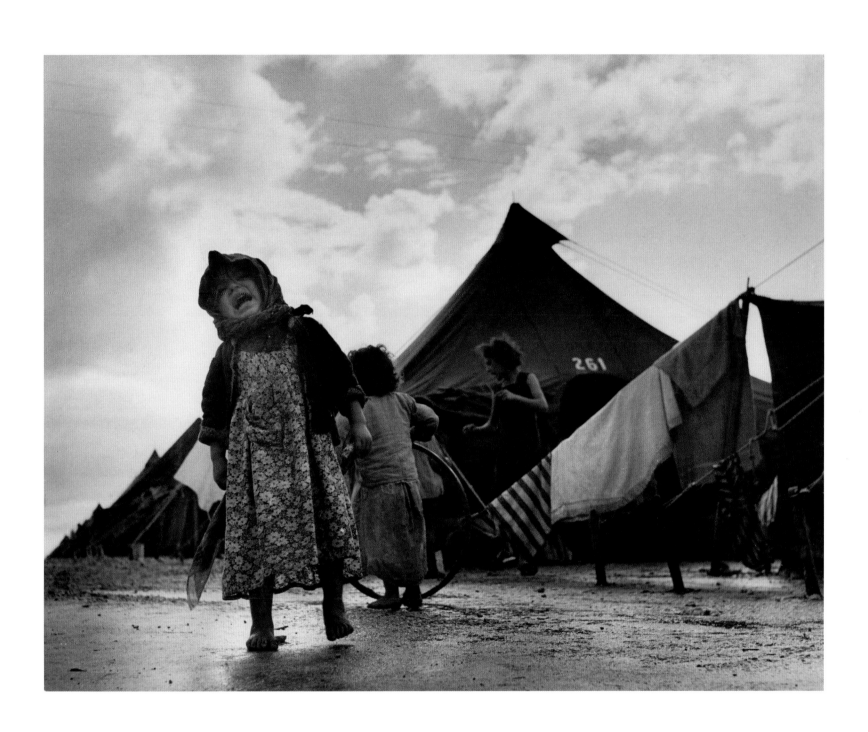

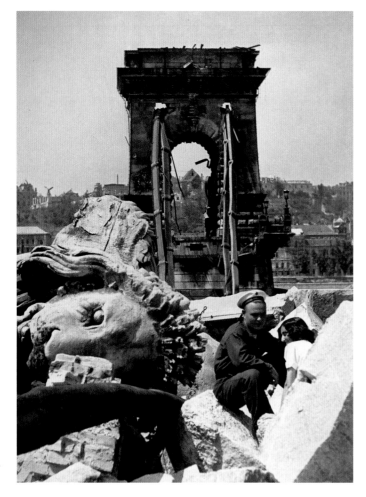

147 | **Kálmán Szöllősy**
Chain Bridge in Ruins
Budapest, 1945
Silver gelatin print, 1966,
40.1 × 30 cm

148 | **Robert Capa**
Elizabeth Bridge Destroyed
Budapest, 1948
Silver gelatin print, 1970, from original negative,
36 × 28 cm

149 | **Robert Capa**
Café on the Riverside Near the Bombed Bristol Hotel
Budapest, 1948
Silver gelatin print, 1970, from original negative,
36 × 28 cm

150 | **Robert Capa**
Chaplin's Latest Film Advertised on Vaci Street
Budapest, 1948
Silver gelatin print, 1970, from original negative,
21 × 17.5 cm

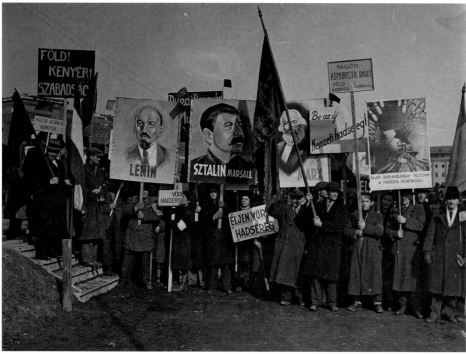

151 | **Miklós Bedő and Katalin Korbuly**
*The Kossuth Version of the Arms of
Hungary on a Hungarian T-34 Tank
Behind Corvin Cinema*
Budapest, 27 October 1956
Digital print, 2011,
16.2 × 23.8 cm

152 | **Unknown photographer**
*Participants in the First Mass Rally
of the Hungarian Communist Party*
Budapest, 1945
Vintage silver gelatin print,
13 × 18 cm

153 | **Ferenc Berendi**
Backlight
Budapest, 1956
Silver gelatin print, 2006,
40.5 × 30 cm

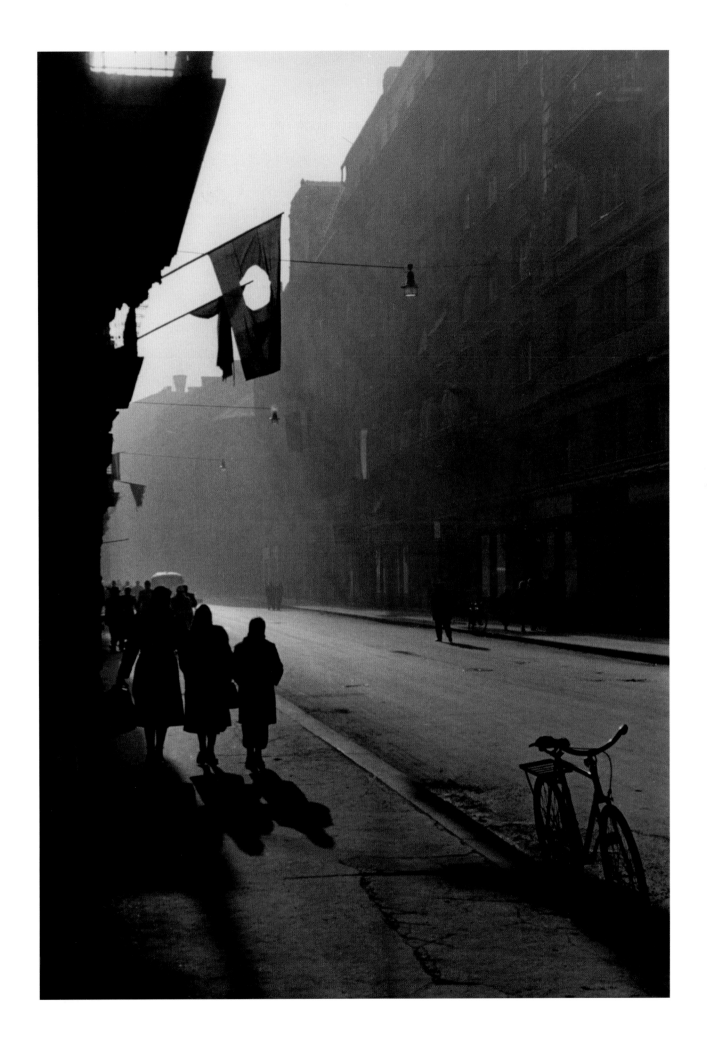

After the Second World War, photographers in Hungary, like artists in every Soviet country, found themselves inhibited by state control. The only kind of photography approved by the state was Socialist Realism. Photographic societies and independent journalism, which had driven the development of the medium between the wars, were restricted, and photography studios were nationalised in the 1950s. Photographers had only a limited awareness of the radical changes taking place on the other side of the Iron Curtain: the growth of informed criticism, an art-sales market, galleries devoted to photography and a market for print sales all passed them by.

One proof of these inhibitions was that none of the known photographs of the 1956 Revolution – the three weeks when a popular movement briefly overthrew the government before being defeated by the Soviet army and its tanks – were taken by Hungarian professionals, even though such practised photographers as Ernő Vadas, Miklós Rév (cats 160–61) and Károly Gink (cat. 158) were at the time working for the Hungarian news agency MTI. Vadas in particular was still making excellent photographs but since becoming a professional he had become more of a social realist, focusing on urban rather than rural life (cat. 156). Other photographers in this section seem to be harking back to happier days in pre-war Hungary

and to a yearning for an unspoilt countryside. Kata Kálmán's *Tiborc* (figs 25.1–2) was re-published in the 1950s, and she was later involved in producing a series of monographs on photographers who had made their reputations before the war, among them Rudolf Balogh, Károly Escher, Ferenc Haár, János Reismann, Ernő Vadas and herself.

Interest in social-documentary photography grew throughout the 1970s, and the predominance of the picture essay, which had become so important between the wars, was now established. Two impressive examples are Tamás Féner's series on gypsies (cats 164.1–6) and Péter Korniss's series following the life of one man from northeastern Hungary over a period of some ten years (cats 166.1–5). Tamás Urban is the toughest and most uncompromising of them all (cats 176–78).

Alongside such socially aware work, with its implicit criticism of the communist state, was a growing avant-garde movement. György Lőrinczy's influential book *New York, New York* (fig. 32), published in Hungary in 1972, was one of the first manifestations of this. Photographs by Gábor Kerekes (cats 168, 171–72, 174) and László Haris, with their exaggerated black-and-white contrast and elements of abstraction, show the influence of Lőrinczy's book.

Gradually, some of this work began to be recognised outside Hungary and a number of photographers won prizes

in the prestigious World Press Photo awards. For László Fejes, however, this backfired. When his prizewinning *Wedding* (cat. 163) was published in the German magazine *Der Spiegel*, the editors pointed out that the shell-pocked walls dated from the 1956 Revolution. As a result, his photographs were banned from publication in Hungary.

During the 1980s restrictions on the flow of information into Hungary eased and photography was taught in institutions of higher education for the first time from 1985. Photographers became less inhibited and more confident, and artistic and conceptual photography began to flourish.

In 1989 Hungary was the first country to open its borders to East Germany. After the Berlin Wall came down altogether, Hungarian photography grew more and more like that of other countries. Globalisation affected the arts as much as it did other elements of people's lives, and Hungarian photography – good, bad or indifferent – was no longer a nationally unique art form. But, for three quarters of a century, Hungary's brilliant and pioneering photographers had helped to shape their medium all over the world.

5

Hungary 1945–1989

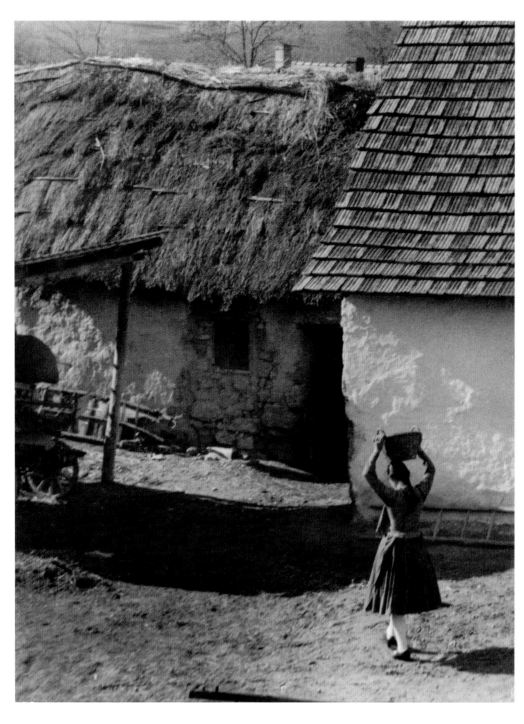

154 | **Angelo**
What Is the Girl Carrying?
Hungary, *c.* 1950
Vintage silver gelatin print,
40 × 35 cm

155 | **Angelo**
Ladders and Ladder Bearers
Budapest, 1950
Vintage silver gelatin print,
39.8 × 29.5 cm

156 | **Ernő Vadas**
Wheels
Hungary, 1951
Vintage silver gelatin print,
39 × 29 cm

157 | **Rudolf Járai**
Steel Furnace in Inota
1951
Vintage silver gelatin print,
30 × 39.5 cm

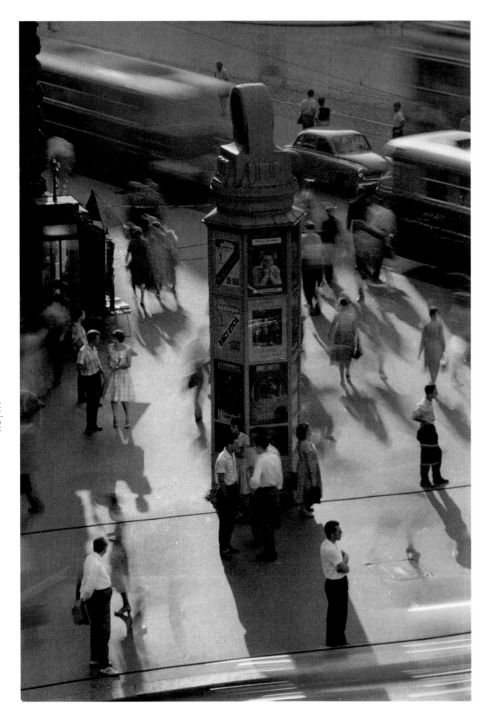

159 | **Zoltán Berekméri**
Winter's Evening in Békéscsaba
1955
Silver gelatin print, 1987,
40 × 30 cm

160 | **Miklós Rév**
Workers on the Elizabeth Bridge
Budapest, 1962
Vintage silver gelatin print,
41 × 30 cm

161 | **Miklós Rév**
Straight Road
Inota, *c.* 1955
Silver gelatin print, 1962,
23.5 × 19 cm

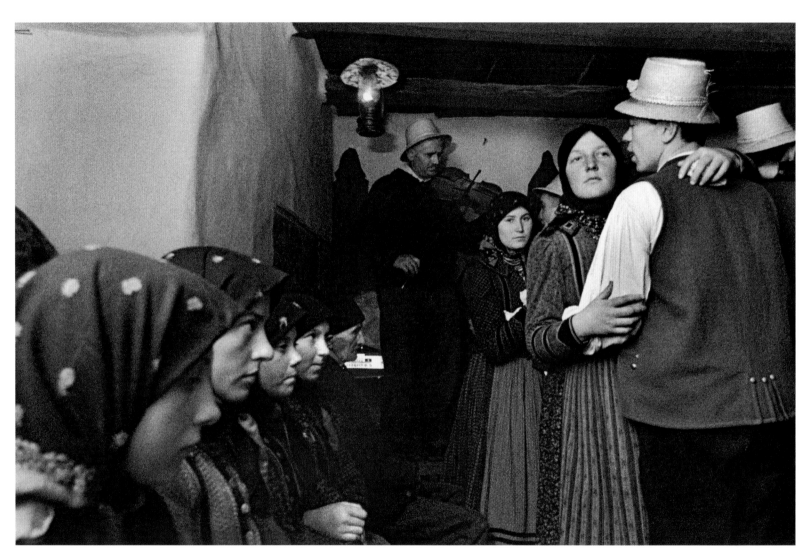

162 | **Péter Korniss**
At the Dance Hall, Romania
1967
Silver gelatin print, 2010,
30 × 40 cm

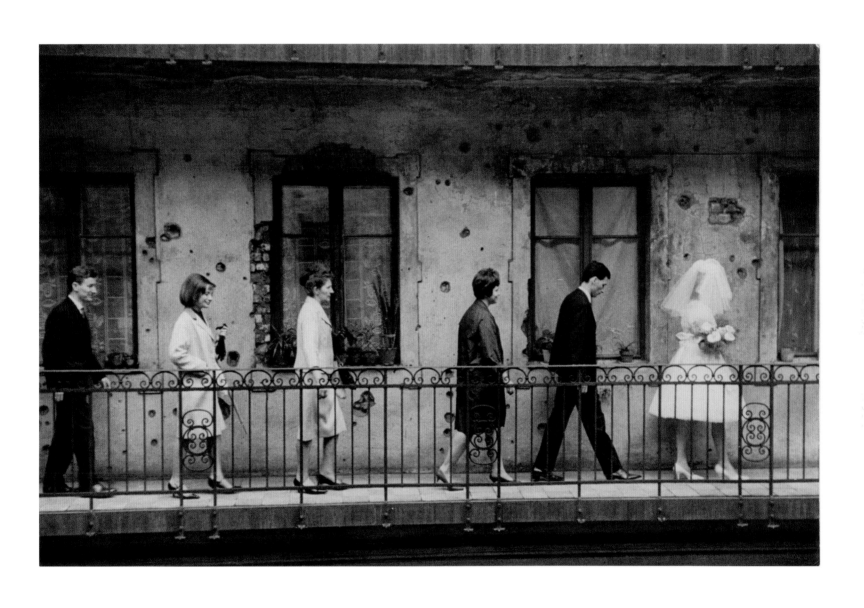

163 | **László Fejes**
Wedding
Budapest, 1965
Vintage silver gelatin print,
15.5 × 23.8 cm

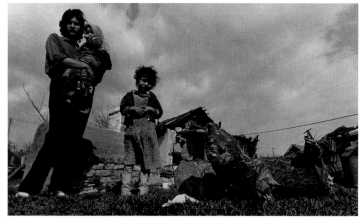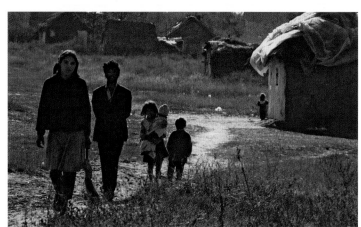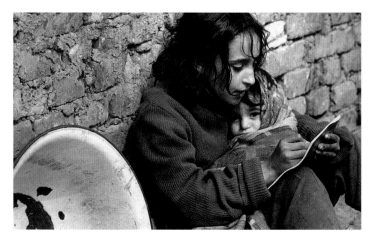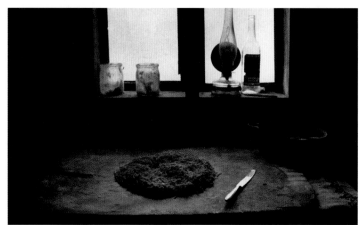

164.1–6 | **Tamás Féner**
Untitled series
Szabolcs county, *c.* 1973
Vintage silver gelatin prints,
12.6 × 23 cm, 15.8 × 23.1 cm,
14.7 × 22.7 cm, 15.8 × 23.1 cm,
13.5 × 25.2 cm, 16.5 × 23.5 cm

165 | **László Haris**
Unlawful Avant-garde
1971
Silver gelatin print, 2010,
30 × 24 cm

166.1–5 | **Péter Korniss**
From the *Guest Worker* series
1978–88
At the Western Station
In Rush Hour
Marriage Bed
Evening Shower
Homecoming
Silver gelatin prints, 2010,
18 × 24 cm (166.3: 24 × 18 cm)

166.1

166.2

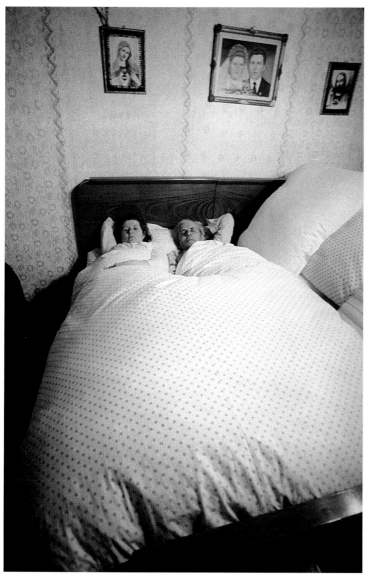

166.3

166.4

166.5

167 | **László Fejes**
Suffering Christ
Szeged, 1969
Vintage silver gelatin print,
30.2 × 23.9 cm

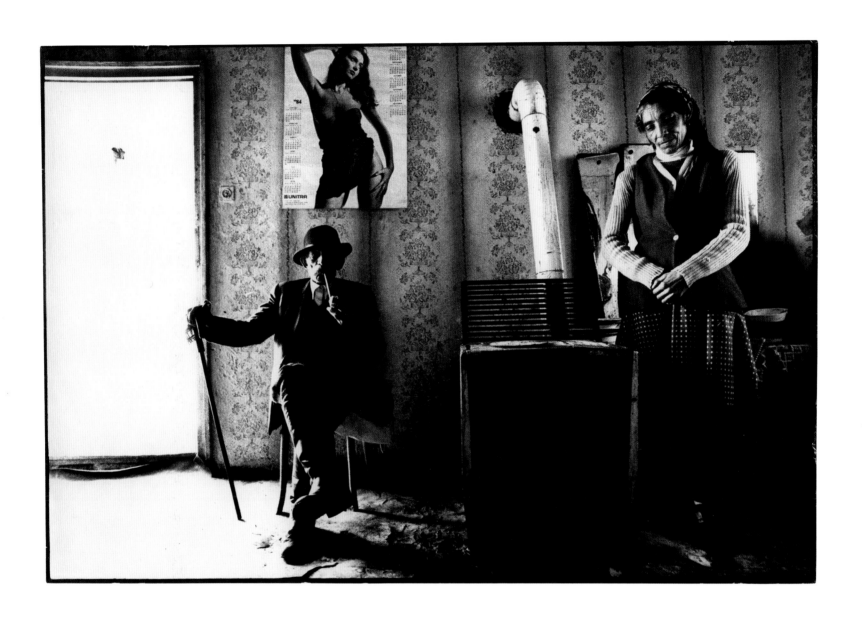

168 | **Gábor Kerekes**
Interior (Gypsy Couple)
Hungary, 1980s
Vintage silver gelatin print,
26.5 × 38.5 cm

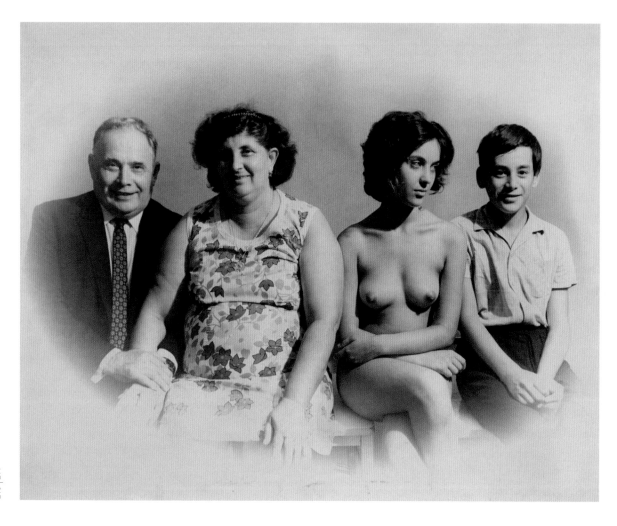

169 | **László Török**
Family
Budapest, 1972
Vintage silver gelatin print
40 × 60 cm

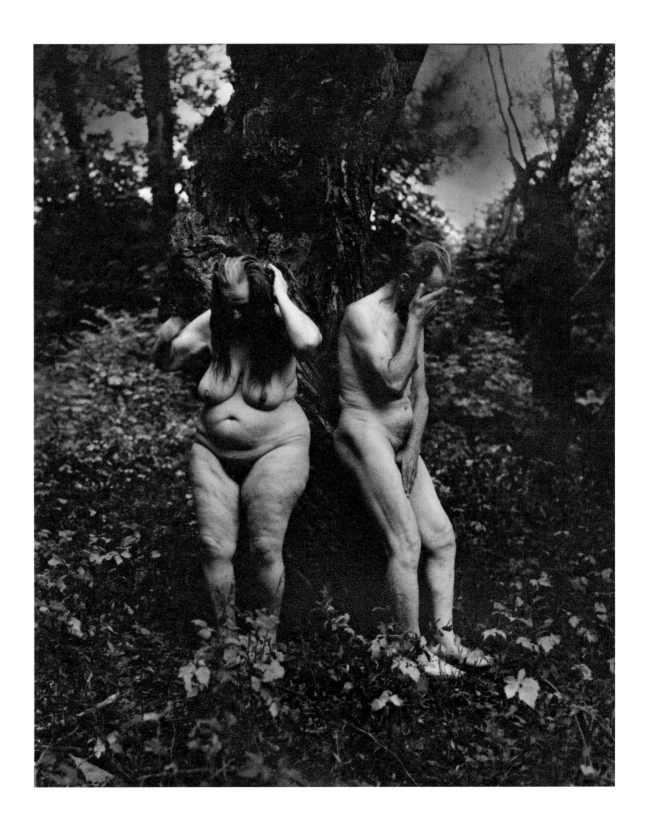

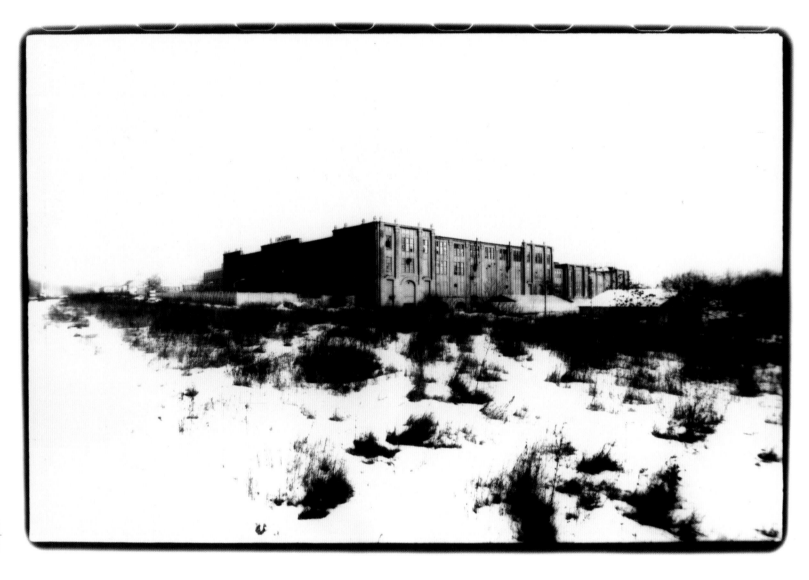

171 | **Gábor Kerekes**
Cotton Works
Budapest, 1978
Vintage silver gelatin print,
24 × 30 cm

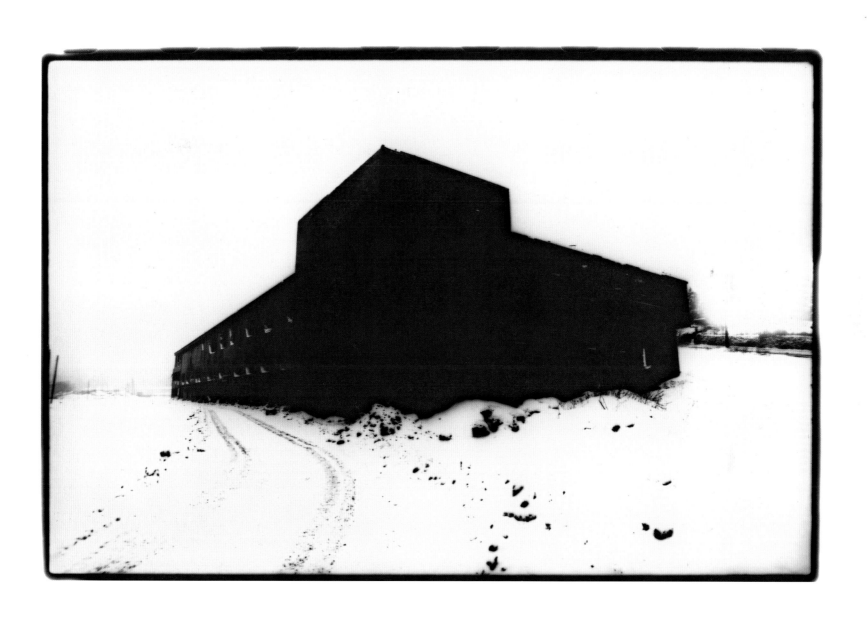

172 | **Gábor Kerekes**
Brick Factory
Hungary, *c.* 1980
Vintage silver gelatin print,
24 × 30.5 cm

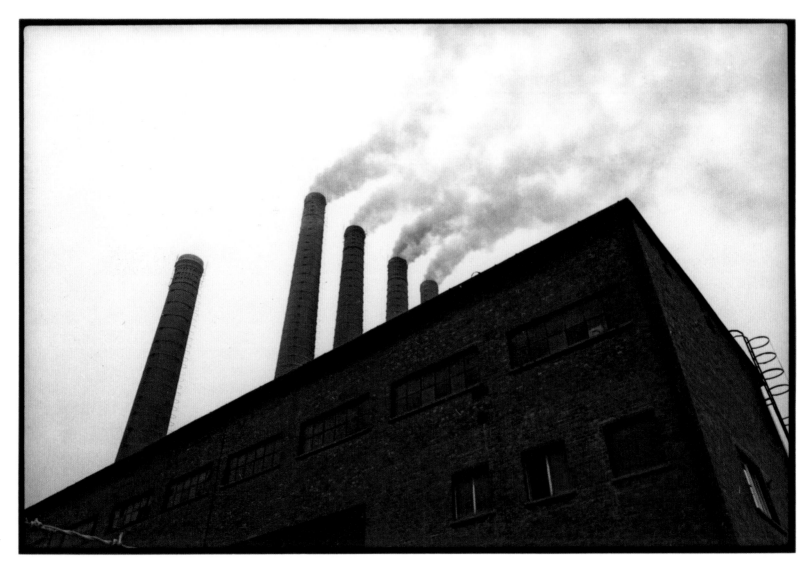

173 | **Magdolna Vékás**
Cement and Lime Plant, Tatabánya
1979
Vintage silver gelatin print,
18 × 24 cm

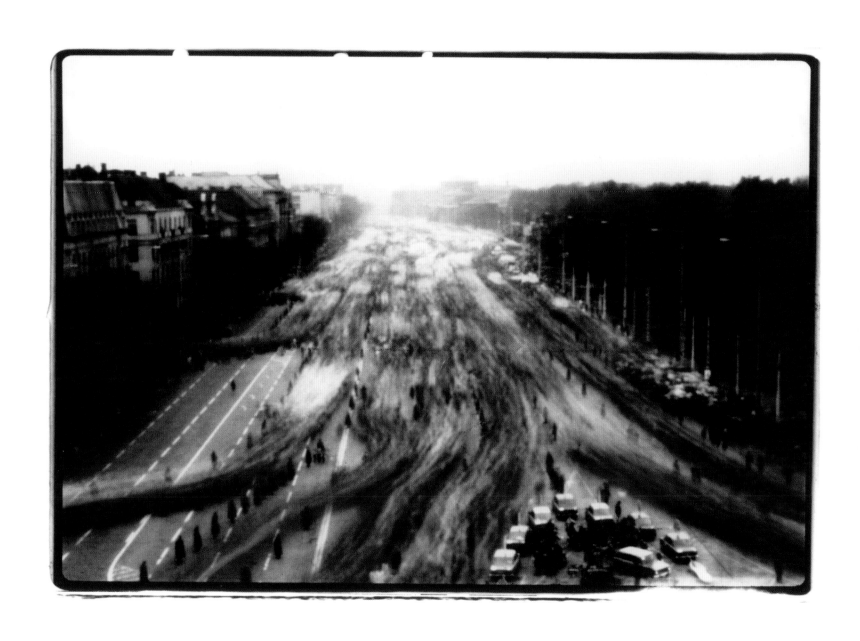

174 | **Gábor Kerekes**
1 May
Budapest, 1984
Vintage silver gelatin print,
17.9 × 24.1 cm

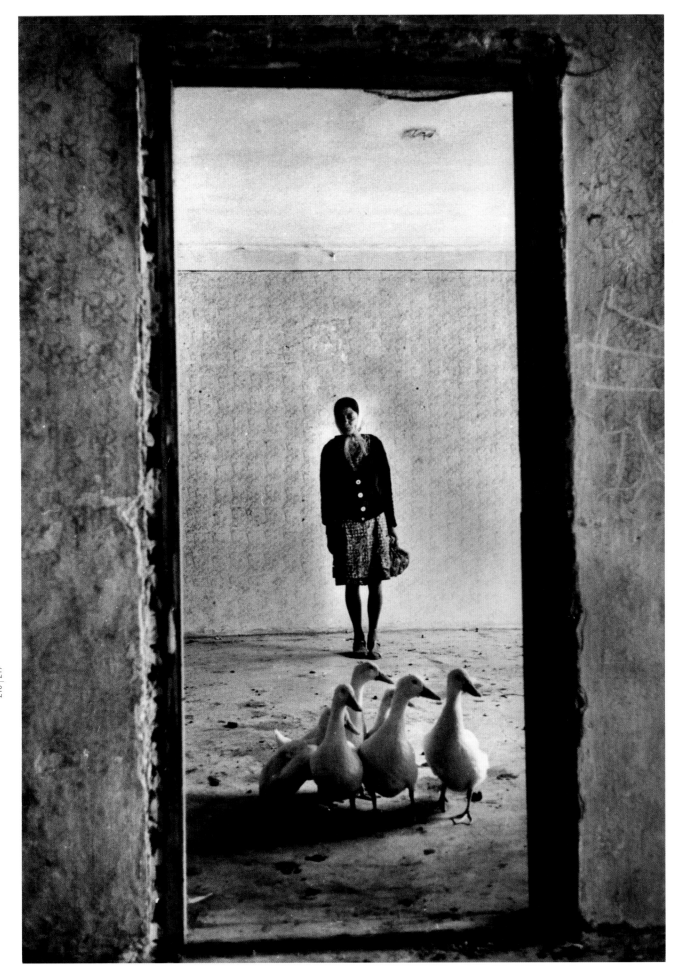

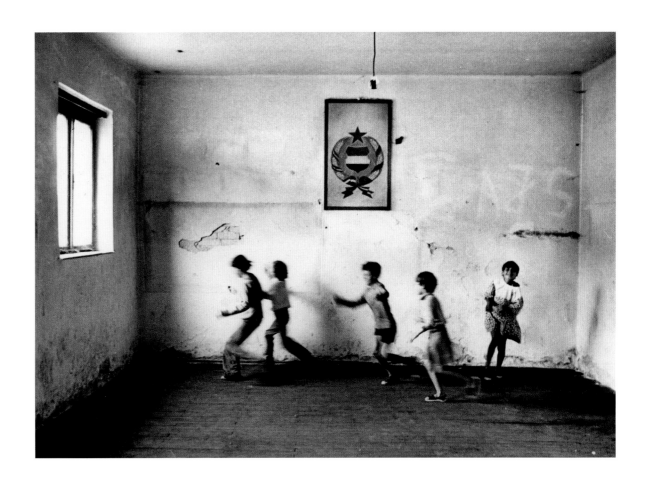

175.1 | **György Stalter**
Tólápa
1982
Vintage silver gelatin print,
24 × 18 cm

175.2 | **György Stalter**
From the Tólápa Series
1982
Vintage silver gelatin print,
18 × 24 cm

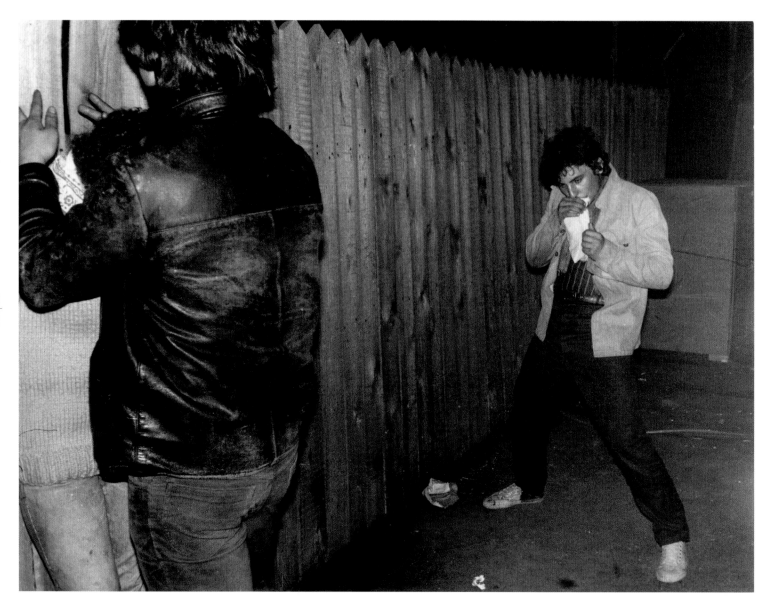

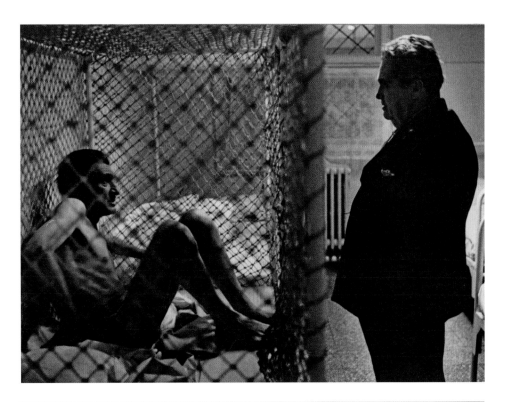

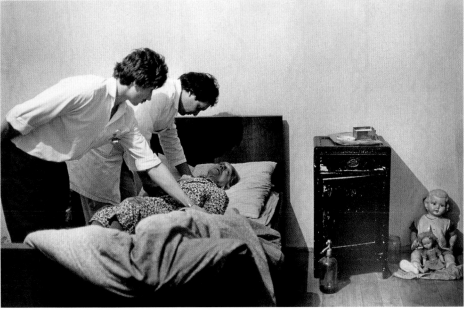

177 | **Tamás Urbán**
Crib
Budapest, 1985–87
Vintage silver gelatin print,
14.7 × 23.1 cm

178 | **Tamás Urbán**
Infants
Budapest, 1985–87
Silver gelatin print, 2010,
24 × 30 cm

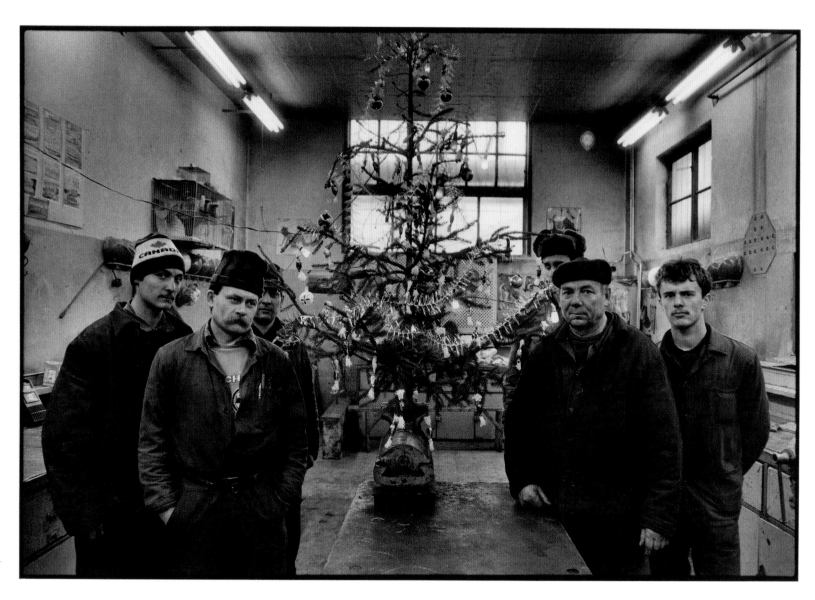

179 | **Imre Benkő**
Pipe Workshop
Ózd, 1989
Silver gelatin print, 2002,
29.3 × 30 cm

180 | **Imre Benkő**
Russian Soldiers Leaving
Hajmáskér, 1990
Vintage silver gelatin print,
23.8 × 16.4 cm

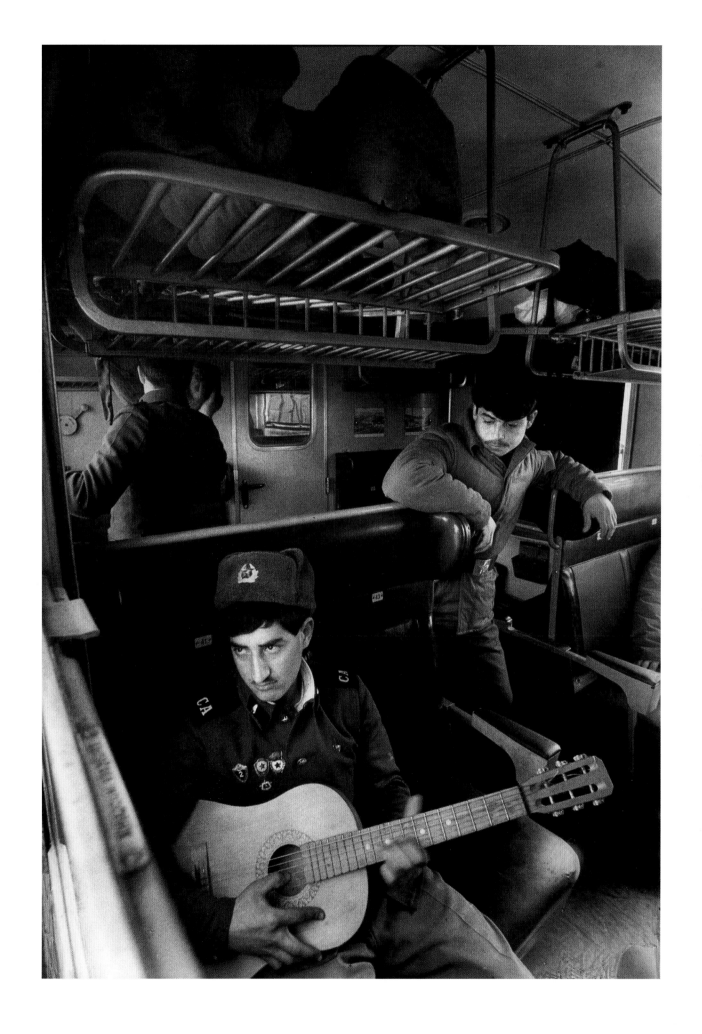

181 | **Imre Benkő**
Lenin Statue Lying Down
Budapest, 1992
Vintage silver gelatin print,
15.5 × 23 cm

182 | **Sylvia Plachy**
Fallen Worker
Érd, 1993
Vintage silver gelatin print,
24.5 × 32.5 cm

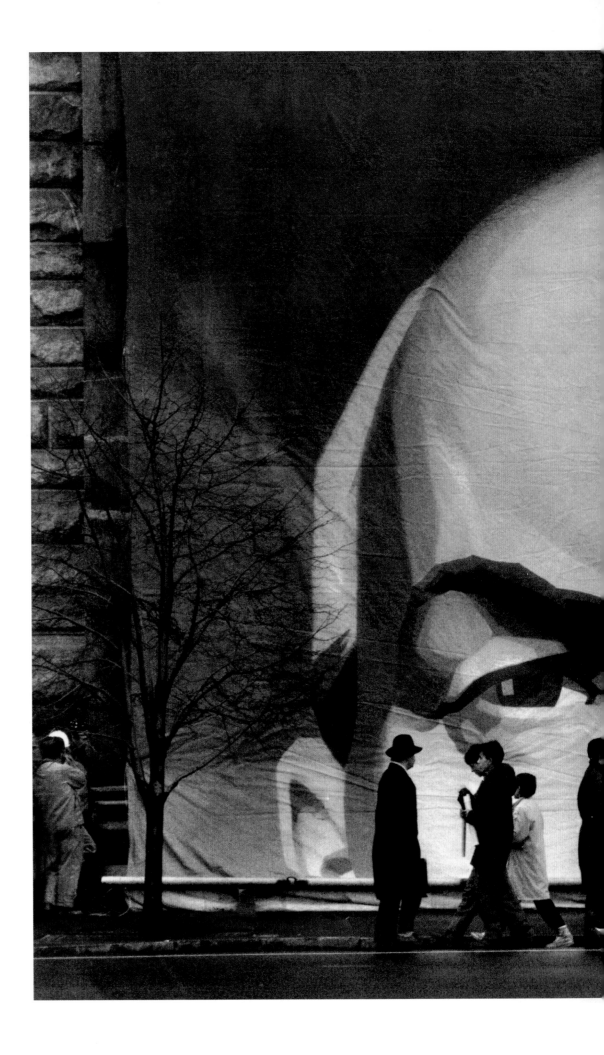

183 | **András Bánkuti**
Twilight, Moscow
1990
Vintage silver gelatin print,
24 × 30 cm

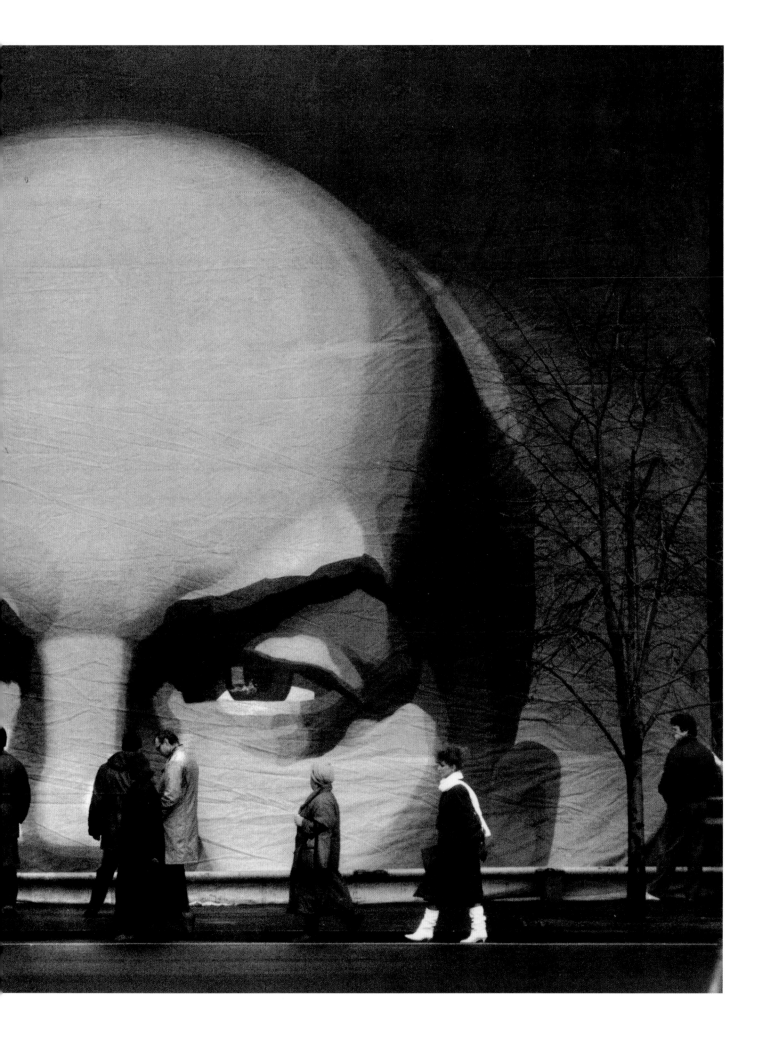

Biographies

Péter Baki with Balázs Zoltán Tóth

Lucien Aigner

b. 14 September 1901, Érsekújvár (Nové Zámky)
d. 29 March 1999, Waltham, Mass.

Lucien Aigner took his first photograph in 1910, using a Kodak Box Brownie that he had received as a gift. In 1921–22 he studied theatre in Berlin, and worked as an assistant cameraman with Stefan Lorant. In 1924 he received his doctorate in law in Budapest, while also working as a journalist and press photographer. In 1926 he moved to Paris, where he became known for his photojournalism; his photographs were published in many magazines and newspapers including *Vu*, *L'Illustration*, *Münchner Illustrierte Presse*, *Pesti Napló* (*Pest Diary*) and *Picture Post*. In 1941 he moved to New York. For eight years beginning in 1947, he worked for the 'Voice of America' as an announcer, editor and producer of foreign-language programmes. Aigner's photos of Albert Einstein, taken at Princeton University, are some of his most famous. In 1954 he opened a portrait studio in Massachusetts while also continuing his press photography. He gave up the studio in the late 1970s and began to catalogue his collection of more than 100,000 negatives and to show his work in exhibitions. Aigner's photographs are preserved in many national collections, and his Massachusetts home is now a museum.

Angelo

(Pál Funk)
b. 31 January 1894, Budapest
d. 13 December 1974, Budapest

Best-known for his pictures of Budapest before the Second World War, Angelo was a studio photographer who kept his work and his art separate. A widely travelled and multifaceted artist, he studied with Rudolf Dührkoop in Hamburg and Charles Reutlinger in Paris, where he also worked as a fashion and costume designer. He completed his training at Aladár Székely's studio in Budapest. He tried his hand at filmmaking, working for Michael Curtis as assistant director and cameraman and taking part in the making of the first experimental Hungarian sound movie. In 1919 he opened a photographic studio in Budapest, but fled abroad at the time of the White Terror. In 1920 he opened studios in Paris and Nice, then in The Hague and Scheveningen. During his fifty-year career, he photographed 450,000 people, including such major figures as Bartók, Josephine Baker, Chaplin, Nijinsky and Picasso. Angelo was an important teacher of photography, and more than fifty Hungarian photographers studied under him. In September 1945 he announced the establishment of the Angelo Photography Academy in Budapest, which boasted the involvement of the most famous professional photographers and lecturers. His style developed from pictorialism to Surrealism. He was a founder member of the Association of Hungarian Photographers in 1956. In addition to several major awards, he received the French Minister of Art's award in 1961 and the Niépce–Daguerre Medal in 1960.

János Babai

b. 1897
d. 1978

János Babai ran a photographic studio in Kőszeg from the 1930s. In 1944 he took several photographs of the deportation of Jewish people from the ghetto in Kőszeg.

Demeter Balla

b. 4 May 1931, Szentes

Balla began taking photographs at the age of nineteen, using a Voigtländer Bessa lent to him by a friend. In 1952 he enrolled in a photography course at MADOME photo club in Budapest, where he was taught by F. G. Haller. He began work as a photojournalist in 1957. From 1969 until his retirement, he was a member of the staff of the Magazine Publishing Company in Budapest. He won the Béla Balázs Prize in 1977 and the Kossuth Prize in 2004. He has been interested in portrait photography as well as photojournalism. His portraits exhibit a great respect for his models. Latterly, Balla turned to still-life, publishing several volumes. His *Legyen meg a Te akaratod* (*Thy Will Be Done*) received the Beautiful Hungarian Book Award in 1994.

Rudolf Balogh

b. 1 September 1879, Budapest
d. 9 October 1944, Budapest

Balogh was a pioneer Hungarian photojournalist and the principal exponent of the so-called Hungarian style in photographic art. He began taking photographs at the age of fourteen using a Zeiss camera, helped initially by his art teacher at school, Miroslav Ruby. After school, he continued his photographic studies at the Höhere Graphische Lehr- und Versuchsanstalt in Vienna, then spent two years refining his skills in Munich, Görz and Constantinople. Balogh became a photojournalist for *Vasárnapi Ujság* (*Sunday News*) in 1902 and opened a studio in Budapest in 1912. When war broke out in 1914, he became a war correspondent for the Austro-Hungarian army, photographing battle scenes and everyday life in the trenches. From 1920 he worked as a photojournalist for *Pesti Napló* (*Pest Diary*). His photographs taken for that newspaper inspired two or three subsequent generations of photographers, and he played an instrumental role in the careers of Martin Munkácsi, Károly Escher and Ernő Vadas. He became a leading figure in Hungarian photographic life, playing a key role in the development of professional photographic magazines, becoming editor of *A Fény* (*The Light*) in 1911 and founder of *Fotóművészet* (*Photo Art*) in June 1914. Because of the outbreak of war, only three issues of the latter title were published, but it was highly regarded. In 1930 Balogh became the editor of *Fotóművészeti hírek* (*Photographic News*). In 1932 he was appointed as photographic laboratory manager at the Hungarian Film Bureau, where he worked until his death. A highly innovative and skilful photographer, he was one of the first to experiment with Autochrome, an early colour process.

András Bánkuti

b. 17 May 1958, Budapest

The photographer and reporter András Bánkuti qualified as a professional photographer in 1978. He joined the Studio of Young Photo Artists in 1982 and the Association of Hungarian Photographers in 1986, and won the Rudolf Balogh Prize and the Pulitzer Prize in 1993. In addition to his photojournalistic work, he has contributed to Hungarian photography by assisting Károly Kincses and Magdolna Kolta in organising the reconstruction of the Mai Manó House in Budapest; he served as its acting director between 2005 and 2006. He has initiated and administered several press-photo exhibitions and yearbooks, and is a member of various photographic committees and bodies. He is currently head photographic columnist at the weekly newspaper *Heti Világgazdaság* (*Weekly World Economy*) and is also editor of the magazine *Fotóriporter* (*Photo Reporter*).

Nándor Bárány

b. 31 May 1899, Kisbér
d. 6 October 1977, Budapest

Bárány was a theoretical optician, a specialist author, a mechanical engineer, a university lecturer, an associate member of the Hungarian Academy of Sciences, and recipient of *American Photography*'s Honourable Mention Award. In 1932 he was involved in the creation of a soft-lens system, which was sold under the name Hafár by the company HAFA. He was the first person in Hungary to produce 'T' reflection-reducing coating. As a practising photographer, he was keen to experiment, and was one of Hungary's first exponents of New Objectivity. His primary aim was to manifest abstract ideas in photographic form. He wrote many specialist works, including the six-volume series *Optikai műszerek elmélete és gyakorlata* (*Theory and Practice of Optical Instruments*) (1947–56), a standard text in the fields of optics and photography. Between 1931 and 1939 he received eighteen awards at foreign exhibitions. In 1951 he was awarded the Kossuth Prize in recognition of his work.

Imre Benkő

b. 17 February 1943, Kispest

Imre Benkő became interested in photography at the age of twenty; five years later his work was awarded the main prize of the National Exhibition for Young Photographers from the KISZ KB (Central Committee of the Alliance of Communist Youth). He was a founder member of the Studio of Young Photo Artists (1976–81) and became an exponent of subjective documentary. Benkő always works in black and white, producing full-frame compositions in which the perforations of the negative film can be seen on the positive prints. He received the Béla Balázs Prize in 1981, the Pulitzer Prize in 1991 and World Press Photo silver and gold medals. He has composed several excellent photo-essays, including the acclaimed *Acélváros: Ózd* (*The Steel City of Ózd*), in which he documented the collapse of one of communist Hungary's industrial centres. In recognition of this work, he won a scholarship in 1992 from the W. Eugene Smith Memorial Fund, New York. He has taught several generations of photographers and continues to teach at several institutions.

Zoltán Berekméri

b. 1 July 1923, Kecskemét
d. 21 May 1988, Pomáz

Zoltán Berekméri began taking photographs at the age of fourteen with a box camera. He later used his younger brother's Rolleicord. After graduation from commercial high school in 1942, the same year as he was Hungarian Student Photographer Champion, he became a post-office employee. Aged thirty-five, he moved to Budapest at the behest of Kata Kálmán. He became a photographer for the Petőfi Literary Museum in the city, making tens of thousands of photographic reproductions of interiors and art objects between 1958 and 1978. This was the most creative period of his career. His specialist fields were landscape, still-life and genre. Berekméri worked against the dominant social-documentary style of the period, and his pictures are completely free of these influences. They are characterised by high professional standards. After twenty years' service at the Petőfi Literary Museum, during which time Berekméri composed a famous composite self-portrait, he was admitted to the psychiatric home in Pomáz, where he was to receive treatment for the rest of his life. In 1995 Mihály Gera began publishing the series *Fényképtár* (*Collection of Photography*), which is designed to fill gaps in Hungarian photographic history, with a presentation of Berekméri's work.

Ferenc Berendi

b. 28 January 1917, Salgótarján
d. 17 April 1994, Budapest

Ferenc Berendi studied at the Academy of Fine Arts in Bratislava, graduating in graphic design and photography. Although he remained a painter throughout his life, he achieved greater professional success in photography. He was a founding member of the Association of Hungarian Photographers, which was established in July 1956. During the 1956 Hungarian Revolution he took photos for *Szabad Föld* (*Free Land*), a daily newspaper that employed him from 1949 until his retirement, thirty years later. He was equally at home in landscape photography, reportage photography and portraits. His photographs may be found in the journal *FOTO* during the 1960s and the 1970s, and in photographic yearbooks of the period. His photographic legacy is preserved in the Hungarian Museum of Photography, Kecskemét, and in Nógrád History Museum, Salgótarján.

Ferenc Berkó

b. 28 January 1916, Nagyvárad
(now Oradea, Romania)
d. 18 March 2000, Aspen, Colorado

Berkó left Hungary on the death of his mother when he was only two years old. He lived with foster parents in Berlin from the age of fourteen, and moved to Frankfurt when he was sixteen. He was greatly influenced by the modernism in his foster parents' home and by the Bauhaus and its exponents László Moholy-Nagy, Walter Gropius and Marcel Breuer. In 1933 he began studying philosophy in London but, finding it difficult to obtain a visa, he divided his time between London and Paris. In 1936 Berkó won £5,000 in a photography competition organised by Boots. One of his pictures was enlarged into an enormous poster by the Leitz factory, and he made short films at the Film Art company in London. His photographs were published in British, American and French newspapers, including *Lilliput, Coronet, Photography, The Naturalist* and *Paris Magazin*. In 1938 he became the British Indian Army's photographer and filmmaker in India, before opening a portrait studio in Bombay. In 1947 Moholy-Nagy invited him to teach photography and filmmaking at the Chicago Institute of Design. After photographing the Goethe Bicentennial Convocation in Aspen, Colorado, he decided to make his home there. In 1951 he organised a conference attended by many prominent American photographers, which led to the establishment of the photography magazine *Aperture*. He was a pioneer in the use of colour photography and was well-known for nude photography, applied (industrial and advertising) photography and portraits of famous people.

Éva Besnyő

b. 29 April 1910, Budapest
d. 12 December 2003, Laren, Holland

Éva Besnyő was born into an affluent Jewish family. Her father, a lawyer, wanted her to continue her studies after school, but she decided to become a photographer, and studied under József Pécsi from 1928. She moved to Berlin in 1938, working for a time as an advertising photographer for René Ahrlé and then, in 1931, for the photo reporter Peter Weller. This meant that many of her photographs were published in the *Berliner Illustrirte Zeitung* under his name. She came into contact with other young left-wing Hungarians residing in Berlin; György Kepes was a close friend. In 1932 she photographed servants and peasants in Hungary, then moved to Amsterdam and opened a studio there. During the Nazi occupation of Holland, she could not work because of her Jewish ancestry. She went into hiding, photographing peasant children clandestinely. In 1958 she won a gold medal at the first Venice Photography Biennale. In the 1970s she documented the activities of the feminist action group Dolle Mina. In 1974 she was commissioned by the Amsterdam Art Foundation to photograph the series 'Women's Occupations'. In 1975 she published a book about the first five years of Dolle Mina entitled *Hey girl, it's only now that I've become truly conscious*. In 1994 the Dutch Ministry of Culture awarded Besnyő its Life's Work Prize.

Brassaï

(Gyula Halász)
b. 9 September 1899, Brassó (now Brasov, Romania)
d. 7 July 1984, Paris

Brassaï left Hungary for Berlin as a young man. He worked as a journalist and enrolled in a course at the Kunstgewerbschule. He met the well-known Hungarian painter Lajos Tihanyi (see fig. 8), who became a good friend. In 1924 Brassaï moved to Paris, where he lived until his death. On his arrival in Paris he showed no interest in photography, but worked as a journalist and painter, developing contacts with other Hungarian émigrés. In 1925 a friend introduced him to the photographs of Jean-Eugène-Auguste Atget, whose example he later sought to follow. In 1926 he became acquainted with André Kertész, and accompanied him on his photographic trips. Kertész taught him the basics of photography, and in 1929 Brassaï began taking his own photographs. His book *Paris de Nuit* (1932; fig. 3, cat. 184) attained international success. In his heart, he always wanted to be an artist: he used the pseudonym Brassaï for his photographic work, and his given name Halász for his paintings, which he hoped would establish his reputation for posterity. In 1932 he published in the Surrealist magazine *Minotaure*, and became friendly with Picasso. The friendship led to a volume of interviews, *Conversations with Picasso* (1964). From 1935 until 1947 Brassaï worked for the agency Rapho. For several decades after 1937 he worked for *Harper's Bazaar*. After the war, he tried his hand at designing stage sets, working alongside such figures as Jean Cocteau and Jacques Prévert. During the 1950s he also became involved in film, achieving several significant successes in the field: at the 1956 Cannes Film Festival, he won the award for the most original film. In addition to numerous awards and prizes, in 1976 Brassaï received the French Order of Merit in recognition of his work.

Cornell Capa

(Kornél Friedmann)
b. 14 April 1918, Budapest
d. 23 May 2008, New York

The younger brother of Robert Capa, Cornell Capa was introduced to photography as an apprentice in the Paris studio of Emmeric Fehér, where he had hoped to learn French. He arrived in the United States in 1937, and adopted the new surname of his elder brother. Initially, he worked in the darkroom at *Life*, but in the 1940s and 1950s he worked for his brother at the PIX photo agency. He became an American citizen in 1943. After the Second World War, he began working as a photojournalist, becoming a staff photographer on *Life* in 1948. During this period, his most important reports were made in South America. In 1954 he became a member of Magnum Photos, becoming its director in 1956, a position he held for three years. In addition to his photographic work, he organised exhibitions and courses in photography and published several works. He regarded the creation of the International Center of Photography in New York City as his main achievement. He served as director of the Center from its establishment in 1974 until 1995.

Robert Capa

(Endre Ernő Friedmann)
b. 22 October 1913, Budapest
d. 25 May 1954, Thai Binh, Vietnam

Capa became interested in journalism a year before graduating from high school. He began taking photographs in 1930. In the same year, he was arrested after taking part in a left-wing demonstration, and had to leave Hungary. He went first to Berlin, where he became a student at the German Political College. Short of money, he took a job in the darkroom of the Dephot photo agency, where he received his first Leica from Simon Guttman. Guttman gave him an assignment to photograph Trotsky at the Socialist Congress in Copenhagen in 1932. In 1933 Capa moved to Paris, where he changed his name, thinking his boyhood nickname (Capa is the Hungarian word for shark) sounded right for a fictitious American photographer. In 1936 he travelled to Spain, having been commissioned to photograph the Civil War. His *Death of a Loyalist Militiaman* (cat. 108) brought him recognition and has become a photographic classic. Thereafter, Capa never looked back, travelling to wherever there was armed conflict. During the Second World War, he took photographs in England, North Africa, Sicily and Italy. On D-Day he accompanied the first American troops to land on Omaha Beach. In 1947 he joined with David Seymour, Henri Cartier-Bresson and George Rodger to found Magnum Photos. He revisited Hungary, where he photographed the country's post-war reconstruction and the slow but inevitable communist takeover. In 1954 he was sent by *Life* to photograph the conflict in Vietnam; he stepped on a landmine near Thai Binh and was fatally wounded. Capa's most famous remark was: 'If your pictures aren't good enough, you're not close enough.'

Tibor Csörgeő

b. 9 January 1896, Budapest
d. 29 July 1968, Budapest

Csörgeő, a founder member of the Association of Hungarian Photographers, was taught by Ernő Vadas, Kálmán Szöllőssy and Rudolf Járai. He worked in Angelo's studio from 1945 to 1946, and became a leading exponent of the so-called Hungarian style. His fine photographs covered a wide range of subject-matter. A pioneer of colour photography in Hungary, he won a national prize for his colour slides in 1942. He was a member of several foreign photography clubs, and in 1945 he was asked to head the Sydney photographic academy. He was the author of numerous articles in the major professional journals.

Sándor Ék

b. 27 August 1902, Szentmihályfa
d. 15 January 1975, Budapest

In 1915 Sándor Ék studied at the Proletarian Art Workshop in Budapest, where he was taught by Béla Uitz and József Nemes Lampérth, and took part in the young workers' movement. In 1921 he attended the Communist Youth International in Moscow, where for several months he was a pupil of El Lissitzky at the VHUTEMAS Fine Art and Technical Workshop in Moscow. From 1925 he lived in Germany, becoming a member of the Communist Party of Germany and the Assoziation Revolutionärer Bildender Künstler Deutschlands. He was a draughtsman for *Rote Fahne, Knüppel, Roter Pfeffer, Eulenspiegel* and the *Arbeiter Illustrirte Zeitung*. In 1933 he left Germany for the Soviet Union, returning to Hungary as a Red Army soldier in 1944. In 1948 he became director of the Museum of Applied Arts, Budapest, and in 1949 was appointed to head the Department of Graphic Art at the College of Fine Arts, Budapest. Although his early works were produced in an energetic cubo-futurist style, he soon consciously rejected avant-garde Constructivism. Influenced by his own life experiences and commitment to the workers' movement, he turned to realism. His newspaper illustrations and posters used elements of caricature to juxtapose the 'class enemy' with the heroic worker. His depictions of workers and his photographs evoking the history of the workers' movement reflect Soviet realism, as do his idyllic genre scenes and his portraits.

Károly Escher

b. 21 October 1890, Szekszárd
d. 16 February 1966, Budapest

Escher studied engineering and technical drawing, and qualified as a professional engineer. He had become interested in photography at the age of ten, making himself a camera out of a cigar box. He received his first proper camera at the age of twelve. At various times in his life, he worked as an engineer and film cameraman. He was helped in his career as a professional photographer by the amateur Imre Belházy, who gave him theoretical and technical advice. In 1928 Rudolf Balogh invited him to work as a photojournalist for the magazine *Az Est* (*Evening*) as a replacement for Martin Munkácsi, who had gone to Germany. Escher became one of the most important figures in Hungarian photojournalism and a pioneer of 35 mm photography: if something newsworthy happened, he would be there with his Contax camera. His work was free of political bias, although he used it to fight poverty and injustice. He was one of the first photographers to use blurred motion. He achieved success at domestic and foreign exhibitions, receiving first prize at the exhibition 'Modern Photography' in London in 1931, the grand prix at the World Exposition of Applied Arts in Milan in 1934 and the gold medal at the First International Photography Exhibition in 1957. After the Second World War, he worked for numerous newspapers and magazines, including *Képes Világ* (*World Illustrated*), *Képes Figyelő* (*Visual Observer*) and *Hungarian Foreign Trade*. In 1965 he received the Distinguished Artist of the Hungarian People's Republic award in recognition of his work.

László Fejes

b. 23 November 1935, Pápa
d. 26 January 1985, Budapest

After leaving school, Fejes worked for a time in a telephone factory and from 1957 as an unskilled worker at the Budapest Photographic Company. He later became a successful photojournalist, winning the AFIAP Award of the Fédération Internationale de l'Art Photographie in 1971 and the Béla Balázs Prize in 1983. From 1964 to 1985 he worked as a journalist for the magazine *Film Színház Muzsika* (*Film Theatre Music*), taking photographs of everything 'from birth to death'. His made his reputation taking jazz and theatre photographs. In 1966 he was the first Hungarian photographer to win a prize in the artistic section of the World Press Photo competition, with his photograph *Wedding* (cat. 163).

Tamás Féner

b. 17 November 1938, Budapest

Féner, a leading figure in Hungarian photographic life from 1970 to 1990, worked first as a photojournalist and photographic editor for several major newspapers and magazines: in 1957–86 he was a photographer and artistic editor for the magazine *Film Színház Muzsika* (*Film Theatre Music*) and in 1986–90 deputy chief editor of *Képes 7* (*Pictorial Weekly*). His initial focus was art and ballet, but he later turned his attention to social themes (gypsies, miners and Jewish issues). His photographic essays reveal a determination to improve society. His methodology was to learn as much as he could about a topic, sometimes spending years at a particular location. His work is characterised by unusual camera angles and novel cutting and editing techniques. He was one of the initiators of photography courses in Hungarian higher education and helped to place the members of the Association of Hungarian Photographers on a professional footing. From 1978 to 1986 he served as general secretary of the Association of Hungarian Photographers and was a founder member and first chairman of the Studio of Young Photo Artists. Since 1992 he has taught at the Faculty of Anthropology and Media Studies of Eötvös Loránd University, Budapest, and at the Further Training Institute of the University of Applied Arts in the same city. He is also a leading professor at the Népszabadság Training Centre, Budapest, where he offers courses in photojournalism. He won the EFIAP Award in 1971, the Béla Balázs Prize in 1973, the Honoured Artist Award in 1984, the Budapest Commemorative Medal in 1997 and the Excellent Artist Award in 2005.

Károly Gink

b. 4 February 1922, Iván
d. 10 May 2002, Budapest

Gink published more books than any other Hungarian photographer. He was, directly or indirectly, a mentor for several artists working in the field of photography. More than 200 exhibitions of Gink's work have been held in Hungary and abroad. His career began in 1942 when he worked for László Várkonyi in his studio. In 1955 he became a freelance photographer and in 1956 a founder member of the Association of Hungarian Photographers. In 1990 he was appointed chairman of the Chamber of Hungarian Photojournalists. He also became an honorary member of the Association of Danish Photographers. He was awarded the Béla Balázs Prize in 1970 and the József Pécsi Prize in 1982. In 1989 he received the Excellent Artist Award and the Life's Work Award of the Association of Hungarian Photographers.

Ferenc Haár

b. 19 July 1908, Csernátfalu
d. 22 December 1997, Honolulu

Haár graduated from the National College of Applied Arts in Budapest in 1927. In 1929 he became a member of the group that formed around the writer and thinker Lajos Kassák, and became a left-wing photographer with a concern for social issues. In the 1930s he became a professional photographer, specialising in the fields of interior design and architecture. In 1934 he was appointed director of Olga Máté's studio and a year later founded his own studio. Several of his photographs were exhibited at the Paris World Exposition in 1937. There he became acquainted with Brassaï, the sculptor József Csáky, and Victor Vasarely. He moved to Paris in 1938, where he operated a studio. In 1940 he began filming in Japan and opened a studio in Tokyo. From 1956 until 1959 he lived in Chicago. From 1960 until his death he lived in Hawaii, where he taught photography at the university and produced book illustrations. He received the highest acclaim for his photography. His major works include the advertising and still-life photographs he took in the 1930s, which show his commitment to the sociographic style and New Objectivity. The book illustrations that he produced in Tokyo are also significant.

László Haris

b. 9 February 1943, Budapest

Haris is an avant-garde photographer who has tended to work with artists. In the 1970s he was the only photographer in the Szürenon Group, and he has exhibited on several occasions at the legendary Chapel Gallery in Balatonboglár. His photography often concerns itself with the magnification of a tiny piece of reality or the detail of an artwork; it also makes use of film footage. Haris won the Annual Poster Award in 1985, the Art Directors Club Award in 1990, and the Tell Prize of the Visual Arts Department of Hungarian Television in 1997.

Kati Horna

b. 19 May 1912, Budapest
d. 19 October 2000, Budapest

Born as Kati Deutsch in Budapest, Horna studied photography at József Pécsi's studio. There she met Robert Capa, who became a close friend. In 1933 she moved to Paris and subsequently photographed the Spanish Civil War. The people in her photographs were mainly civilians, women and children, all struggling to survive behind the battle lines. It was in Spain that she met her husband, José Horna. In 1939 the couple travelled to New York and from there to Mexico City, where they settled in the Colonia Roma district of the city. Kati Horna worked as a photographer and her husband as a sculptor. As a prominent member of the community of European émigré artists, Horna instructed a generation of Central American photographers.

Rudolf Járai

b. 12 October 1913, Trieste
d. 4 July 1993, Budapest

Járai was a leading figure in the second generation of photographers pursuing the Hungarian style. From 1935 until 1948 he worked for the Hungarian General Credit Bank, where he began taking photographs under the direction of Tibor Csörgeő. Numerous magazines, such as *Új Idők* (*New Times*) and *Pesti Napló* (*Pest Diary*), published his urban and tourism photographs in the Hungarian style. Virtually all his positives and negatives were destroyed during the Siege of Budapest in 1944. A full-time photographer from 1948, he was a founder member of the Photographic Artisan Production Co-operative in the same year, but he also worked for the photographic department of the Hungarian News Agency, where he served as technical director from 1957 until 1973. He joined the Association of Hungarian Photographers in 1957. He received the EFIAP Award in 1958 and the József Pécsi Prize in 1985. He acquired a reputation for advertising, aerial and urban photography. He also published several articles and books, which have become standard texts for Hungarian photographers.

Gyula Jelfy

b. 13 December 1863
d. 9 January 1945

Gyula Jelfy was a prominent figure in the first generation of Hungarian photojournalists. His *œuvre* included society events, political reports, sport and theatre pictures, as well as battlefield coverage. He recorded the Archduke Friedrich's meeting with Admiral Horthy, but he also photographed the burning of the Bratislava ghetto, the unveiling of statues, the start of the Constantinople–Budapest motor race, and the attempted return of King Charles I to Hungary. In 1914 he arrived at the front as a journalist working for the weekly newspaper *Vasárnapi Ujság (Sunday News)*. He travelled to all the theatres of war where Austro-Hungarian troops were fighting, and produced some 1,000 photographs during the war years. He was registered as an assistant photographer in 1882, and his first-known photography studio opened in the 1920s.

Kata Kálmán

b. 25 April 1909, Korpona
d. 31 March 1978, Budapest

Kálmán graduated from high school in Komárom in 1927. She then enrolled at the Alice Madzsar Dance and Movement Art School in Budapest, where, in addition to mastering the Mesendieck system of movement, she became acquainted with Kata Sugár, who was to become the other leading exponent of sociographic photography. She also met the photographic aesthete Iván Hevesy, whom she married in 1929. He encouraged her to take up photography in 1931. She soon developed her own style, almost immediately producing her famous picture of a child eating bread, *Laci Varga, Four Years Old* (cat. 41). Initially, she made sociographic portraits of peasants, the unemployed and children. The influence of New Objectivity can be seen in these pictures. In 1937 she published her highly successful book *Tiborc* (fig. 25; cat. 191). Two further albums followed: *Szemtől-szembe* (*From Eye to Eye*, 1940) and *Tiborc uj arca* (*Tiborc's New Face*, 1955). She took portraits of important figures in Hungarian cultural life, such as Béla Bartók, Ditta Pásztory and Zsigmond Móricz. She was an accomplished editor and was instrumental in the launch of a series of books on photographers published by Corvina. The last in the series – on her own life and work – was published just after her death. She was a recipient of the Béla Balázs Prize in 1969 and the Honoured Artist Award in 1976.

György Kepes

b. 4 October 1906, Selyp
d. 29 December 2001, Cambridge, Mass.

György Kepes was a pupil of István Csók at the College of Fine Arts in Budapest from 1924 to 1928. From 1928 he belonged to Lajos Kassák's Work Circle, where he learnt about Constructivism. For a time he gave up painting and turned to social-documentary photography, photograms and photomontages. From 1930 he worked alongside László Moholy-Nagy in Berlin and London. In Berlin many artists, including Éva Besnyő, congregated around him. Between 1935 and 1937 he made photograms. In 1937 he moved to Chicago, where he became head of the light and colour department at Moholy-Nagy's School of Design. In 1944 he wrote about his years in Chicago in a work entitled *Language of Vision*. In 1945 he became professor of visual planning at the Massachusetts Institute of Technology. During his years at MIT he came into contact with such prominent figures as Marcel Breuer, Charles Eames, Erik Erikson, Walter Gropius and Jeroma Wiesner. In 1965–66 he published *Vision and Value*, a six-volume collection of essays on social themes and architecture with a critique of the language of vision. In 1966 he called for closer co-operation between artists and designers, those working in architecture, urban planning and musical composition. In the autumn of 1967, the Center for Advanced Visual Studies opened in Cambridge, Mass.; Kepes directed the centre until his retirement in 1974. In 1991 he donated more than 200 of his works to the city of Eger in northern Hungary; most are displayed in a permanent exhibition. Eger has since become a venue for international symposiums on light. The International Kepes Society, which seeks to foster the artist's legacy, is based in the city.

Gábor Kerekes

b. 2 August 1945, Oberhart, Germany

After graduating from high school, Kerekes taught himself photography while working as a waiter. He went on to become a leading figure in Hungarian experimental photography. He has always distinguished between his artistic work and his other photographic assignments. In 1973, after qualifying as a professional photographer, he became a reporter for the Budapest Photographers' Co-operative. After several positions in photography, in 1971 he became a member of the editorial board of *Képes 7* (*Pictorial Weekly*), Hungary's leading Hungarian weekly magazine at the time. He is a precise but daring photographer, whose technical repertoire extends from the camera obscura and historical processes to professional, large-format equipment. In recent years, he has addressed the neglected relationship between art and science. Kerekes joined the Association of Hungarian Photographers in 1980. For several years he was artistic director of the Studio of Young Photo Artists. He was awarded the prize of the Hungarian National Association of Journalists in 1988 and the Béla Balázs Prize in 1990. In 1995 he joined forces with György Stalter to found the ASA photo studio in Budapest, where he has taught ever since. *Seventies-Eighties*, a monograph published by the Hungarian Museum of Photography, Kesckemét, in 2003, contains his work of more than thirty years.

István Kerny

b. 25 August 1879, Szeged
d. 13 June 1963, Budapest

Kerny was active as a photographer for more than sixty years, and thus became acquainted with almost all photographic techniques and procedures. He was a driving force behind the so-called Hungarian style. He tried his hand in all fields of photography, and published more than 44 articles on the art. He and Ervin Kankowszky founded the Amateur Photographic Museum in Budapest, whose irreplaceable collection was destroyed in 1944. His pictures were published in several major newspapers and magazines (*Uj Idők* [*New Times*], *National Geographic*). He served as general secretary of the Association of Hungarian Journalists from 1930 to 1932 and became a member of the Association of Hungarian Photographers in 1957. Kerny won the Nièpce–Daguerre Award in 1959 and the AFIAP Award in 1960.

André Kertész

(Andor Kertész, originally Kohn)
b. 2 July 1894, Budapest
d. 28 September 1985, New York

Kertész graduated from commercial high school in 1912, and started work at the Budapest Stock Exchange. He taught himself to be a photographer, and a friend, László Chmura, advised him on developing his pictures. In late 1914 he was called up into the army, and took a Voigtländer in his pocket to the front. During the war, he took his first two pictures to be published in magazines. In 1925 he moved to Paris, exchanging the life of a clerk for that of an artist, achieving success with a profoundly humanist, subjective and unique style, a style that has made him one of the greatest photo-artists of all time. As Henri Cartier-Bresson said: 'Whatever we have done, Kertész did first.' In Paris, Kertész worked for such publications as *Vu*, *The Sunday Times* (London), *Berliner Illustrirte Zeitung* and *Uhu*. He encouraged both Brassaï and Robert Capa to try their hand at photography. His first exhibition was held in Paris at the Sacre du Printemps Gallery in 1927. In 1936 he travelled to America at the behest of Keystone Studios, intending to stay a few months. The outbreak of war kept him there. From 1937 until 1949 he worked as a freelance photographer, receiving assignments from *Look*, *Harper's Bazaar* and *Vogue*. In 1944 he became an American citizen. From 1963 until his death, he devoted himself to sorting and publishing his life's work, always continuing to take photographs. He was highly acclaimed and received many awards. During a 1984 visit to Hungary, he received the Order of the Flag of the Hungarian People's Republic, the only photographer thus far to have received this prestigious award.

Imre Kinszki

b. 10 March 1901, Budapest
d. spring 1945

Imre Kinszki was born in Budapest to assimilated Jewish parents. He studied medicine at university, but lost his place after the introduction of the Numerus Clausus, which limited the number of Jewish students. He found work in the archives of the National Association of Industrialists in Budapest. He was interested in the natural sciences, and took photographs using a microscope. He wrote articles about the textile industry, published essays on philosophy, and explored Hungarian literature. In 1926 Kinszki received his first camera, from his wife; in 1930 he invented the KINSECTA camera, to take close-up photographs. From 1931 to 1936 he was a member of the National Association of Hungarian Amateur Photographers. From the early 1930s he regularly published articles in Hungarian and foreign photography magazines. His essay 'Shadows of the Past' was published in the magazine *Fotóművészeti Hírek* (*Photo Art News*) in 1936. In 1937 he established the Modern Hungarian Photographers Group, which organised the Daguerre Centenary Exhibition. This was followed by the publication, in 1939, of an album entitled *Magyar Fényképezés* (*Hungarian Photography*), co-edited by Kinszki. In the same year he converted to the Greek Catholic faith. However, in 1943 he was drafted into forced labour because of his Jewish ancestry. He died while marching to Sachsenhausen concentration camp early in 1945.

Péter Korniss

b. 4 August 1937, Kolozsvár (now Cluj, Romania)

Péter Korniss moved to Budapest from Transylvania in 1949. He attended Eötvös József High School before enrolling in a course in law at Eötvös Loránd University, Budapest. He was expelled from university for taking part in the 1956 Revolution. The following year he became an unskilled worker at the Budapest Photographers' Co-operative and in 1961 qualified as a professional photographer. A photojournalist, Korniss has received acclaim for his reports on the disappearing world of Transylvania. At a time when Transylvania was a sensitive subject, he held exhibitions of his photographs taken there. A sensitive and responsible photographer, he has never been satisfied with superficialities, but has treated his subject-matter in great depth. From 1961 until 1987 he worked as a photojournalist for *Nők Lapja* (*Women's Weekly*), where he served as photographic editor between 1987 and 1989. From 1991 until 1999, he was photographic editor at the magazine *Színház* (*Theatre*). Over a period lasting almost a decade, he created the photographic essay *Vendégmunkások* (*Guest Workers*; cats 166.1–5). He has produced several television broadcasts on photography (*Fotózz velünk*, 1965, and *Fotográfia*, 1975) and served as a member of the World Press Photo jury in 1977–80. His first photographic exhibition in 1974 was a milestone in Hungarian photography. Korniss has won several awards and prizes, including the Béla Balázs Award in 1975, the Honoured Artist Award in 1983, the Order of Merit of the Republic of Hungary, Commander's Cross, in 1996, the Kossuth Prize in 1999, and the Pulitzer Memorial Prize in 2004.

György Lőrinczy

b. 22 April 1935, Budapest
d. 27 May 1981, New York

Lőrinczy was the first Hungarian photographer to publish a photographic essay that was a book in its own right, rather than merely a set of illustrations. The volume, entitled *New York, New York* (fig. 32; cat. 193), was published in 1972. Lőrinczy worked in several fields of photography, including photojournalism, printing and advertising. He also published several works on photographic theory. In 1965, in conjunction with Zoltán Nagy and Csaba Koncz, he held an exhibition at the Builders' Club that is considered one of the most important shows of Hungarian avant-garde photography. Lőrinczy left Hungary for America in 1973, where he over-painted his photographs with acrylic paint on stretched paper, adding the emulsion by hand. He staged his first one-man exhibition in New York in 1981, but died just a month later.

Olga Máté

b. 3 January 1879, Szigetvár
d. 5 April 1965, Budapest

Máté was a portrait photographer who opened a studio in Budapest in 1899. She studied photography in Berlin and Dresden from 1907 to 1909, under Nicola Perscheid and Rudolf Dührkoop. In 1911 she joined the staff of the photography magazine *A Fény* (*The Light*). In 1912 she opened a new studio, which became a meeting place for famous Budapest intellectuals. She became friendly with members of the 'Sunday Circle', including Károly Mannheim, Arnold Hauser, Béla Balázs and György Lukács. Máté's husband Béla Zalai was a philosopher who died during the First World War. In 1912 Máté was awarded – with József Pécsi – the gold medal of the 5th Congress of the Association of International Professional Photographers in Paris and her work was recognised in various competitions. She was involved in many fields of photography, from classical studio portraits to dance photography. She was also an exponent of architectural and still-life photography in the Bauhaus style. A monograph on her work was published by Csilla E. Csorba in 2006.

László Moholy-Nagy

(László Weisz)
b. 20 July 1895, Bácsborsód
d. 24 November 1946, Chicago

After graduating from high school in Szeged, László Moholy-Nagy moved to Budapest, where he enrolled as a law student. Following the outbreak of the First World War, he enlisted and was seriously wounded in battle. During his stay at the military hospital he began to draw and paint. In 1919 he was forced to flee to Austria, where he became acquainted with Lajos Kassák, the avant-garde poet, novelist, painter, essayist, editor and thinker. At Kassák's suggestion, Moholy-Nagy joined the Bauhaus, where he was asked to teach, and where he helped to develop the theoretical programmes and ethos of the school. In Berlin he met his first wife Lucia Schultz, from whom he learnt the techniques of photography. With his extensive photographic experience and theoretical knowledge, Moholy-Nagy showed that it was possible to use light, shadow, space, mass, colour and drawing to make unconventional photographs. He was one of the first photographers to experiment with the photogram. He used photo-montage as a means of portraying reality in a novel manner. With the rise of fascism in Germany, he moved abroad. In 1937 he settled in Chicago (at the invitation of Gropius), where he helped to establish the New Bauhaus. When the New Bauhaus was dissolved, he established his own School of Design, which became the College of Design in 1944. He directed the college until his premature death from leukaemia.

János Müllner

b. 1870
d. 1925

Relatively little is known about Müllner's life, although his surviving photographs show that he was an outstanding member of the first generation of Hungarian photojournalists. They are all stamped 'János Müllner, Photo Illustrator', with an address in a working-class area of Budapest. Müllner's mostly political photographs were published in such Hungarian newspapers as *Uj Idők* (*New Times*), *Az Érdekes Ujság* (*Interesting Newspaper*), *Vasárnapi Ujság* (*Sunday News*) and *Az Est* (*Evening*) from 1894. He frequently photographed political demonstrations before the First World War. At the beginning of the war, he photographed soldiers preparing for active service, but spent the war years recording the impact of the conflict on Budapest and its inhabitants. He photographed the events surrounding the coronation of Charles IV as King of Hungary in 1916, and during the Hungarian Socialist Republic. His photographs are some of the earliest to favour a high viewpoint. His rich legacy is preserved at the Hungarian National Museum, the Historical Museum and the War History Museum (all in Budapest), as well as the Hungarian Museum of Photography in Kecskemét.

Martin Munkácsi

(Márton Munkácsi, Márton Mermelstein)
b. 18 May 1896, Kolozsvár
d. 13 July 1963, New York

Munkacsi moved to Budapest with his parents and six siblings at the age of fourteen, and left the family home – still as Márton Mermelstein – when he was sixteen, to work as a painter and decorator. He also wrote poetry and tried his hand at amateur drama. He became a journalist, illustrating his articles with his own photographs. At the age of eighteen, he was publishing articles regularly. He took up portrait photography alongside his journalistic career, opening several studios in Budapest. From 1924 he took sport photographs for such publications as *Az Est* (*Evening*), *Pesti Napló* (*Pest Diary*) and *Délibáb* (*Mirage*). As a sport photographer he aimed to produce novel compositions, often climbing onto a roof or up a ladder to find an unusual angle. He moved to Berlin in 1928. Having joined the publishers Ullstein Verlag, he became a fast-moving photojournalist, always on the spot when something happened. He photographed Zeppelin's airship and took portraits of Leni Riefenstahl and Kemal Atatürk. While still in Hungary, he had formulated his ideas about photojournalism: 'To see within a thousandth of a second the things that indifferent people blindly pass by – this is the theory of the photo reportage. And the things we see within this thousandth of a second, we should then photograph during the next thousandth of a second – this is the practical side of the photo reportage.' In 1934, in the face of growing fascism, Munkácsi emigrated to the United States, where he soon became New York's highest-paid photojournalist. His innovative approach to fashion photography for *Harper's Bazaar*, *Fortune* and *Vogue* brought motion and dynamism to the genre, which reached its zenith in the work of Richard Avedon. Munkácsi died of a heart attack while watching a football match.

József Pécsi

b. 1 April 1889, Budapest
d. 7 October 1956, Budapest

Pécsi graduated in photography in 1910 from the photographic college in Munich, where he was taught by Rudolf Dührkoop. He opened a studio in Budapest in 1911. He established photography courses at the Budapest Applied Arts School and is thus regarded as the founder of photography education in Hungary. He was dismissed in 1920, but later taught at the successor institution, the Fine Arts Lyceum from 1946 to 1948. In 1922 he became vice-chairman of the Budapest Industrial Guild of Photographers, where he was also a teacher and head of the examinations committee. He was editor of the guild's professional magazine, *Magyar Fotográfia* (*Hungarian Photography*), and chairman of the Industrial Guild. Pécsi was an art collector, researcher, innovator and inventor, and master of many 'alternative processes'. In the 1930s, however, he used aspects of New Objectivity and Kassák's pictorialism. He helped to create a school for advertising photography in Hungary and became an influential figure in portrait, nude and genre photography. He was the first Hungarian to receive the distinguished award for photography, the Dührkoop Medal, and also received recognition abroad. By 1940 he had won seventeen major awards, including five gold medals, five silver medals and many other trophies. His name is commemorated by the Pécsi József Prize and by a plaque on the wall of the house on Dorottya Street in Budapest where he had his studio.

Sylvia Plachy

b. 24 May 1943, Budapest

Plachy fled Hungary with her family in 1956 at the time of the Hungarian Revolution, aged only thirteen and carrying just a small suitcase and a teddy bear. The family arrived in New York in 1958, and she has lived there ever since. She later studied photography in New York, and was taught by André Kertész among others. Her first book, *Unguided Tour*, won the Infinity Prize for best book of the year in 1990. She has also published *Red Light* (1996), a book about the sex industry, and *Signs and Relics* (2000). She has won a Guggenheim fellowship, and her work is regularly published in the *New Yorker*, *TIME*, *Smithsonian*, *Geo* and the *Village Voice*. She has had solo shows at the Whitney Museum, the Queens Museum and the Minneapolis Insitute of Fine Arts, as well as in Budapest, Ljubljana, Manchester, Berlin, Vancouver, Tokyo, Perpignan, Arles and Pingyau (China). Her works are in numerous public collections, among them those of the Museum of Modern Art, New York, the Museum of Modern Art, San Francisco, and the George Eastman House, Rochester, New York.

Miklós Rév

b. 20 October 1906, Sátoraljaújhely
d. 22 May 1998, Budapest

Rév began taking photographs in 1923 while working as a carpenter. In 1934 he became a member of the Socialist Artists Group, taking photographs with Lajos Lengyel, Tibor Bass and Ferenc Haár. After the Second World War, he worked for several publications and, from 1957 until his retirement, was employed as a photojournalist by the newspaper *Népszabadság* (*People's Freedom*). He took fascinating series in many parts of the world, and made valuable contributions to the fields of stereo photography and photographic graphics. He is particularly remembered for classic photojournalism. He served as chairman of the Association of Hungarian Photographers from 1965 and subsequently as honorary chairman. He received the Béla Balázs Prize in 1970 and the Honoured Artist Award in 1973.

Révész and Bíró

b. 1895 | b. unknown
d. 1975 | d. unknown

'Révész and Bíró' stands for Imre Révész (Emery P. Révés) and his wife Irma Bíró. Révész became known in Hungary for his photojournalism, studio portraits and advertising photography. In 1919 he photographed street battles during Hungary's short-lived Soviet Republic and Count Mihály Károlyi, Prime Minister and later President of Hungary, as he entered in a register the name of the first war-wounded solider to receive a grant of land under land reforms. In 1932 Révész published *Photo-reklám* (*Photo-Advertisement*), a highly acclaimed book on advertising photography. In 1934 he moved to the United States, where he became an advertising photographer for United Artists. His advertising and fashion photographs were published in *Harper's Bazaar* and other leading magazines.

Dénes Rónai

b. 16 July 1875, Békésgyula
d. 8 April 1964, Budapest

Rónai began work as a carpenter. By 1939 he was an award-winning photographer, receiving the Nièpce–Daguerre Medal in that year. He was producer and cameraman on the first Hungarian film for children (1913), and was actively involved in puppet plays. Between 1929 and 1936, he was editor of the magazine *Magyar Fotográfia* (*Hungarian Photography*) and became an art collector. Although he was familiar with traditional photographic procedures, he was always open to new artistic styles. His contribution to photographic theory was substantial. In 1898, for instance, he won an award for his article 'Retus szükségessége és célja' ('The Necessity and Purpose of Retouching'). Later, he gave lectures at the Industrial Guild of Photographers in Budapest. Rónai invented various photographic techniques and procedures. In 1902, at the first German photography exhibition, he announced a 'paper invented and manufactured by himself'. He sold the method to a German company for a very small fee. The company then manufactured it under the name Mattalbumin and made a huge profit. In 1912, after five years of work, he produced a 'plastic photograph fixed in metal' that he called the 'photo plaque', for which a company in Philadelphia received the international patent. In 1950 he announced to the National Invention Office that he had invented a multi-layer bromide silver paper. In 1955 the Office informed him that 'ownership of the invention has been transferred to the Hungarian state'. Within a year, a well-known foreign company was manufacturing the paper. Many objects from Rónai's valuable art collection and archives were destroyed in 1945, when his studio was hit by a bomb. After the war, he opened another studio. He served as chairman and from 1948 as honorary chairman of the Budapest Industrial Guild of Photographers.

György Stalter

b. 11 January 1956, Budapest

Stalter qualified as a photographer in 1978. He then studied to be a photojournalist at the School of Journalism of the Association of Hungarian Journalists, graduating in 1983. He was a member of the Studio of Young Photo Artists from 1978 until 1983 and its secretary from 1983 until 1986. He has had various jobs, even working in the ambulance service for a time. From 1978 until 1988, he was a journalist at the magazine *Magyar Ifjúság* (*Hungarian Youth*). In 1993 a photographic essay on the life of the Roma community – compiled with his wife Judit Horváth – won a special prize in the press photo competition of the Association of Hungarian Journalists. Stalter is an active and creative photographer. In his youth he concentrated on nude photography, body landscapes and sociographic photographic essays. Today, however, portraits and photojournalism are his main areas of work. He received the Rudolf Balogh Prize in 1997 and the Association of Hungarian Photojournalists Prize in 2000.

Kata Sugár

(Katalin Ágnes Kalmár)
b. 3 September 1910, Szeged
d. 22 December 1943, Budapest

Born to affluent Jewish parents, Sugár was educated at prestigious Budapest schools. She moved in left-wing circles from an early age. Having finished her studies, she travelled to Timisoara, where her father had lived, but was deported from Romania for involvement in the communist movement. In 1932 she married the artist Andor Sugár. From 1934 she learned how to take photographs at Marian Reismann's studio. In the late 1930s she became mentally ill, underwent psychoanalysis, was admitted to hospital on several occasions, and seems to have attempted suicide more than once. She became increasingly unconfident about the value of her work and, shortly before her death, destroyed most of it. Portraits of peasants and workers make up most of her surviving photographs, along with landscapes, pictures of animals and children, and portraits of famous people. Her many portraits reveal her love for, and tenderness towards, her young sitters. Her photographs frequently show the influence of New Objectivity, particularly when the subjects are people in their surroundings. She liked to use diagonal settings, unusual camera positions and tight cropping. Like many of her contemporaries, she was interested in industrial forms, machinery and structures.

Kálmán Szöllősy

(Kálmán Schwerer)
b. 10 September 1887, Pécs
d. 31 July 1976, Budapest

Szöllősy began taking photographs in 1906, but it was only in 1932 – after many years of working for public and private firms – that he obtained a licence to work as a professional. In the 1920s he studied photography with Rudolf Balogh, Ervin Kankowszky and Iván Vydareny. His first published picture, a bromide oil print, appeared in 1927. He became an outstanding exponent of the Hungarian style, travelling through much of Hungary on foot or by bicycle to photograph folk costumes. He also received recognition for his genre and portrait photography and in particular for his nude photography. In 1928–29 he was in charge of publication of the magazine *Fényképészeti Hírek* (*Photography News*) and became the Hungarian member of the editorial board of *Die Galerie*. His photographs were frequently published in the world's leading photographic journals. Szöllősy's photograph *Gorky-illustration* received second prize in a competition held by *Die Galerie* in 1933 (Ernő Vadas won first prize for his photograph *Geese*). Szöllősy was a founder member of the Photographic Collective in 1945 and a founder member of the Association of Hungarian Photographers in 1956. He also organised a photographic delivery service, and published extensively on the theory of photographic techniques.

László Török

b. 20 April 1948, Budapest

Török qualified as a photographer in 1975, having already won a Golden Eye Award in the 1972 World Press Photo competition for *Family* (cat. 169). He joined the Association of Hungarian Photographers in 1979. In 1997 he was asked to head the Association's artistic committee. In 1991 he established the Pajta Gallery in Salföld, where he and Lajos Keresztes have staged exhibitions and workshops. He has also headed the First Active Artists Group. Török has made an important contribution to photography in Hungary. He has received recognition for his bi-tonal and long-exposure photographs and his nude photography in ironic settings (see cat. 169). His art photography is characterised by forward planning and thoroughness. The series *Roma*, which he produced in collaboration with Károly Bari, represents an important part of his life's work.

Tamás Urbán

b. 6 July 1945, Satu Mare, Romania

A founder member of the Studio of Young Photo Artists and its first secretary, Urbán started taking photographs in 1961, inspired to do so by the photojournalism of István Kotroczó. Urbán has worked as a photojournalist for several major newspapers and magazines, including *Ifjúsági Magazin* (*Youth Magazine*) between 1972 and 1990. He received the Béla Balázs Prize in 1975. In 1990 he moved to the newspaper *Blikk* (*Shot*), where he currently reports on crime. One of the few photographers able to portray the negative side of the communist régime, he compiled photojournalistic reports about the children's home in Aszód and about young drug addicts.

Ernő Vadas

b. 17 December 1899, Nagykanizsa
d. 30 May 1962, Budapest

Vadas studied photography as an amateur with Rudolf Balogh from 1927. He became one of the most successful photographers of the interwar period, receiving both the AFIAP and EFIAP awards. His well-composed pictures are characterised by the bold use of light and shadow, backlight, and artistic vigour. In 1934 the magazine *Die Galerie* awarded him its first prize of 1,000 gold francs, and the Royal Photographic Society awarded him its Emerson Medal for his photograph *Geese*. In 1938 the *American Photography Yearbook* placed him fifth among 13,424 exhibitors of photographic works. In 1936 he founded the Association of Modern Hungarian Photographers, which was later banned by the country's right-wing authorities. A concentration-camp survivor, Vadas returned to Hungary in late 1945. He was a founder member of the Photographic Collective in 1945, and also worked as a reporter for the Hungarian News Agency. As a teacher, he was instrumental in encouraging young people such as Rudolf Járai and Kálmán Szöllősy to make their careers in photography. He published extensively and acquired an international reputation. He attempted to combine the Hungarian style of photography with socialist realism, but as a result his work became, in the opinion of many, obsolete. He served as chairman of the Association of Hungarian Photographers from 1956 until his death.

Magdolna Vékás

b. 23 July 1956, Budapest

Vékás was a member of the Studio of Young Photo Artists from 1977 until 1981, and then joined the Association of Hungarian Photographers, becoming a founder of the First Active Artists Group. Since 1985, when she attended a workshop on photographic techniques in Gödöllő led by Károly Kincses (founding director of the Hungarian Museum of Photography, Kecskemét), she has attempted to use traditional processes such as albumen, salt paper, cyanotype and chromotype. These processes have given an extra dimension to her work. Vékás, who teaches at several colleges, received the Divald Károly Commemorative Plaque in 1998.

Further Reading

Where English editions are available these are listed.

Brassaï

Laure Beaumont-Maillet and Denoyelle and Dominique Françoise (eds), *La Photographie humaniste, 1945–1968, autour d'Izis, Boubat, Brassaï, Doisneau, Ronis*, Paris, 2006
Brassaï, *Conversations with Picasso*, Chicago, 2003
Brassaï, *Henry Miller, Happy Rock*, Chicago, 2002
Brassaï, *The Secret Paris of the 30s*, translated by Richard Miller, London and New York, 1978 (reprinted 2001)
Diane Elisabeth Poirier, *Brassaï: An Illustrated Biography*, Paris, 2005 (simultaneously published in French as *Brassaï: intime et inédit*)
Alain Sayag and Annick Lionel-Marie (eds), *Brassaï: 'No Ordinary Eyes'*, London, 2000 (original French edition Paris, 2000)
Anne Wilkes Tucker, with Richard Howard and Avis Berman, *Brassai: The Eye of Paris*, exh. cat., Museum of Fine Arts, Houston, 1999
Marja Warehime, *Brassaï: Images of Culture and the Surrealist Observer*, Baton Rouge, 1996

Robert Capa

Juan P. Fusi Aizpúrua, Richard Whelan and Catherine Coleman, *Heart of Spain: Robert Capa's Photographs of the Spanish Civil War*, New York, 1999
Cornell Capa, Henri Cartier-Bresson and Richard Whelan, *Robert Capa Photographs*, New York, 2005
Robert Capa, *Images of War, by Robert Capa, with Text from His Own Writings*, New York, 1964
Robert Capa, *Slightly Out of Focus*, New York, 1947
Diana Forbes-Robertson and Robert Capa, *The Battle of Waterloo Road*, New York, 1941
Alex Kershaw, *Blood and Champagne: The Life and Times of Robert Capa*, London, 2002
Richard Whelan, *Robert Capa: The Definitive Collection*, London, 2001
Richard Whelan, *This Is War! Robert Capa at Work*, exh. cat., International Center of Photography, New York, and Barbican Centre, London, 2007
Cynthia Young (ed.), *The Mexican Suitcase*, 2 vols, exh. cat., International Center of Photography, New York, 2007

André Kertész

André Kertész, exh. cat., Arts Council of England, London, 1979
Jane Corkin, *André Kertész: A Lifetime of Photography*, London, 1982 (the American and Canadian editions were entitled *André Kertész: A Lifetime of Perception*)
Colin Ford, *André Kertész*, exh. cat., National Museum of Photography, Film and Television, Bradford, and Arts Council of Great Britain, London, 1984–85
Colin Ford, *André Kertész and Avant-garde Photography of the 1920s and 1930s*, exh. cat., Annely Juda Fine Art, London, 1999
Michel Frizot and Annie-Laure Wanaverbecq, *André Kertész*, exh. cat., Musée Jeu de Paume, Paris, Fotomuseum, Winterthur, Martin-Gropius-Bau, Berlin, and Hungarian National Museum, Budapest, 2010–11
Sarah Greenough, Robert Gurbo and Sarah Kennel, *André Kertész*, exh. cat., National Gallery of Art, Washington, 2005
André Kertész, *Day of Paris*, George Davis (ed.), New York, 1945
André Kertész, with an introduction by Hilton Kramer, *Distortions*, Nicolas Ducrot (ed.), London and New York, 1976–77
André Kertész, *J'aime Paris: Photographs Since the Twenties*, Nicolas Ducrot (ed.), London and New York, 1974
Sandra S. Phillips, David Travis and Weston J. Naef, *André Kertész: Of Paris and New York*, exh. cat., Art Institute of Chicago and Metropolitan Museum of Art, New York, 1985
Harold Riley (ed.), *André Kertész*, Manchester, 1984

László Moholy-Nagy

Andreas Haus, *Photographs and Photograms: Moholy-Nagy*, translated by Frederic Samson, New York and London, 1980
Eleanor M. Hight, *Picturing Modernism: Moholy-Nagy and Photography in Weimar Germany*, Cambridge, Mass., 1995
Renate Heyne and Floris M. Neusüss with Hattula Moholy-Nagy (eds), *Moholy-Nagy: The Photograms, A Catalogue Raisonné*, Ostfildern, 2009
Hattula Moholy-Nagy (ed.), *László Moholy-Nagy: The Art of Light*, exh. cat., Martin-Gropius-Bau, Berlin, and Gemeentemuseum, The Hague, 2010
László Moholy-Nagy, *The New Vision: Fundamentals of Design, Painting, Sculpture, Architecture*, translated by Daphne M. Hoffmann, London, 1939
László Moholy-Nagy, *Painting Photography Film*, translated by Janet Seligman, London, 1969
László Moholy-Nagy, *Vision in Motion*, Chicago, 1947
Kristina Passuth and Terence A. Senter, *I, Moholy-Nagy*, exh. cat., Arts Council of Great Britain, London, 1980
Vanessa Rocco, *Expanding Vision: László Moholy-Nagy's Experiments of the 1920s*, exh. cat., International Center of Photography, New York, 2004

Martin Munkácsi

F. C. Gundlach (ed.), *Martin Munkácsi*, London and New York, 2006
Susan Morgan, *Martin Munkácsi*, New York, 1992
Martin Munkácsi, *Fool's Apprentice*, New York, 1945
Spontaneity and Style: Munkácsi, A Retrospective, exh. cat., International Center of Photography, New York, 1978

General

Péter Baki, *Chosen Photographs: The Association of Hungarian Photographers 1956–2006*, Budapest, 2006
Colin Ford (ed.), *The Hungarian Connection: The Roots of Photojournalism*, exh. cat., National Museum of Photography, Film and Television, Bradford, 1987
Fotóriporter, 2004/3–2005/1, with English text
Michel Frizot and Cédric de Veigy, *Vu: The Story of a Magazine That Made an Era*, London and New York, 2009
Katalin Jalsovszky and Ilona Balog Stemler (eds), *History Written in Light: A Photo Chronicle of Hungary 1845–2000*, Budapest, 2000
Károly Kincses, *Made in Hungary*, exh. cat., multiple venues, 1998–2002
Kati Marton, *The Great Escape, Nine Jews Who Fled Hitler and Changed the World*, New York, 2006
Martin Parr and Gerry Badger, *The Photobook: A History, Volume 1*, London and New York, 2004
Martin Parr and Gerry Badger, *The Photobook: A History, Volume 2*, London and New York, 2006
Mike Weaver (ed.), *The Art of Photography 1839–1939*, exh. cat., Royal Academy of Arts, London, 1989
Matthew S. Witkovsky, with an introduction by Peter Demetz, *Foto: Modernity in Central Europe, 1918–1945*, exh. cat., National Gallery of Art, Washington, Solomon R. Guggenheim Museum, New York, Milwaukee Art Museum and Dean Gallery, Edinburgh, 2007–08

Endnotes

Colin Ford (pp. 10–23)

1 Traditional Transylvanian song.
2 Quoted in *Life*, 19 April 1997. Capa was presumably mirroring what Michael Curtiz (Mihály Kertész, originally Mihály Kaminer), director of such Hollywood films as *Casablanca* (1942), once said: 'It isn't enough to be Hungarian; you need talent too.'
3 John G. Morris, *Get the Picture*, New York, 1998, p. 29.
4 Hungarian census, 1910.
5 His daughter has suggested that this may have been because he was a pacifist. F. C. Gundlach (ed.), *Martin Munkácsi*, London, 2006, p. 37.
6 Jane Corkin, *André Kertész: A Lifetime of Photography*, London and New York, 1982, p. 9.
7 Gábor Szilyági, 'An Album of War', in Colin Ford (ed.), *The Hungarian Connection: The Roots of Photojournalism*, exh. cat., National Museum of Photography, Film and Television, Bradford, 1987, p. 10.
8 Cornell Capa and Richard Whelan (eds), *Cornell Capa: Photographs*, New York, 1982, p. 13 (quoting an interview with Cornell Capa in *Camera*, 1963).
9 Kertész photographed the exiled Károlyi in Paris in 1927.
10 Károly Escher photographed its manager at the swimming pool (cat. 18).
11 Kati Marton, *The Great Escape: Nine Jews Who Fled Hitler and Changed the World*, New York, 2006, p. 132. Because two of the nine heroes of this excellent book (written by a Hungarian émigré) are Robert Capa and André Kertész, it has been a very useful resource for writing this essay.
12 Martin Munkácsi, *Fool's Apprentice*, New York, 1945.
13 Ibid., p. 343.
14 Many of the opinions in this essay are derived from conversations over some thirty years with Hungarian friends and colleagues, notably André Kertész, Andor Kraszna-Krausz, Péter Korniss and my late mother-in-law Irene Grayson (a Hungarian from Transylvania). I am grateful to them all, but must emphasise that the opinions are, ultimately, my own.
15 *André Kertész*, exh. cat., Arts Council of England, London, 1979, p. 3.
16 Cornell Capa and Richard Whelan (eds), *Cornell Capa: Photographs*, New York, 1982, p. 15.
17 Arthur Koestler, quoted by Kati Marton, *The Great Escape: Nine Jews Who Fled Hitler and Changed the World*, New York, 2006, p. 11.
18 Alex Kershaw, *Blood and Champagne: The Life and Times of Robert Capa*, London, 2002, p. 16 and note on p. 258.
19 The Budapest equivalent, where artists had been meeting since the 1890s, was, coincidentally, called the 'New York kávéház'.
20 Brassaï, 'My Friend André Kertész', *Camera*, 4 April 1963, p. 7.
21 See, for instance, Anne Wilkes Tucker, with Richard Howard and Avis Berman, *Brassaï: The Eye of Paris*, exh. cat., Museum of Fine Arts, Houston, 1999, pp. 30 and 125, note 77.
22 His first book, *Enfants*, had been published three years earlier, in 1936.
23 His father presumably changed his original name when he settled in Vienna. Though Guttman was born in Vienna, he held a Hungarian passport. His mother was German.
24 His family and close friends had usually called him 'Bandi', a popular Hungarian diminutive for Andor and Endre, however.
25 Weisz later married the English painter Leonora Carrington in Mexico. It seems likely that it was he who arranged to have the 'Mexican suitcase' of negatives by Capa, Gerda Taro and 'Chim' (David Seymour) sent to Mexico.
26 Robert Gurbo, *André Kertész: The Early Years*, New York, 2005, p. 23 and note 13; taken from Kertész's diary for 10 July 1924 (now held by The André Kertész Foundation, New York).
27 Lajos Tihanyi exhibited there in 1926.
28 Quoted in Colin Ford, *André Kertész and Avant-garde Photography of the 1920s and 1930s*, exh. cat., Annely Juda Fine Art, London, 1999.
29 Hilton Kramer has pointed out that these were contemporary with such similar works of painting and sculpture as Picasso's *Girl Before a Mirror*, Henry Moore's first open-form *Reclining Nude*, Matisse's *Pink Suite* and Dalí's *Dreamscapes*.
30 Cecil Beaton and Gail Buckland, *The Magic Image*, London, 1975, p. 146.
31 The full name of the agency was Rado-Photo, and it distributed the work of other Hungarian photographers in Paris, such as Nora Dumas, Ergy Landau and 'Ylla' (Camilla Koffler).
32 Quoted in Károly Kincses, *Made in Hungary*, exh. cat., multiple venues, 1998–2002.
33 F. C. Gundlach (ed.), *Martin Munkácsi*, London, 2006, p. 11.
34 Interview with Bela Ugrin in Sarah Greenough, Robert Gurbo and Sarah Kennel, *André Kertész*, exh. cat., National Gallery of Art, Washington DC, 2005, p. 275.
35 Martin Munkácsi, *Fool's Apprentice*, New York, 1945, p. 9.

Péter Baki (pp. 24–33)

1 Krisztina Passuth and György Szücs (eds), *Magyar Vadak Párizstól Nagybányáig 1904–14* (*The Hungarian Fauves from Paris to Nagybánya, 1904–14*), exh. cat., Hungarian National Gallery, Budapest, 2006.
2 The first colour photography processes for the mass market were developed in Paris by Auguste and Louis Lumière between 1904 and 1907.
3 See István Batta, *Ónodi Veress Ferenc a színesfotografozás történetében* (*Ferenc Ónodi Veress in the History of Colour Photography*), published by the author, 1913; and Károly Kincses, *Levétetett Veressnél, Kolozsvárt* (*Photographed by Veress, in Kolozsvár*), Budapest, 1993.
4 *Fényképészeti Szemle* (from 1900), *Magyar Photo-Club Közlönye* (from 1901), *Phototechnika* (from 1902), *Az Amatőr* (from 1904), *A Fény* (from 1906), *Foto-Optik* (from 1907).
5 'Magyar Fényképészek Országos Szövetsége' (National Association of Hungarian Photographers), *A Fény*, 1906, 1–3, pp. 41–42.
6 Rudolf Balogh, 'Az olvasóhoz' ('To the Reader'), *Fotóművészet*, 1914, 1, p. 2.
7 Works in this style were published in many European photography magazines, including *The Studio* (Great Britain), *Photographie*, *Photoillustrations* (France), *Die Galerie* (Austria) and *Camera* (Switzerland).
8 György Oláh, *Három millió koldus* (*Three Million Beggars*), Miskolc, 1928.
9 Lajos Gró, in *Munka*, 1932, 22, p. 623.
10 The title refers to a character of peasant origins featured in József Katona's drama *Bánk bán* (1815). In 1861 Ferenc Erkel (composer of the Hungarian national anthem) adapted the work into an opera.
11 Helmar Lerski, *Köpfe des Alltags*, Berlin, 1931.
12 Zeitgeschichte Verlag und Vertriebs-Gesellschaft, Berlin, no date.
13 The words of Demeter Balla (1931), the photographer and holder of the Kossuth Award (2004).
14 Gábor Pataki, 'A magyar művészet története 1949–1968' ('The History of Hungarian Art, 1949–1968'), in *Nézőpontok/Pozíciók. Művészet Európában 1949–1999* (*Points of View/Positions. Art in Europe 1949–1999*), exh. cat., Contemporary Art Museum – Ludwig Museum, Budapest, 2000.
15 The 'definition' stems from the poet Mihály Ladány. Cited in Klára Szarka and Zoltán Fejér, *Fotótörténet* (*Photo History*), Budapest, 1999, p. 131.
16 *Tiborc Uj Arca* (*Tiborc's New Image*), Budapest, 1955. The volume includes a foreword by the author Zsigmond Móricz, written in 1937, thus demonstrating the enduring validity of his words.
17 Minutes of the founding meeting of the Association of Hungarian Photographers, 28 July 1956. Archive of the Hungarian Museum of Photography, Kecskemét.
18 Iván Vydareny's undated letter to Ernő Vadas. Archive of the Hungarian Museum of Photography, Kecskemét.
19 Ernő Vadas's letter to Iván Vydareny, 27 September 1956. Archive of the Hungarian Museum of Photography, Kecskemét.
20 Péter Baki and Árpád Göncz, *Magyar Forradalom – 1956 – Hungarian Revolution*, exh. cat., Association of Hungarian Photographers and Hungarian Museum of Photography, Kecskemét, 2006.
21 See Sándor Szilágyi, *Neoavangárd tendenciák a magyar fotóművészetben 1965–1984* (*Neo-Avant-garde Trends in Hungarian Photography*), Budapest, 2007.
22 Various versions of the photograph's story circulated in professional circles; the authentic version was clarified by Ferenc Markovics in the course of his research in 2006. Ferenc Markovics, *Fények és tények. Ötvenéves a Magyar Fotóművészek Szövetsége* (*Lights and Facts. The Association of Hungarian Photographers Is Fifty Years Old*), Budapest, 2006.

George Szirtes (pp. 34–41)

1 Cited in Paul Lendvai, *The Hungarians: A Thousand Years of Victory in Defeat*, London, 2003, p. 348.
2 John Lukács, *Budapest 1900*, London, 1993, p. xiii.
3 See Ignács Romcsics, *Hungary in the Twentieth Century*, Budapest, 1999, pp. 22–23.
4 Klára Tóry, 'Károly Escher', translated by Krisztina Rozsnyai, in Colin Ford (ed.), *The Hungarian Connection: The Roots of Photojournalism*, exh. cat., National Museum of Photography, Film and Television, Bradford, 1987, pp. 29–32.
5 Bruno de Marchi, 'The Red News-reel of the Tanácsköztársaság (Councils/Soviets): History Dream and Cinema Imagination', *Hungarian Studies*, 3, 1–2, 1987, Akadémiai Kiadó, Budapest, p. 21.

List of Works

72 **László Moholy-Nagy** *Photogram*, Germany, 1925. Silver gelatin print, 1995, from original negative, 35.5 × 28.5 cm. Hungarian Museum of Photography, Kecskemét, 2010.627

73 **Martin Munkácsi** *Boys Marching*, Germany, c. 1930. Silver gelatin print, 1994, from original negative, 35.5 × 27.7 cm. Hungarian Museum of Photography, Kecskemét, 2009.152

74 **Martin Munkácsi** *Joke for Breakfast*, Berlin, 1933. Silver gelatin print, 1994, from original negative, 35.5 × 27.7 cm. Hungarian Museum of Photography, Kecskemét, 2006.16948

75 **György Kepes** *Juliet Shadow Cage (Vision II)*, 1939. Silver gelatin print, 1987, 25.7 × 20 cm. Hungarian Museum of Photography, Kecskemét, 92.36

76 **László Moholy-Nagy** *Lucia on the Beach*, Germany, c. 1920. Silver gelatin print, 1995, from original negative, 35.5 × 28.5 cm. Hungarian Museum of Photography, Kecskemét, 2009.54

77 **Martin Munkácsi** *Beach!*, c. 1930. Silver gelatin print, 1994, from original negative, 27.7 × 35.5 cm. Hungarian Museum of Photography, Kecskemét, 2006.16893

78 **Martin Munkácsi** *Leni Riefenstahl*, Germany, 1931. Silver gelatin print, 1994, from original negative, 35.5 × 28.5 cm. Hungarian Museum of Photography, Kecskemét, 2010.623

79 **László Moholy-Nagy** *Paris*, 1925. Silver gelatin print, 1995, from original negative, 35.5 × 27.5 cm. Hungarian Museum of Photography, Kecskemét, 2004.9723

80 **László Moholy-Nagy** *Port Transbordeur*, France, c. 1925. Silver gelatin print, 1995, from original negative, 33 × 22.5 cm. Hungarian Museum of Photography, Kecskemét, 2004.9703

81 **Brassaï** *Barge*, Paris, 1935. Vintage silver gelatin print, 23.6 × 17.7 cm. Hungarian Museum of Photography, Kecskemét, 2009.169

82 **László Moholy-Nagy** *Boat, Negative*, c. 1925. Silver gelatin print, 1995, from original negative, 38.7 × 29 cm. Hungarian Museum of Photography, Kecskemét, 2009.47

83 **Brassaï** *Parisian Couple at the Quatre Saisons Dance Hall (Rue de Lappe)*, 1932. Vintage silver gelatin print, 29.5 × 23 cm. Hungarian Museum of Photography, Kecskemét, 89.58

84 **André Kertész** *Hôtel des Clochards*, Paris, 1927. Silver gelatin print, 1967, 25.3 × 20.4 cm. Hungarian Museum of Photography, Kecskemét, 2010.592

85 **Brassaï** *Eiffel Tower*, Paris, 1930s. Silver gelatin print, 1949, 25.5 × 19.7 cm. National Media Museum, Bradford (by courtesy of the Board of Trustees of the Science Museum), 1990-5131/83/10097

86 **Brassaï** *Fiacre, Montparnasse*, Paris, 1930s. Silver gelatin print, 1949, 23.7 × 17.8 cm. National Media Museum, Bradford (by courtesy of the Board of Trustees of the Science Museum), 1990-5131/83/10095

87 **Brassaï** *Champs-Elysées*, Paris, 1930s. Silver gelatin print, 1949, 23.8 × 17.8 cm. National Media Museum, Bradford (by courtesy of the Board of Trustees of the Science Museum), 1990-5131/83/10094

88 **Brassaï** *Bank of the Seine*, Paris, 1931. Vintage silver gelatin print, 28.5 × 22 cm. Hungarian Museum of Photography, Kecskemét, 2010.652

89 **André Kertész** *Portrait of a Young Woman*, Paris, 1926. Vintage silver gelatin print (carte postale), 15.5 × 7 cm. Wilson Centre for Photography, London, 05:8911

90 **André Kertész** *Mr and Mrs Rosskam*, Paris, 1927. Vintage silver gelatin print, 16.3 × 19.2 cm. Wilson Centre for Photography, London, 03:7546

91 **Brassaï** *Bijou of Montparnasse*, Paris, 1932. Silver gelatin print, 1973, 23.5 × 25.5 cm. Victoria and Albert Museum, London, Ph. 502-1975

92 **Brassaï** *Prostitute Playing Russian Billiards*, Paris, 1932. Silver gelatin print, 1973, 30 × 23.8 cm. Victoria and Albert Museum, London, Ph. 504-1975

93 **André Kertész** *Meudon*, Paris, 1928. Silver gelatin print, 1967, 25.3 × 20.4 cm. Hungarian Museum of Photography, Kecskemét, 2009.128

94 **Brassaï** *Suburban Apartment House*, Paris, 1930s. Silver gelatin print, 1949, 29.5 × 23.2 cm. National Media Museum, Bradford (by courtesy of the Board of Trustees of the Science Museum), 1990-5131/83/10096

95 **Brassaï** *In Picasso's Studio, Rue des Grands Augustins*, Paris, 1939. Vintage silver gelatin print, 30 × 23 cm. Hungarian Museum of Photography, Kecskemét, 2010.654

96 **André Kertész** *Chez Mondrian*, Paris, 1926. Silver gelatin print, 1967, 25.3 × 20.3 cm. Hungarian Museum of Photography, Kecskemét, 2004.8523

97 **Brassaï** *Matisse with His Model*, 1939. Silver gelatin print, 1973, 23.5 × 27.5 cm. Victoria and Albert Museum, London, Ph. 508-1975

98 **André Kertész** *Chagall and Family*, Paris, 1933. Silver gelatin print, 1967, 20.3 × 25.3 cm. Hungarian Museum of Photography, Kecskemét, 86.176

99 **André Kertész** *Satiric Dancer*, Paris, 1926. Silver gelatin print, 1967, 25.2 × 20.3 cm. Hungarian Museum of Photography, Kecskemét, 86.169

100 **André Kertész** *Distortion no. 157*, Paris, 1933. Silver gelatin print, 1967, 25.3 × 20.3 cm. Hungarian Museum of Photography, Kecskemét, 2009.130

101 **Kati Horna** *Stairway to the Cathedral*, Spain, 1937. Photomontage, 25.4 × 20.3 cm. Private collection, London

102 **Brassaï** *Tramp*, Marseilles, 1930s. Vintage silver gelatin print, 30 × 23 cm. Hungarian Museum of Photography, Kecskemét, 2010.653

103 **Brassaï** *Meadows in the Isère Valley*, date unknown. Silver gelatin print, c. 1980, 29.5 × 23 cm. Hungarian Museum of Photography, Kecskemét, 89.54

104 **Brassaï** *Festivities in Bayonne*, c. 1936. Vintage silver gelatin print, 29 × 23 cm. Hungarian Museum of Photography, Kecskemét, 2010.655

105 **André Kertész** *Elizabeth and I*, Paris, 1931. Silver gelatin print, 1967, 25.2 × 20.2 cm. Hungarian Museum of Photography, Kecskemét, 2010.620

106 **Ferenc Berkó** *Trouville: Beach Scene*, 1937. Silver gelatin print, 2000, 35.2 × 27.7 cm. Hungarian Museum of Photography, Kecskemét, 2010.642

107 **Martin Munkácsi** *Four Boys at Lake Tanganyika*, c. 1930. Silver gelatin print, 1994, from original negative, 35.5 × 27.5 cm. Hungarian Museum of Photography, Kecskemét, 2009.150

108 **Robert Capa** *Death of a Loyalist Militiaman*, Cerro Muriano, Cordoba, 1936. Silver gelatin print, 1970, from original negative, 28 × 36 cm. Hungarian Museum of Photography, Kecskemét, 67.21

109 **Lucien Aigner** Contact sheet, nos 8–15: *Mussolini at Stresa*, 1935. Silver gelatin print, 1970s, 20.7 × 25.4 cm. Victoria and Albert Museum, London, Ph. 873-1980

110 **Lucien Aigner** *Mussolini at Stresa*, 1935. Silver gelatin print, 1970s, 35.7 × 27.8 cm. Victoria and Albert Museum, London, Ph. 871-1980

111 **László Moholy-Nagy** *Sackville Street, London*, 1936. Silver gelatin print, 1995, from original negative, 35.2 × 27.8 cm. Hungarian Museum of Photography, Kecskemét, 2004.9861

112 **Cornell Capa** *Winchester College*, 1951. Silver gelatin print, 1970, 40.5 × 50.5 cm. Hungarian Museum of Photography, Kecskemét, 2002.811

113 **László Moholy-Nagy** *Eton, Playing Fields*, 1936. Silver gelatin print, 1973, from original negative, 21 × 26.7 cm. Hungarian Museum of Photography, Kecskemét, 2004.9725

114 **Cornell Capa** *Hyde Park*, London, 1951. Silver gelatin print, 1970s, 35.1 × 25 cm. National Media Museum, Bradford (by courtesy of the Board of Trustees of the Science Museum), 1990-5131/83/10100

115.1 **Robert Capa** *Pit Heads and Heaps*, Glamorgan, 18 July 1942. Vintage silver gelatin print, 20 × 23.2 cm. National Media Museum, Bradford (by courtesy of the Board of Trustees of the Science Museum), 1983-5236/13685

115.2 **Robert Capa** *Nearly Completed Thirty Years Underground*, Glamorgan, 18 July 1942. Vintage silver gelatin print, 22 × 20.4 cm. National Media Museum, Bradford (by courtesy of the Board of Trustees of the Science Museum), 1983-5236/13684

115.3 **Robert Capa** *Let's Bring That Up at the Meeting Tonight*, Glamorgan, 18 July 1942. Vintage silver gelatin print, 21 × 20.3 cm. National Media Museum, Bradford (by courtesy of the Board of Trustees of the Science Museum), 1983-5236/13688

116 **André Kertész** *Melancholic Tulip*, New York, 1939. Silver gelatin print, 1967, 25 × 20 cm. Hungarian Museum of Photography, Kecskemét, 2009.131

117 **Robert Capa** *Ingrid Bergman During the Filming of 'Arch of Triumph'*, Hollywood, 1946. Silver gelatin print, 1970, from original negative, 36 × 28 cm. Hungarian Museum of Photography, Kecskemét, 2002.220

118 **Martin Munkácsi** *Nude*, America, 1935. Silver gelatin print, 1994, from original negative, 27.7 × 35.5 cm. Hungarian Museum of Photography, Kecskemét, 2006.16974

119 **Martin Munkácsi** *The First Fashion Photo for Harper's Bazaar (Lucile Brokaw)*, America, 1933. Silver gelatin print, 1994, from original negative, 35.5 × 27.5 cm. Hungarian Museum of Photography, Kecskemét, 2005.12954

120 **Martin Munkácsi** *Swimsuit*, America, 1935. Silver gelatin print, 1994, from original negative, 28.5 × 35.5 cm. Hungarian Museum of Photography, Kecskemét, 2009.162

121 **Martin Munkácsi** *Nude in Straw Hat*, America, 1944. Silver gelatin print, 1994, from original negative, 35.5 × 27.5 cm. Hungarian Museum of Photography, Kecskemét, 2000.163

122 **Martin Munkácsi** *Pennsylvania Station*, New York, 1935. Silver gelatin print, 1994, from original negative, 35.5 × 28.5 cm. Hungarian Museum of Photography, Kecskemét, 2010.651

123 **Martin Munkácsi** *Harper's Bazaar Fashion Plate*, America, c. 1940. Silver gelatin print, 1994, from original negative, 28.5 × 35.5 cm. Hungarian Museum of Photography, Kecskemét, 2009.161

124 **Martin Munkácsi** *Baby on the Roof*, New York, 1940. Silver gelatin print, 1994, from original negative, 35.5 × 27.5 cm. Hungarian Museum of Photography, Kecskemét, 2009.167

125 **André Kertész** *Homing Ship*, New York, 13 October 1944. Silver gelatin print, 1967, 25.3 × 20.3 cm. Hungarian Museum of Photography, Kecskemét, 2009.136

126 **André Kertész** *McDougal Alley*, New York, 1965. Silver gelatin print, 1967, 22.3 × 25.3 cm. Hungarian Museum of Photography, Kecskemét, 86.193

127 **André Kertész** *Washington Square*, New York, 9 January 1954. Silver gelatin print, 1967, 25.3 × 20.3 cm. Hungarian Museum of Photography, Kecskemét, 2009.616

128 **André Kertész** *Lost Cloud*, New York, 2 March 1937. Silver gelatin print, 1970s, 25 × 20.3 cm. Estate of André Kertész, courtesy Vintage Gallery, Budapest

129 **André Kertész** *Landing Pigeon*, New York, 1960. Silver gelatin print, 1967, 25.3 × 20.3 cm. Hungarian Museum of Photography, Kecskemét, 86.189

130 **André Kertész** *Martinique*, 1 January 1972. Vintage silver gelatin print, 25.3 × 20.3 cm. Hungarian Museum of Photography, Kecskemét, 2009.129

131.1–9 **André Kertész** *Untitled*, New York, 1979–82. Colour SX-70 Polaroids, each 7.9 × 7.9 cm. Estate of André Kertész, courtesy Vintage Gallery, Budapest

132 **Kata Kálmán** *Transporting Snow on the Banks of the Danube*, Budapest, 1940. Silver gelatin print, 1991, 23.7 × 18.1 cm. Hungarian Museum of Photography, Kecskemét, 2006.4

133 **Károly Escher** *Hungarian Soldier Entering the Re-annexed Territories*, c. 1940. Vintage silver gelatin print, 1942, 24 × 18 cm. Hungarian National Museum, Budapest, 60.1132

134 **Károly Escher** *Soldier Portrait*, 1947. Vintage silver gelatin print, 24.3 × 18 cm. Hungarian National Museum, Budapest, 60.1133

135 **Unknown photographer** *Miklós Horthy and Hitler Disembarking from a Ship*, Hamburg, August 1938. Vintage silver gelatin print, 20.8 × 14.2 cm. Hungarian National Museum, Budapest, 67.3091

136 **Robert Capa** *Drinking Tea at the Refuge*, London, 1941. Silver gelatin print, 1970, from original negative, 36 × 28 cm. Hungarian Museum of Photography, Kecskemét, 2000.222

137 **Robert Capa** *American Soldier Landing on Omaha Beach, D-Day*, Normandy, 6 June 1944. Silver gelatin print, 1970, from original negative, 28 × 36 cm. Hungarian Museum of Photography, Kecskemét, 2002.88

138 **Robert Capa** *American Pilot*, 1943. Silver gelatin print, 1970, from original negative, 36 × 28 cm. Hungarian Museum of Photography, Kecskemét, 76.240

139 **Robert Capa** *American Soldiers Arrest German Generals*, Normandy, 1944. Silver gelatin print, 1970, from original negative, 39 × 39.5 cm. Hungarian Museum of Photography, Kecskemét, 67.8

140 **János Babai** *Jewish People in Köszeg at the Railway Station*, 18 June 1944. Silver gelatin print, 1955, 12.8 × 17.5 cm. Hungarian National Museum, Budapest, n.no.14705

141 **Robert Capa** *Woman, Who Had a Child with a German Soldier, Being Marched through the Street*, Chartres, August 1944. Silver gelatin print, 1970s, from original negative, 33 × 49 cm. Hungarian Museum of Photography, Kecskemét, 67.27

142 **Robert Capa** *The Last Victim of the War*, Leipzig, 1945. Silver gelatin print, 1970, from original negative, 36 × 28 cm. Hungarian Museum of Photography, Kecskemét, 2005.12098

143 **Sándor Ék** *The Corpses of Arrow Cross Victims Are Exhumed in the Grounds of the Jewish Hospital in Maros Street*, 13 April 1945. Vintage silver gelatin print, 19.3 × 17 cm. Hungarian National Museum, Budapest, 65.975

144 **Sándor Bojár** *Arrow Cross Leader Ferenc Szálasi's Execution*, Budapest, 12 March 1946. Silver gelatin print, 1964, 13 × 9 cm. Hungarian National Museum, Budapest, 64.998

145 **Robert Capa** *Ruins of the Warsaw Ghetto*, 1945. Silver gelatin print, 1970, from original negative, 28 × 36 cm. Hungarian Museum of Photography, Kecskemét, 76.236

146 **Robert Capa** *Refugees in Front of the Sha'ar Ha'Aliya Refugee Camp, Haifa*, 1950. Silver gelatin print, 1970, from original negative, 39 × 49 cm. Hungarian Museum of Photography, Kecskemét, 67.29

147 **Kálmán Szöllősy** *Chain Bridge in Ruins*, Budapest, 1945. Silver gelatin print, 1966, 40.1 × 30 cm. Hungarian Museum of Photography, Kecskemét, 68.924

148 **Robert Capa** *Elizabeth Bridge Destroyed*, Budapest, 1948. Silver gelatin print, 1970, from original negative, 36 × 28 cm. Hungarian Museum of Photography, Kecskemét, 2002.62

149 **Robert Capa** *Café on the Riverside Near the Bombed Bristol Hotel*, Budapest, 1948. Silver gelatin print, 1970, from original negative, 36 × 28 cm. Hungarian Museum of Photography, Kecskemét, 2002.63

150 **Robert Capa** *Chaplin's Latest Film Advertised on Vaci Street*, Budapest, 1948. Silver gelatin print, 1970, from original negative, 21 × 17.5 cm. Hungarian Museum of Photography, Kecskemét, 2002.216

151 **Miklós Bedő** and **Katalin Korbuly** *The Kossuth Version of the Arms of Hungary on a Hungarian T-34 Tank Behind Corvin Cinema*, Budapest, 27 October 1956. Digital print, 2011, 16.2 × 23.8 cm. Hungarian National Museum, Budapest, 2002.305

152 **Unknown photographer** *Participants in the First Mass Rally of the Hungarian Communist Party*, Budapest, 1945. Vintage silver gelatin print, 13 × 18 cm. Hungarian National Museum, Budapest, 72.437

153 **Ferenc Berendi** *Backlight*, Budapest, 1956. Silver gelatin print, 2006, 40.5 × 30 cm. Hungarian Museum of Photography, Kecskemét, 2010.648

154 **Angelo** *What Is the Girl Carrying?*, Hungary, c. 1950. Vintage silver gelatin print, 40 × 35 cm. Hungarian Museum of Photography, Kecskemét, 75.359

155 **Angelo** *Ladders and Ladder Bearers*, Budapest, 1950. Vintage silver gelatin print, 39.8 × 29.5 cm. Hungarian Museum of Photography, Kecskemét, 67.156.4

156 **Ernő Vadas** *Wheels*, Hungary, 1951. Vintage silver gelatin print, 39 × 29 cm. Hungarian Museum of Photography, Kecskemét, 58.283.1.F

157 **Rudolf Járai** *Steel Furnace in Inota*, 1951. Vintage silver gelatin print, 30 × 39.5 cm. Hungarian Museum of Photography, Kecskemét, 69.285

158 **Károly Gink** *Blaha Lujza Square*, Budapest, c. 1950s. Silver gelatin print, c. 1960s, 22 × 15 cm. Hungarian Museum of Photography, Kecskemét, 2010.640

159 **Zoltán Berekméri** *Winter's Evening in Békéscsaba*, 1955. Silver gelatin print, 1987, 40 × 30 cm. Hungarian Museum of Photography, Kecskemét, 90.162

160 **Miklós Rév** *Workers on the Elizabeth Bridge*, Budapest, 1962. Vintage silver gelatin print, 41 × 30 cm. Hungarian Museum of Photography, Kecskemét, 2010.656

161 **Miklós Rév** *Straight Road*, Inota, *c.* 1955. Silver gelatin print, 1962, 23.5 × 19 cm. Hungarian Museum of Photography, Kecskemét, 2010.649

162 **Péter Korniss** *At the Dance Hall, Romania*, 1967. Silver gelatin print, 2010, 30 × 40 cm. Private collection

163 **László Fejes** *Wedding*, Budapest, 1965. Vintage silver gelatin print, 15.5 × 23.8 cm. Hungarian Museum of Photography, Kecskemét, 2003.5618

164.1–6 **Tamás Féner** Untitled series, Szabolcs county, *c.* 1973. Vintage silver gelatin prints, 12.6 × 23 cm, 15.8 × 23.1 cm, 14.7 × 22.7 cm, 15.8 × 23.1 cm, 13.5 × 25.2 cm, 16.5 × 23.5 cm. Hungarian Museum of Photography, Kecskemét, 2010.632-7

165 **László Haris** *Unlawful Avant-garde*, 1971. Silver gelatin print, 2010, 30 × 24 cm. Hungarian Museum of Photography, Kecskemét, 2011.11

166.1–5 **Péter Korniss** From the *Guest Worker* series, 1978–88. *At the Western Station, In Rush Hour, Marriage Bed, Evening Shower, Homecoming*. Silver gelatin prints, 2010, 18 × 24 cm (166.3: 24 × 18 cm). Private collection

167 **László Fejes** *Suffering Christ*, Szeged, 1969. Vintage silver gelatin print, 30.2 × 23.9 cm. Hungarian Museum of Photography, Kecskemét, 2003.5436

168 **Gábor Kerekes** *Interior (Gypsy Couple)*, Hungary, 1980s. Vintage silver gelatin print, 26.5 × 38.5 cm. Hungarian Museum of Photography, Kecskemét, 2010.657

169 **László Török** *Family*, Budapest, 1972. Vintage silver gelatin print, 40 × 60 cm. Private collection

170 **Demeter Balla** *Adam and Eve*, Hungary, 1984. Vintage silver gelatin print, 50 × 41 cm. Hungarian Museum of Photography, Kecskemét, 2004.7415

171 **Gábor Kerekes** *Cotton Works*, Budapest, 1978. Vintage silver gelatin print, 24 × 30 cm. Hungarian Museum of Photography, Kecskemét, 2010.658

172 **Gábor Kerekes** *Brick Factory*, Hungary, *c.* 1980. Vintage silver gelatin print, 24 × 30.5 cm. Hungarian Museum of Photography, Kecskemét, 2010.659

173 **Magdolna Vékás** *Cement and Lime Plant*, Tatabánya, 1979. Vintage silver gelatin print, 18 × 24 cm. Hungarian Museum of Photography, Kecskemét, 2010.646

174 **Gábor Kerekes** *1 May*, Budapest, 1984. Vintage silver gelatin print, 17.9 × 24.1 cm. Hungarian Museum of Photography, Kecskemét, 2005.12278

175.1 **György Stalter** *Tólápa*, 1982. Vintage silver gelatin print, 24 × 18 cm. Hungarian Museum of Photography, Kecskemét, 2010.639

175.2 **György Stalter** From the *Tólápa Series*, 1982. Vintage silver gelatin print, 18 × 24 cm. Hungarian Museum of Photography, Kecskemét, 2010.638

176 **Tamás Urbán** *Druggies*, Pécs, 1983. Vintage silver gelatin print, 18 × 24 cm. Hungarian Museum of Photography, Kecskemét, 2010.631

177 **Tamás Urbán** *Crib*, Budapest, 1985–87. Vintage silver gelatin print, 14.7 × 23.1 cm. Hungarian Museum of Photography, Kecskemét, 2011.12

178 **Tamás Urbán** *Infants*, Budapest, 1985–87. Silver gelatin print, 2010, 24 × 30 cm. Hungarian Museum of Photography, Kecskemét

179 **Imre Benkő** *Pipe Workshop*, Ózd, 1989. Silver gelatin print, 2002, 29.3 × 30 cm. Hungarian Museum of Photography, Kecskemét, 2010.641

180 **Imre Benkő** *Russian Soldiers Leaving*, Hajmáskér, 1990. Vintage silver gelatin print, 23.8 × 16.4 cm. Hungarian National Museum, Budapest, 2000.703

181 **Imre Benkő** *Lenin Statue Lying Down*, Budapest, 1992. Vintage silver gelatin print, 15.5 × 23 cm. Hungarian National Museum, Budapest, 2000.699

182 **Sylvia Plachy** *Fallen Worker*, Érd, 1993. Vintage silver gelatin print, 24.5 × 32.5 cm. Hungarian Museum of Photography, Kecskemét, 2010.647

183 **András Bánkuti** *Twilight, Moscow*, 1990. Vintage silver gelatin print, 24 × 30 cm. Hungarian Museum of Photography, Kecskemét, 2010.660

184 **Paul Morand** and **Brassaï**, *Paris de Nuit: 60 photos inédites de Brassaï*, Editions Arts et Métiers graphiques, Paris, 1932. Victoria and Albert Museum, London, L. 3381-1986

185 **Pierre Mac-Orlan** and **André Kertész**, *Paris vu par André Kertész*, Librairie Plon, Paris, 1934. Private collection

186 *Life*, 36, 23, 7 June 1954. Private collection

187 *Vu*, 125, 6 August 1930. Private collection

188 **László Moholy-Nagy** *Malerei, Photographie, Film*, Bauhaus Bücher 8, Munich, 1925. Chelsea College of Art and Design Library, University of the Arts London

189 *Berliner Illustrirte Zeitung*, 33, 21 August 1932. Private collection

190 *Harper's Bazaar*, 2677, November 1935. Private collection

191 **Kata Kálmán** *Tiborc*, Cserépfalvi, Budapest, first edition, 1937. Vintage Gallery, Budapest

192 *Picture Post*, 73, 6, 12 November 1956. Getty Images, London

193 **György Lőrinczy** *New York, New York*, Magyar Helikon, Budapest, 1972. Collection Martin Parr

194 *Berliner Illustrirte Zeitung*, 37, 18 September 1932. Private collection

195 *Harper's Bazaar*, 2711, July 1938. Private collection

196 **Brassaï** *Camera in Paris*, Focal Press, London, 1949. Private collection

197 **László Moholy-Nagy** *The New Vision, from Material to Architecture*, trans. by Daphne M. Hoffmann, Brewer, Warren and Putnam Inc., New York, 1932. Victoria and Albert Museum, London, 38041800159774

198 Publisher's catalogue for the series of fourteen Bauhaus Bücher made under the direction of Walter Gropius and László Moholy-Nagy, Albert Langen, Munich, 1927. Victoria and Albert Museum, London, 38041800715583

199 *Lilliput*, 18, 3, 105, March 1946. Private collection

200 *Picture Post*, 1, 10, 3 December 1938. Victoria and Albert Museum, London, 38041800715880

201 *Regards*, 155, 31 December 1936. Victoria and Albert Museum, London, 38041800715898

202 *Picture Post*, 2, 3, 21 January 1939. Getty Images, London

203 **Robert Capa** *Death in the Making*, Covici-Friede, New York, 1938. Collection Martin Parr

204 *Vu*, 129, 3 September 1930. Private collection

Lenders to the Exhibition

Bradford
National Media Museum

Budapest
Hungarian National Museum
Vintage Gallery

Kecskemét
Hungarian Museum of Photography

London
Chelsea College of Art and Design Library, University of the Arts
Getty Images
Victoria and Albert Museum

Collection Martin Parr

and others who wish to remain anonymous

Photographic Acknowledgements

Every effort has been made to trace the copyright holders of works reproduced. Copyright of all works illustrated, the artists, their heirs and assigns:

© From the Estate of Lucien Aigner: cats 109, 110
© Brassaï Estate – RMN: cats 81, 83, 85–88, 91, 92, 94, 95, 97, 102–04, fig. 3
© Demeter Balla: cat. 170
© András Bánkuti: cat. 183
Ferenc Berkó © berkophoto.com, courtesy Gitterman Gallery, New York: cat. 106
© Eva Besnyö/Maria Austria Instituut: cat. 15
© DACS, 2011: cats 41, 42, 132, 143, 147, 158, 164.1–6, 168, 169, 171–74, 179–181, fig. 25
© Getty Images: figs 29.1–2
© Estate of Francis Haár: cat. 10
© 2011, László Haris: cat. 165, fig. 30
© Kati Horna. All rights reserved, 2010: cat. 101
© Hungarian Museum of Photography, Kecskemét: cats 2, 7–9, 13, 21, 25, 28, 30, 31, 33, 36–39, 43–49, 53, 64, 153–57, 159, 163, 167, figs 21, 23, 24, 26–28, 31, 34
© Hungarian National Museum, Budapest: cats 56–61, 63, 65
© ICP/Magnum Photos: cats 108, 112, 114, 115.1–3, 117, 136–39, 141, 142, 145, 146, 148–50, fig. 7
© György Kepes/Hungarian Museum of Photography, printed with permission from Juliet K. Stone: cat. 75
© Estate of André Kertész/Higher Pictures: cats 1, 3–6, 12, 14, 16, 17, 19, 20, 54, 62, 84, 89, 90, 93, 96, 98–100, 105, 116, 125–131.1–9, figs 4, 8–11, 36, 37
© Péter Korniss: cats 162, 166.1–5
© Hattula Moholy-Nagy/DACS, 2011: cats 66–72, 76, 79, 80, 82, 111, 113, figs 12, 15, 16
© Estate of Martin Munkácsi, courtesy Howard Greenberg Gallery, New York: cats 24, 26, 50, 73, 74, 77, 78, 107, 118–24, fig. 18
© 2011, Sylvia Plachy: cat. 182
© Bojár Sándorné: cat. 144
© György Stalter: cats 175.1–2
© Péter Timár: fig. 33
© Ullstein Bild: cat. 135
© Courtesy Vintage Gallery, Budapest: cats 27, fig. 32

All works of art are reproduced by kind permission of the owners. Specific acknowledgements are as follows:

© Robert and Caroline Ashby Collection, Swannington: fig. 3
Courtesy Stephen Bulger Gallery: cats 3–6
© J. Paul Getty Museum, Los Angeles: fig. 11
Courtesy US Harper's Bazaar, New York: fig. 19
© Ministère de la Culture, Paris – Médiathèque du Patrimoine, dist. RMN: figs 10, 36
© Museum of Fine Arts, Houston: fig. 8
© National Gallery of Art, Washington DC: figs 22, 37
National Media Museum/SSPL: cats 85–87, 94, 114, 115.1–3
© 1954. The Picture Collection Inc., New York. Reprinted with permission. All rights reserved: fig. 6
Private collection: fig. 18
Prudence Cuming Associates Ltd: fig. 32
Courtesy San Francisco Book Company, Paris: fig. 4
© Scala, Florence (2011, The Museum of Modern Art): fig. 14
Magdalena Szirtes: fig. 35
© Victoria and Albert Museum, London: cats 91, 92, 97, 109, 110, fig. 3
Courtesy Vintage Gallery, Budapest: cats 128, 131.1–9

Index

All references are to page numbers; those in **bold** type indicate catalogue plates, and those in *italic* type indicate essay illustrations